8⁹⁵/

# ETCHING
# AND ENGRAVING

## TECHNIQUES AND THE
## MODERN TREND

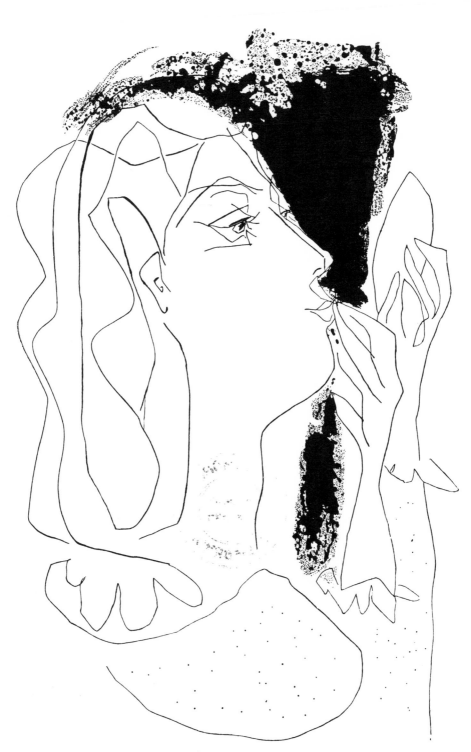

PABLO PICASSO  *Gongora: Girl Rougeing her Lips*  drypoint and sugar aquatint
12½ × 8 inches

# ETCHING
# AND ENGRAVING

## TECHNIQUES AND THE
## MODERN TREND

### JOHN
### BUCKLAND-WRIGHT

DOVER PUBLICATIONS, INC.
NEW YORK

Published in Canada by General Publishing Com-
pany, Ltd., 30 Lesmill Road, Don Mills, Toronto,
Ontario.
Published in the United Kingdom by Constable
and Company, Ltd.

This Dover edition, first published in 1973, is an
unabridged and unaltered republication of the work
originally published in 1953 in London by The
Studio Limited and in the United States by The
Studio Publications, Inc.
This edition published by special arrangement
with Studio Vista, Ltd., Blue Star House, Highgate
Hill, London, N. 19, England.

*International Standard Book Number: 0-486-22888-6*
*Library of Congress Catalog Card Number: 73-75499*

Manufactured in the United States of America
Dover Publications, Inc.
180 Varick Street
New York, N. Y. 10014

THIS BOOK
IS DEDICATED
to the many
artists and students
from whom I have learnt
the technique of engraving
but especially to
JOSEPH HECHT
STANLEY WILLIAM HAYTER
ROGER LACOURIÈRE
and
NIGEL LAMBOURNE

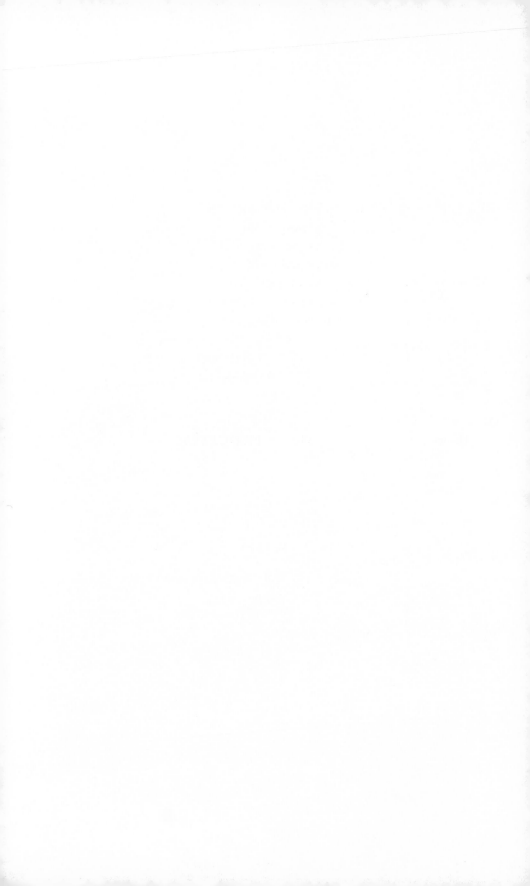

# CONTENTS

# ACKNOWLEDGMENTS

A book of this type could hardly be written without reference to past publications on the subject and the co-operation of artists. I should, therefore, like to acknowledge my indebtedness to such authorities as Mr Herbert Furst's *Original Engraving and Etching*; (Nelson) and *The Modern Woodcut* (The Bodley Head); and the late Joseph Pennell's *Etchers and Etching* (Macmillan) and to Mr Douglas Percy Bliss, who has been kind enough to allow me to quote from *A History of Wood Engraving* (Dent) his youthful criticism of Dürer, with which he says he no longer agrees! I have also to thank Sir Osbert Sitwell and Messrs Macmillan & Co for their kind permission to quote Sickert's views on etching from *A Free House*; and the Folio Society for allowing me to make extensive use of my own articles on engraving published in *The Folio*.

For the illustrations I wish to thank the Trustees of the British Museum for their permission to reproduce the prints on pages 22, 24, 25, 27, 65, 66 (top), 68 (lower), 70, 71, 105, 112 and 117; the authorities of the Victoria and Albert Museum for those on pages 77 (lower) and 192; the Courtauld Institute for the print on page 106; Messrs Faber and Faber for those on pages 26, 141 and 144 lately published in Mr Geoffrey Keynes' *William Blake's Engravings*, and the Golden Cockerel Press for those on pages 44 and 234.

I also gratefully acknowledge the kindness and co-operation of my friends Mr A· Zwemmer of the Zwemmer Gallery for the prints on pages 75, 76, 77 (top), 154, 160 (below), 196 and 217; Messrs Brown and Phillips of the Leicester Galleries for those on pages 67, 72, 73 (below), 74, 117 and 192; Messrs Gerald Duckworth & Co for the plate on page 123; Mr Charles and Mr Peter Gimpel for the plates on pages 41 and 78; Mr A. Wheen for that on page 42; Orovida for those on pages 73 (top) and 206; Dr Richard Gainsborough for the plate on page 54 and Mr Clifford Hall for that on page 69.

Above all I must acknowledge my debt to the artists of many nationalities who have so generously allowed their work to be reproduced and especially those pioneers and experts of contemporary engraving, such as Mr Stanley William Hayter, Mr Roger Lacourière, Mr Nigel Lambourne, Mr Sam Kaner, Orovida, Mr and Mrs Roland Ginzel of the Iowa Print Group and Mr Frank Martin.

And finally I wish to express my sincere gratitude to Miss Ella Moody for her invaluable work and advice in preparing this book for the press.

JOHN BUCKLAND-WRIGHT

# LIST OF ILLUSTRATIONS

## LINE ENGRAVING

## DRYPOINT

# MEZZOTINT

# ETCHING

# SOFT GROUND ETCHING

# AQUATINT

# SUGAR AQUATINT

# DEEP ETCH AND RELIEF

# COMBINED PROCESSES

## COMBINED PROCESSES—*continued*

## WOODCUT AND LINOCUT

# WOOD ENGRAVING

# PREFACE

## By John Piper

To be with Buckland-Wright in a workshop, being shown how to hold a burin or how to hand-wipe a plate, is probably the nearest thing we shall know in life to the artist-apprentice relationship of history. He is an artist himself and a master of the techniques of engraving, and is therefore in a position—and one of the few people to be so—to help artists to express themselves in a medium that has many pitfalls. Many pitfalls, but no secrets, in spite of profitable mysteries that have in the past been created round it by necromancers of the etching-needle. Such near-secrets as remain, the author divulges clearly and simply.

It is generous of him to have put his ideas and his knowledge into this book, for much of it must be boring ground-clearing to him. But it will be valuable, and it may even be revolutionary. Because etching is out of fashion—a promising fact: a lot of students want to study it—a more promising fact. They know that Picasso and Miro and other artists they admire have worked with Hayter at the celebrated Atelier 17 in Paris, a school and workshop with which Buckland-Wright himself has been intimately associated, and they realize that etching and line engraving are not the stuffy crafts that people of older generations tended to think them and make them: that they are not necessarily imitative or reproductive, or expressive only of the sentimental or the acceptedly pictorial. On the other hand, they can be vital and lively arts. Conservative etching is still with us, and it is still based on the practice of fifty years or so ago. It has papers, inks, acids, printing presses in common with the kind of etching that this author deals with, but not a great deal else, for he works on the principle that etching and engraving are immediately dependent, and must be firmly based, on the artist's own drawing and painting, and that that in turn must be based on the expression of a rich, present life.

# INTRODUCTION

The theory of engraving must be, to a great extent, a personal point of view. It must also, from the nature of things, be bound up with the technical aspect, but it is possible to dissociate the purely factual and scientific processes from the theory.

Technique is presented here, to the student, the artist and the amateur in its simplest form, listing the bare minimum of materials, and showing that engraving and etching are not the complicated, mysterious processes which the expert craftsmen would have us believe. They are, in fact, perfectly simple, straightforward techniques, to which any and every artist may turn at times for an additional and inspiring means of expression.

These techniques are not, and should not be, regarded as forms of specialization, the curse of the modern world; but should be part and parcel of every artist's equipment, a corollary to drawing and painting. There is an unfortunate tendency in art schools today to separate illustration and design, and their so-called associated techniques of engraving, etching and lithography, from painting and drawing. But there is no painting which is not illustrative in some degree, and the best painters have always been the best illustrators, etchers and engravers, simply because the qualities which make the one are the qualities which produce the other. That this fact has been lost sight of is due mainly to the technicians and craftsmen who, taking up a process where the artist left off, have used it for imitation and reproduction. They have often exhausted a technique by developing its possibilities to the limit; the obvious examples being the reproductive line engraving of the eighteenth, and the wood engraving of the nineteenth, centuries. Such practitioners are apt to miss the purpose of a technique as an expressive medium and to regard the means as the end. Technique becomes a fetish, a mystery, requiring initiation and long apprenticeship, a host of materials and a specialized workshop.

In fact it is nothing of the sort, and the artist should take up a burin or an etching needle with the same confidence as he takes up a pencil or a paint-brush. But for this he must be convinced that the technique is fundamentally simple and straightforward. For this it is necessary to review the origins and history of the different processes; to show that with a few materials he can get to work in the corner of his studio or ground his plates on the kitchen stove and etch them in the sink, and that a few hours of instruction will enable him to proceed under his own steam and may provide him with another form of expression with almost limitless possibilities.

This is the object of such a book as this, though it must be admitted that its purpose has completely altered since its inception three years ago. The initial

idea was to show the contemporary trend of engraving by collecting as many examples as possible of good work from every country; to show a cross-section of modern engraving in all its phases. The difficulties encountered in the attempt proved overwhelming. Customs regulations were the greatest handicap, though lack of exhibitions and the difficulty of locating the relevant artists were hinderances of sufficient magnitude in themselves. Government sponsored artists are not necessarily those who are the most interesting, but to ignore their proffered material sometimes almost leads to a deterioration in international relations. For these reasons, apart from the fact that an appreciative text, however valuable, must in the end be a purely personal reaction and consequently of ephemeral interest, it was decided to concentrate more on technical aspects. Each technique is sufficiently detailed for all practical purposes and the book contains, not only the well-known processes described in more explicit treatises, but several which appear in print for the first time. Without being an exhaustive treatise on each its aim is the simplification of the techniques with a view to encouraging artists and interesting students, amateurs and others in the possibilities inherent in the known processes and their contemporary adaptations.

To do this it was inevitable to refer to the origins and history of engraving. This meant that a great number of prints, which would normally have found publication in the first concept of the book, have had to be excluded, not because they were not of sufficient value or interest, but because they did not illustrate either the points raised in the theoretical sections or the technical aspects described. I would like, therefore, to thank all those artists who have been kind enough to send me their work for consideration and to apologize for any disappointment they may be caused by this necessary alteration.

If the examples chosen for illustration seem to show any particular bias, this is unintentional. The only object in making the choice was to provide a few simple, direct examples of undoubted value from the mass of available material, especially of past work, to illustrate the origins and the contemporary trend in engraving. This trend is often expressionistic and essentially experimental. This is inevitable. Traditional etching and engraving, unless in the hands of a great master such as de Segonzac, have lost their impact through a misconception of their character and purposes. Their application to contemporary vision, however, and the rediscovery and understanding of existing processes has already gone far in creating a revival of the oldest and one of the most beautiful forms of expression.

JOHN BUCKLAND-WRIGHT

# LINE ENGRAVING · *Theory*

ENGRAVING, the process of scratching or incising lines on a surface is, in all probability, the oldest art of mankind. Primitive man cut lines on rock and bone and scratched them on clay and pottery. The habit is universal. Every ancient monument is covered as far as hand can reach with graffiti of every description and of every period. The schoolboy's desk and the walls of the prison cell are evidence of the idle hours of confinement; and the trees of the forest bear witness to the passing of lovers.

Mortal man possesses an irresistible impulse to record, in some substance more permanent than his own, his presence and his transient thoughts and to invoke by the same means, his needs and desires. This natural stimulus in the artist turns to evocative statement, to self expression in terms of art and to decoration in every conceivable form. From earliest times men have decorated their possessions, adding a personal character to the object, increasing its value and making a thing of use a thing of beauty.

The discovery of metal, especially the rarer and softer species, added enormously to the possibilities of engraved decoration. Homer and the Bible abound with references to the skill of the worker in metals and the fashion in which he decorated their surfaces. Engraving in line, the simplest of all forms of decoration, was obviously practised extensively throughout the ages. But it was not until early in the fifteenth century that a print on paper was ever taken from the designs. It is a matter of purely academic importance whether printing from metal was first discovered in Germany or Italy. What is important is to remember that the origins of line engraving lie in the decoration of armour and precious metals; that such work was simple and direct, formal and arbitrary and that ornamentation was the first requisite. As Ruskin says, 'The object of the engraver is, or ought to be, to cover the surface of the metal with lovely *lines*, forming a lacework and including a variety of spaces, delicious to the eye'. And again, 'To engrave well is to ornament a surface well, not to create a realistic impression'.

This quality of ornament is implicit in all the best engraving. It is found in the highest degree in all the early Italian line engravings and in the best of the early German school. It is either purely lineal, strongly evocative and decorative, of an almost abstract quality, or lineal combined with a purely arbitrary shading. This shading, which sometimes suggests chiaroscuro, is in reality mainly constructive in the sense that it underlines the composition, leading the eye through

the intricacies of the pattern. It is used as emphasis and hardly ever in a really descriptive sense.

Of the purely lineal type there is no better example than the magnificent anonymous *Portrait of a Lady*, page 21, in the Berlin Print Room. It is sheer delineation, superb decoration of the space and at the same time a sensitive and admirable portrait. The line of the profile, with the sloping, swelling medieval forehead, the long Grecian nose, the sensitive mouth and the subtle modelling of the small plump chin, is the work of a master and a Florentine at that. The head-dress and sleeve are evidence of the goldsmith and make a magnificent complex arabesque in direct contrast to the severity of the profile. This is line engraving in its simplest terms and in some respects at its best.

The second type, where shading is used constructively and for emphasis may be seen in one of the Tarocchi cards, the *Astrologia*, page 22, where the figure is shaded to give solidity and importance to the design rather than for any naturalistic effect. This latter is, in any case, completely nullified by the purely arbitrary shadow behind the face, the black stars and the band of heavy tone behind, which are all vital elements of the composition.

These prints are typical of the principles laid down by Ruskin when he said, 'The dignity and virtue of a plate is in the exactly reverse ratio of its fullness in chiaroscuro. All the finest engravers, therefore, leave much white paper, and use their entire power on the outlines'. And here he is upheld by no less a person than William Blake, who said, 'The great and golden rule of art, as well as life is this: That the more distinct, sharp and wiry the bounding line, the more perfect the work of art; and the less keen and sharp, the greater the evidence of weak imagination, plagiarising and bungling'.

Outline is, in effect, the most important factor in line engraving. By outline, or rather contour, is meant the bounding line which, in the hands of a good artist, suggests the third dimension, implying what lies in front of it and that which is behind. It can possess immense subtlety in line engraving due entirely to the intrinsic character of the burin line.

For engraved line has a quality possessed of no other technique save only sculpture. Not only has it, in common with every other drawn line, the attributes of length, breadth and direction, and all the varieties of which these are capable, but it has in addition depth. The engraver, pushing his burin through the metal, *feels* this depth of line as he raises or lowers his angle of attack. This fourth quality gives to line engraving a sculpturesque nature which it alone possesses and differentiates it from every other type of engraving.

The early Italians were quick to appreciate this factor and by the shading they employed often stressed the sculptural quality, giving their prints the effect of a bas-relief. Foremost among such engravings are those of Pollaiuolo and Andrea Mantegna. The former is best known for his *Battle of the Naked Men*, one of the

most beautiful prints of its kind in existence, but which Ruskin heartily disliked. Mantegna, though obviously influenced by this print, produced plates which are really a new creation in the medium. He formed his style independently and in a thoroughly individual manner, and changes in technique are obvious in each of the seven plates which can be definitely ascribed to him. The insistence on contour is characteristic throughout. It is heavy and flexible and forms part of the background. The modelling of the figures is made up of diagonal parallel lines, with finer lines laid between them at a slight angle but without crossing. The shading stops short of the contour, thus increasing the third-dimensional quality by suggesting a reflected light. The background is shaded in a purely arbitrary manner and always in the same direction as the shading on the figures, thus producing an extraordinary unity. This technique gives the impression that the surface recedes from the edges of the print, coming forward again to the original level in the highlights or between the contours of a figure. The whole expression is that of sculpture. Yet it has the essential quality of metal, an astringency and a combination of strength and softness that can be obtained in no other manner. His vision is not that of life but of a mental conception made visible.

Unfortunately, the lineal technique of the earlier prints and the sculpturesque engravings of Mantegna were soon to succumb to the virtuosity of the northern craftsmen. Dexterity in the handling of the burin and technical skill are not art nor are they necessarily desirable beyond a certain point. These are the assets of the craftsman who has little to say and can therefore spend his time in saying it very well. Pure imaginative and expressive line is one of the most difficult of achievement and the lesser artist is only too ready, as Blake said, to cover up his lack with superfluous and often meaningless detail. He describes his subject at length rather than expressing it in a few short evocative sentences.

This technical dexterity of the North, which was to influence the whole of engraving, culminated in the work of Albrecht Dürer, while the example of his far greater compatriot, Martin Schöngauer, remained neglected. Dürer was an artist almost despite his technique. His virtuosity added nothing. And in his engravings on copper it undoubtedly lessened their expressive and aesthetic content. Instead of treating the medium in its true sense of a sculpturesque, simple and direct linear technique, he was carried away by his own cleverness and filled every inch of the plate with cross-hatching, line and dot, of incredible variety. His conception was not that of the bas-relief, of decorative explicit line, as practised by the Italians; but rather that of a picture, in which he did his utmost to render tone and shadow, texture, detail, and even atmosphere. He portrayed, he did not express. Nothing is left to the imagination of the spectator. There is nothing for him to do but accept the subject in its entirety and wonder at the technique. His imagination is arrested and not released. Delight comes, not from any vivid suggestion of third-dimensional qualities, from variety and

expressiveness of line, from pattern and shape; but from the different rendering of wood and cloth and stone, of hair and fur; from the brilliantly detailed portrayal of natural objects; from a purely objective approach even in his most imaginative conceptions. The sunlight streams through the windows of Saint Jerome's cell and casts the pattern of the lattice upon the wall. We know that half the sand has yet to run through the hour-glass above the figure of Melancholia, and can trace the veins in the head of the sleeping greyhound at her feet.

This delight in precision and detail is typical of the north and of the craftsman who loves to show his own dexterity. It is, inevitably, the guarantee of popularity; the popularity of the multitude, who prefer definition to suggestion and wealth of detail to formal expression. It becomes poetry when it is in Dürer's hands, but it is the facile poetry beloved of the unimaginative and the uneducated.

Technically perfect from the point of view of sheer craftsmanship, Dürer's engravings are only too often a negation of the medium. He pushes his virtuosity too far till it almost becomes an end in itself, and thereby sows the seeds of its inevitable decay. He showed that, given a sufficiency of unimaginative craftsmanship, an aptitude for unremitting industry, and patience amounting almost to a vice, every pictorial effect could be obtained with the point of the burin on the copper. The consequence was that line engraving became a reproductive medium, used for the dissemination of paintings and other works throughout the subsequent centuries.

We cannot blame Dürer for this any more than we can blame Michelangelo for the development of baroque in sculpture, painting and architecture. Artistic development follows the rhythm of life, and Dürer was as inevitable in the course of things as Bewick, who unwittingly fathered the reproductive wood engraving of the last century. But we may be permitted to criticize the host of engravers who have taken his technique as a model. In any art the sense of the medium is paramount; and in line engraving, one clean, vital and expressive line is worth a mass of cross-hatching and stippling. Such methods can safely be left to the craftsman, who has little to say and needs must gloss and furbish his emptiness.

The history of line engraving is one of a magnificent original means of expression which rapidly deteriorated into a process of reproduction. Once such an artist as Dürer had set it on its downward path towards pictorial representation and imitation, lesser men were not slow to follow. Dürer, though he misused his medium, must still take his place as a great original engraver. There has been no greater since, for the simple reason that no artist of his calibre has taken to line engraving, which until modern times well deserved the name of the 'handmaiden of the arts'. Raphael was quick to perceive the value of the propaganda as well as the financial aspect of having his pictures reproduced by such a man as

Raimondi. From then on the medium was used in a purely pictorial and reproductive sense, that is that even where the design was original the technique employed was in defiance of the true character of line engraving. Those who employed it used it as a means, not as an original and creative technique. The variety of cut and dot was capable of rendering every conceivable texture and effect. The great range of tone from the white of the untouched plate to the velvety black of intricate cross-hatching offered possibilities provided by no other medium. The very tediousness and slowness of the work enabled pictures to be built up with the highest degree of accuracy. Line engraving and virtuosity went hand in hand. To condemn the brilliant exponents of what had now almost become a craft is, however, unfair. They were interpreters, executants of unsurpassed brilliance standing in relation to the originals much as musicians stand in relation to the works of the composers. Seen in this light and admitting the medium as a reproductive rather than creative one it is possible to delight in their productions. Though one cannot compare their work with the original creations of the great masters, the world would be infinitely poorer without it. The scenes of contemporary life and the unsurpassed portrait engravings of the best of the French school of the seventeenth century are masterpieces of technique. Reproductions though they are, there is an element of creation in the interpretation into another medium, and to anyone of aesthetic sense they stand, in consequence, far above the mechanical though perfect photographic reproductions of today.

However, we are not concerned with the reproductive engravers here but with those rare few who used the medium in its true creative sense. And between the time of Dürer and today, despite the many able practitioners in Italy and Germany, there are but two who stand out as great original artists. These are Jean Duvet in France in the sixteenth century and William Blake.

Little or nothing is known about Duvet save that he was at one time goldsmith to Francis I. It is possible that this calling gave him a better understanding of the art than he might otherwise have had. He produced some sixty plates, among them the *History of the Unicorn* and an *Apocalypse*. This latter comprised twenty-three plates. They are a little crude in technique but perhaps the more expressive on that account. They are magnificent compositions packed with detail where the figures teem and swirl in rhythmic designs of intense vitality. They possess a fiery emotion and an almost breath-taking imagination. Beside them Dürer's famous prints for the same subject look tame and static. Duvet was a mystic, and like Blake his forms are often derivative, but he welds them into an intense personal vision. His conception often outran his execution so that he sometimes left plates unfinished. But they possess the semi-sculpturesque feeling, the astringency and metallic glitter of true line engraving.

Blake was trained from early youth as a professional reproductive engraver

and throughout his life was forced to continue this hack work to earn his living. A lesser man would have easily succumbed but Blake, though his technique was often inexpressive due to a laborious and indiscriminate process of cross-hatching, made it serve his needs for his intensely original designs well enough. Technical reformation is the most difficult self-discipline that an artist can achieve, yet Blake almost at the end of his life was able to rediscover his medium. He was shown some early Italian engravings by Linnell which completely altered his outlook. When he came to study them he found that every stroke was made to tell. It was simple and straightforward with no muddled and careless cross-hatching, no ineffectual lozenges and dots. The beauty of contour and its preservation at all costs was the main principle to which every other consideration was subservient. He saw that the early Italian engravers were not prepared to disturb the dignity of their plates by any compromise with subtlety of modelling, delicate distinction of values and intricacy of detail. They consciously sacrificed variety and wide range of effects in order to preserve the bounding line and keep the work of the burin as broad and simple as possible.

Blake improved on his original designs in the twenty-two plates he made for the *Book of Job* and actually composed direct on the copper, a practice unknown in England until modern times. It gave the engravings an added vitality which was hardly affected by the tightness of the technique he still used for producing tone. Before finishing the *Job* Blake started on a series of engravings for Dante's *Divine Comedy*. But he was already failing in health and had often to work at the designs in bed. He had done seven plates, some of them unfinished, when he died in 1827. In these engravings Blake sought the direct treatment of the early engravers and attempted to dispense with mechanical cross-hatching for tone. But even now he could not bring himself completely to abandon his early training, and still preserved the short, closely engraved lines in his shading. However, the prints are magnificent, imaginative and of great solidity, and almost achieve the sculpturesque qualities of the early Italians.

Though he rediscovered line engraving as an original and expressive medium Blake had no followers until the twentieth century, and even now they are few and far between. The reason lies perhaps in Blake's own comment on this difficult technique: 'I curse and bless Engraving alternately, because it takes so much time and is so intractable, tho' capable of such beauty and perfection'.

Line engraving today is at least an original medium. That is to say, it is no longer used as a reproductive process. This operation has been taken over by the camera only too well. So that when an artist takes to this beautiful technique, he does so because he believes that it is only through it that he can express what he has to say. There are, however, two schools of thought. There are those who, still dazzled by the virtuosity of Dürer, use it for the expression of a purely

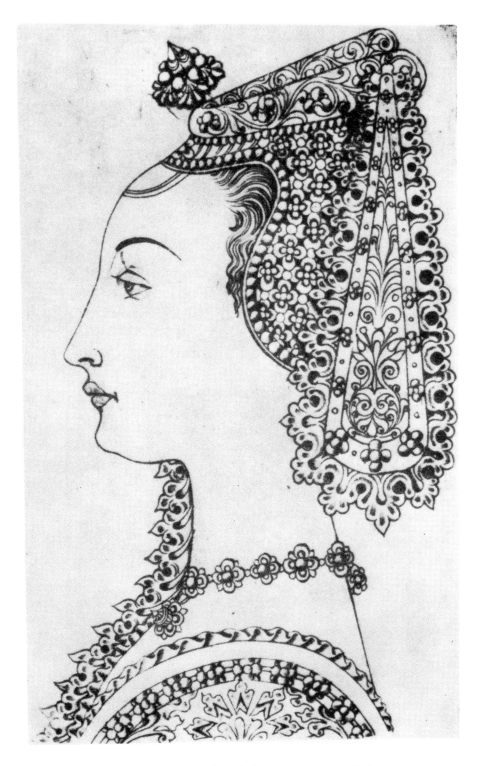

Anonymous *Portrait of a Lady* line engraving 9 × 5¾ inches

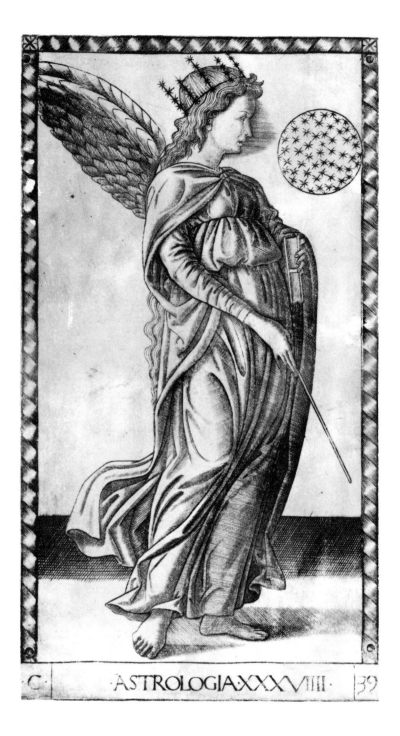

Anonymous *Tarocchi card: Astrologia* line engraving: actual size

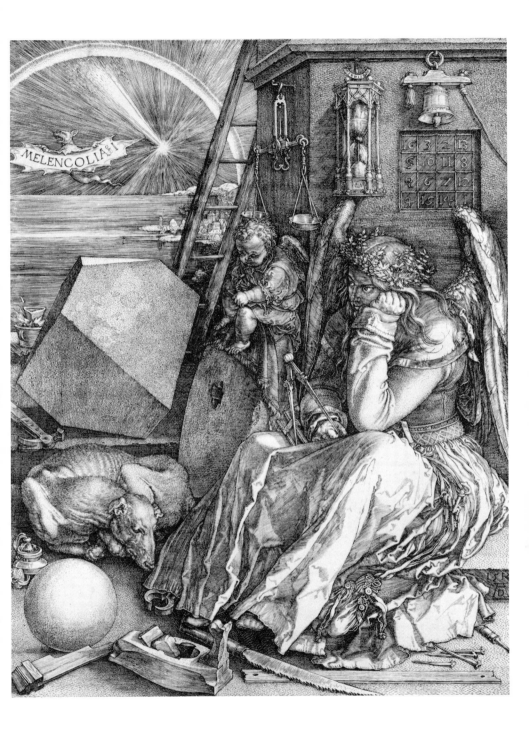

ALBRECHT DÜRER *Melancholia* line engraving 9⅜ × 7¼ inches

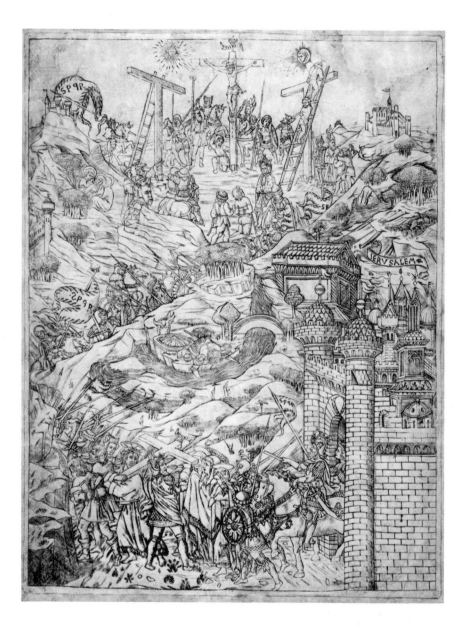

MASO FINIGUERRA *Road to Calvary* line engraving 10¼ × 7¾ inches

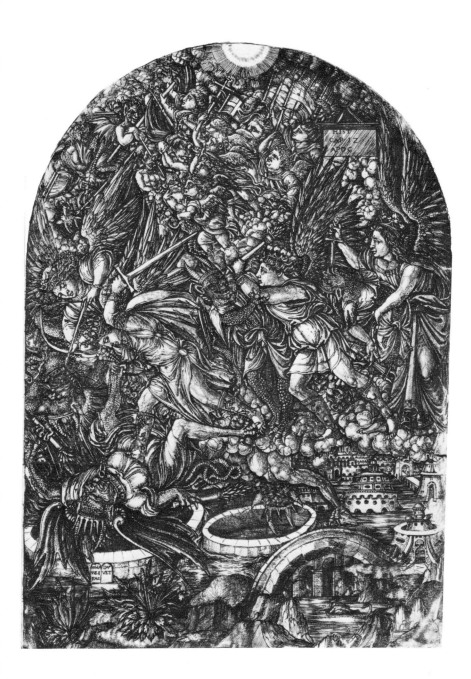

JEAN DUVET *Apocalypse* line engraving 11½ × 8¼ inches

WILLIAM BLAKE *Dante's Inferno* line engraving 9⅝ × 13¼ inches

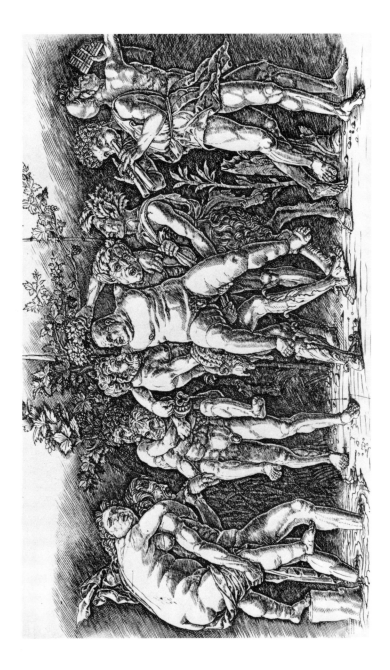

ANDREA MANTEGNA *Bacchanalia* line engraving 10 × 16¾ inches

JOSEPH HECHT *Gnu* line engraving 8 × 10½ inches

pictorial concept, and those who, understanding its true qualities, use it with a sensitive perception of its linear and third-dimensional possibilities.

Joseph Hecht, of Paris, was one of the first in this century who, returning to the origins of engraving, rediscovered the essential simplicity of the medium. His engravings of birds and animals, in which he specializes, have something in common with prehistoric drawings, the same vitality and simple statement as well as something that recalls the animal drawings of Persia. They are creations of expressive line and sparkling cut and dot. His outline is nervous, sometimes broken and intensely evocative. He creates an extraordinary feeling of texture by suggestion rather than rendering. There is an immense variety of line from thick heavy blacks to the finest greys, and a rigidity, an accented quality in his cutting which is truly metallic, as well as flexibility and resilience. The line itself seems to possess the character of life and is never merely descriptive. All these qualities can be seen in his print of *Leopards Hunting*, page 33. All his prints are worth the closest study. But the essential difference between the work of Hecht and other engravers is that his subject matter, his birds and animals seem to possess a life of their own apart from any associated ideas, that is they have an existence in our imaginations apart from their existence as natural phenomena. On looking at the well-known Chinese terra-cotta horses, at Persian drawings or at the work of the early Italian engravers there is a sensation that, though they have their origin in the world about us, they are entirely dissociated from it. They inhabit the emotional world of the mind and of sensual experience. A child, whose imagination has not been dulled by factual knowledge or teaching can believe in their existence far more than in any photographic rendering from life. At any moment they may start to move, to breathe or turn fiercely upon one another. They are far more real than reality, far more evocative of life, and indeed, instinct with a life of their own. It is another interpretation of Keats' difficult saying 'What the imagination seizes as beauty is truth'.

All the best art possesses this intrinsic life and without it the subject matter is but a visual record of the external world, interesting alone to those who prefer fact to imagination and the photograph to aesthetic experience. It was this quality that Hayter perceived and realized in the work of Joseph Hecht and on which he founded his own art. The essential difference between the two is a difference of concept, of vision. Hecht explored the visible world and created imaginatively. Hayter, believing that artists should accept and utilize the scientific discoveries of their age, as they did in the Renaissance, has chosen to explore the realm of the subconscious and the theories of space. To him, as to any thinking artist, perspective is merely a formula for describing on a two-dimensional surface the visual appearances which occur in three-dimensional space. Parallel lines look as though they meet at the vanishing point. In fact they remain equidistant and perspective is no more a reality than pictorial modelling

is round. He is not interested in the visual world but in imaginative experiences and, casting aside the outworn conventions of perspective, chiaroscuro and modelling, he has invented new ones of an imaginative and sometimes tactile character. In the few cases where Hayter's subject matter comes near to naturalistic phenomena his engraved lines seem to describe the movement of the fingers over the object, as though a blind man was 'seeing' by means of his finger-tips, or as a sculptor in the dark might sense with exactness the visual shape of his creation. This returns us to Berenson's 'tactile quality', which he found in early Italian painting, to the tactile, non-visual art of the child, who draws a nose as a triangle, as he feels it and not as he sees it.

Hayter describes the artist pushing his burin through the metal of the plate like a fish in water which has no gravity. He can travel and turn in any direction, move up and down; and though in the end he is tied to the surface of the metal, he moves in imagination with complete freedom of action. The plate printed with a slight film of ink gives the sensation of a three-dimensional void in which engraved lines, recreating imaginative experiences, can express the properties of matter, force, motion and space. Textures etched into the plate suggest torsion, tension and interpenetration, either parallel, or at angles, to the picture plane. These textures being transparent approach the picture plane the deeper they are etched and more lightly etched ones can be seen apparently behind them. By gouging out whites and printing them in relief, projections in front of the picture plane can be produced, and as the print is virtually a mould from the plate they stand actually higher than the surrounding surface of the print. Like the 'practical' or real tree placed in front of a painted avenue in a stage set they enforce the illusion. Behind the real tree the painted ones appear to take up their distances, and instead of a painted avenue we have the illusion that a real avenue exists. So the raised whites force back the other elements engraved and etched on the plate and give an intensified illusion of actual space.

The combination of these techniques in the hands of a sensitive artist almost amounts to the rediscovery of pictorial space with practically limitless and untried possibilities. To some this may appear to be an over-intellectual and scientific approach. And in fact there is a danger, especially when it is combined with visual appearances of naturalistic forms, that the attention is arrested rather than released; that instead of enjoyment, a state of analysis is set up in the mind of the spectator by a transposition that is carried too far. But this attitude begs the question as to how we can dissociate science or intellectual qualities from aesthetics. The Impressionists with their theories of light were regarded by their contemporaries as being over-scientific yet we accept them today and utilize their discoveries. The artists of the Renaissance who first used the newly discovered convention of perspective must have seemed over-intellectual and scientific to many of their colleagues. Aesthetics cannot be relegated to a water-tight

compartment. They are part and parcel of the age and are coloured by the intellectual processes and scientific discoveries of that age. There is no hard and fast line to be drawn between art and intellect or art and science. Art is the synthesis of all human mental, emotional and psychic experience. The fundamentals remain constant, though the superficial means of communication may change as the centuries progress. How much we respond to the work of Hayter and those who follow him depends, not on a superficial appreciation of past aesthetic practice, but on our awareness of the implications of the present and their impact on the creative mind.

Hayter has probably had more personal influence on the course of engraving than any artist in the history of the art. In 1927 he set up a workshop in Paris called Atelier 17, after the number of the house in which it was situated, and artists of every nationality and category came there to learn, to practise and to pool their ideas. In 1940 the Atelier was transferred to New York and its influence has been directly responsible for the renaissance of print making in the United States. Most of the well-known artists from Picasso downwards have at one time or another made plates under the inspiring impetus of its founder. Among these was Roger Vieillard who from his very first plate showed a facility and a personal vision in his work which has made him the most outstanding French engraver of today. He has taken more from Hecht and the early Italians than from Hayter. Not everyone has the necessary exploratory impulse to pioneer in new forms of expression. There are more roads than one that lead to Rome and it is not all of us who are willing to exclude the visual world and its associations from our aesthetic experiences. Vieillard is an engraver in the great tradition of the early Italians, of Mantegna, whom he has closely studied, of Duvet and Hecht. He is as capable of translating such an every-day scene as the *Place Dauphine* into terms of pure engraving as he is of creating a fantasy as disturbing as his *Temple of Liberty*: both are reproduced on page 34. He brings a French wit flavoured with a tinge of surrealism to most of his work which gives it a character and an impact all its own. His engravings are more colourful than any before or since, that is by the discreet use of his burin he is able to convey with line, dot and hatching a sense of tonal colour which is the rarest attribute of the engraver. As an example it is interesting to compare his *Nature Morte*, page 43, with a decorative engraving of the same subject by Edward Bawden. The latter is beautifully engraved and designed but it is cold and formal beside the rich rendering of Vieillard. The comparison is unfair in that Bawden has done few engravings and those of a purely decorative nature; his work is in other fields, whereas Vieillard has restricted himself to the use of the burin. In Britain the line engravings of David Jones, done as illustrations to the *Ancient Mariner*, page 42, have been much publicized. It would appear that this series is almost the only venture this artist has made in this technique and naturally it

betrays the tiro. His line, like that of Eric Gill, has no expressive variation in width and he is addicted to the same tiresome mannerism of arbitrary cross-hatching initiated by Laboureur. These illustrations might equally well have been done in drypoint or etching if we consider the quality of the line. But when this has been admitted there can be no further criticism. They are magnificent imaginative creations in pure line, if we except the cross-hatching, and as illustrations are typical of one of the finest artists in England.

Line engraving has always been an admirable technique for book illustration and will always remain such. There is a discipline and a severity intrinsic in the medium which consorts well with typography. Unfortunately, the price of printing such works makes it prohibitive in these days except for the most expensive collector's items. And so far there are only two possible ways of reproducing it satisfactorily: the first by collotype, which has the advantage of rendering the tone left by the thin film of ink over a plate, enhancing its three-dimensional quality; the second that of lithography. The copperplate inked with lithographic ink and printed on to transfer paper retains every line and dot, however minute, and in no other way can such delicacy of line be obtained, but the tone is lost. This is a poor substitute for the original print but more use could be made of a technique which can give a quality of line possible by no other method.

The contemporary trend of line engraving is to use it in combination with other processes for composite prints which are discussed in another section. Apart from a few brilliant exponents and some admirable technicians it is virtually speaking a neglected medium. Its nature may be summed up again in Blake's words: 'It takes so much time and is so intractable, though capable of so much beauty'.

# *Technique*

## MATERIALS

Burins or Gravers: square and lozenge
  in section, fitted to handles

Aloxite stone    ⎫ for sharpening
Arkansas stone   ⎬ burins
Machine oil      ⎭ and scraper
Copper plates
Scraper
Burnisher

Fixative     ⎫ for tracing
Carbon paper⎭ if required

Snakestone   ⎫ for
Engraver's    ⎪ removing
  charcoal     ⎬ scraper
Metal polish  ⎭ marks
Flat file: for bevelling edges
  of plate

JOSEPH HECHT *Leopards Hunting* line engraving $11\frac{3}{4} \times 15\frac{1}{2}$ inches

34

opposite:
ROGER VIEILLARD
*Temple of Liberty*
line engraving
9¼ × 7 inches

opposite, below:
ROGER VIEILLARD
*La Place Dauphine*
line engraving
3¼ × 5 inches

above:
S. W. HAYTER
*Grolier*
line engraving
6 × 5 inches

left:
JOHN BUCKLAND-WRIGHT
*Solidarité*
line engraving
4¼ × 2½ inches

35

s. w. hayter  *Paysage Anthropophage*  line engraving $7\frac{1}{4} \times 14$ inches

## TECHNIQUE

Line engraving is done by cutting the polished surface of a metal plate with a graver or burin. This tool is a short highly tempered steel bar, square or lozenge in section with a facet cut off at an angle. It is the same tool as that used for wood engraving, but for use on metal the facet instead of being cut at 30° should be anything from 45° to 60° to the axis of the bar. The undersurfaces should be true and meet in a sharp clean line, or however much the facet is sharpened the tip will break and scratching and slipping be the result. This is especially true of very fine work or when engraving some really hard metal such as steel plate.

The most useful type of burin is that with a square section, as it turns easily and very little burr is raised. Lozenge-sectioned burins are useful for the fine lines but throw up more burr on the edges of the line. Generally speaking, an artist can do anything he wants with a square burin of about one-tenth of an inch. Well sharpened it is capable of producing the finest lines as well as thick ones, giving the greatest variety of line, and consequently of expression. The beginner is often tempted to buy a selection but in the end he finds himself using a couple of favourites while the others remain neglected. Every effort should be made to obtain old burins which are made of far better steel than those of today.

The burin should not be straight set into its handle but bent just as it enters, so that while the steel lies flat on the plate the handle comes up comfortably into the palm of the hand. If the burin and handle are straight when bought, the burin should be extracted and the tapering end which enters the handle made red-hot over a gas ring. With two pairs of pliers it can then be bent to any angle between 15° and 30° as preferred. When heating, care should be taken not to heat to red more than the portion required or the temper will be lost.

Old burins which are too short can be provided with longer handles to obtain the correct length. A burin when held in the hand should project not more than half an inch beyond the natural grip of the fingers.

HOW TO HOLD THE BURIN. Artists hold their burins in different ways and provided you can engrave there is no hard and fast rule. If the tool is laid flat on a table or plate and picked up into the hand you will have got the proper hold for working. A little practice soon gives ease and confidence. The point of this is that if the fingers are round the burin the angle of attack must be so great as to prevent any incision other than a dot, while you should be able to engrave a hair line with the whole hand resting on the plate and the angle of the burin practically level with it.

The hand should be relaxed and the pushing movement should come through the palm from the shoulder, not from the wrist or fingers. As in drawing and painting the fingers should only hold the instrument; direction and impetus must come from the arm, or the result is meticulous, weak and inexpressive. This

was the classical hold up to the seventeenth century and only reproductive craftsmen use their burins in any other fashion.

SHARPENING. A really sharp burin has three true polished surfaces meeting in a point. Two of these are the undersurfaces of the tool and they should be perfectly straight, parallel to the length and sharpened to such an extent that no light is reflected along their meeting edge. To obtain this the burin should be placed on its side diagonally across the aloxite stone. The point should be within the area of the stone and two fingers of the left hand should bear down heavily upon it. The right hand presses down the handle and the tool is then drawn up and down the oiled surface until ground flat. This is repeated for the other side and the process done all over again on an oiled arkansas stone to polish away the minute scratches and burr left by the aloxite. Once these two surfaces are perfect they seldom need regrinding. The third surface to be ground is the end facet and this will need constant attention as engraving proceeds. The tool should be held as near the point as possible, keeping the facet flat on the stone and ground with a rotary motion with the wrist as rigid as possible so as not to change the angle. Plenty of oil should be used and both stones should be used as before, the aloxite for grinding and the arkansas for honing. While working on the plate it is useful to hone the facet from time to time either on arkansas stone or the finest make of emery paper. It then remains sharp for much longer. Needless to say, artists are notoriously lax at keeping their gravers in perfect condition; but it is only the admirable craftsman who can afford to do so. When Roger Lacourière was in London and visiting an English engraver he examined his burins; 'If my father had found me with tools like that', he said, 'I should have been thrown out neck and crop. You must be a good artist. Only a good artist can work with bad tools'.

THE PLATE. Copperplates should be 16 or 18 gauge. Thinner than this they are apt to cut the fingers and thicker ones burst the paper in printing and offer no advantages. Zinc is too soft and is unpleasant to cut, but its main disadvantage is that the lines tend to close up after a few prints. Steel plates should, of course, be of soft steel, but even then they are about three times as hard to engrave as copper, and if not sharpened perfectly the point will go with every few strokes.

Highly polished plates are trying to the eyes but the surface can be dulled by rubbing with a non-gritty kitchen powder or by oxydizing them for a few seconds in a weak acid solution. The makers sometimes supply them 'brushed' with a mechanically dulled surface. A dull day when the light is too bad for any other work is an admirable time for engraving. It is not necessary to have the traditional screens in front of the window. The best engravers of today do not use them but at times they can be a help. No engraver who has any regard for his eyes should work by artificial light unless the conditions are perfect, and even then it is inadvisable.

DRAWING ON THE PLATE. When the plate is dull, brushed or oxydized, it is fairly easy to draw on it with a lead pencil and this should be sufficient guide, always remembering that when printed the design will be in reverse. If the work is to be creative any drawing on the copper should be no more than an indication and placing of the design. All drawing should thenceforth be done with the burin. However, there are occasions when it is useful to make a careful tracing. The lines need not be followed with the burin but the fact that the design is on the plate gives greater confidence and, consequently, it is easier to transpose and alter as the work proceeds.

To trace a drawing accurately on a polished plate, paint the copper all over with ordinary charcoal fixative and allow it to dry. This provides a basis on which the carbon will take, which it will not do on a highly polished plate. When the design is traced through carbon paper—in reverse if necessary—it can be fixed to prevent the lines rubbing by spraying it with more fixative. Or the artist may prefer to scratch in the drawing with a dry point and rub in a little printing ink to make it visible. The drypoint lines can be burnished away at a later date. The fixative can be removed with methylated spirits when no longer required. By using a metal point for tracing, the most intricate designs can be clearly drawn out on the plate; and far more accurately than by any of the methods usually advocated. It is also possible to draw on polished plates with litho chalk, litho ink and grease pencil.

CUTTING. The position for engraving is a matter of personal taste. Some prefer to rest the right elbow on the table with the plate on the same level. Others like a support for the plate such as a book or a sandbag. Certainly the latter makes it easier to swing the plate round when cutting curves, and as the plate can be held by a corner, a slip with a blunt tool does not necessarily draw blood.

The usual mistake made by the beginner is to force the tool into the metal at too high an angle. The result is like catching a crab when rowing; it is extremely difficult either to move or to get back to the surface again. The right angle for cutting is extremely low. Held almost flat on the plate a really sharp burin will bite into the metal. Once this bite is felt the tool can be pushed forward with confidence and by lifting and depressing the angle of attack the line cut will be fine or thick. Once this is mastered, engraving becomes comparatively easy and with the hand relaxed the line becomes sensitive and the burin moves sweetly through the metal while a thin spiral of copper grows like a serpent from the moving point.

To make a curve the right hand scarcely moves while the left rotates the plate. The relation of movement between the two hands will determine the ratio of the curve. With a steady slow rotation the most perfect curves are easily cut after a little practice.

Lines can be ended deep in the metal by withdrawing the burin and cutting off the spiral of metal with the scraper, making a square end, or the tool can be slowly or suddenly brought to the surface, producing an ending in a fine line or a pointed deep one. Dots are made either by driving the burin into the metal at a high angle, producing a triangular dot when the outstanding point of copper is cut off, or by putting the point of the tool into the plate and rotating the latter; the lower the angle of the burin the larger the circular dot.

Beginners are apt to try and rub off the upstanding points of metal from the ends of lines or triangular dots with their fingers, but once they have drawn blood they cut them off with the scraper in the proper manner. Whether the burr on lines should be removed or not is a matter for personal preference: leaving it on gives a richness which is often very attractive, but too much of it produces a woolly look inconsistent with the character of line engraving. As the work proceeds it is helpful to rub copperplate ink into the lines to estimate the effect of the cutting. This should always be removed at the end of the day's work or it will dry hard and may have to be scraped out or boiled with caustic soda.

SHADING. There are three methods of shading and the infinite variations seen in the reproductive prints of the seventeenth and eighteenth centuries are merely elaborations of these three. The first in point of time, and the best, is the diagonal hatching, cutting from right to left with a natural movement of the arm. The closer the lines are spaced the darker the tone and a pure black can be obtained in this manner with the simplest means. If thin lines, broken lines or dots are cut between the first set of hatchings it is possible to produce shading of infinite variety and liveliness. Mantegna varied the angle of his cuts while maintaining the general direction. Too much change of direction makes for loss of unity and is rarely successful. This method of shading is that of the early Italians and for truly creative work has never been bettered though the inventiveness of craftsman in later times has produced an inconceivable variety of tonal textures. The other two main methods are cross-hatching and stippling. Cross-hatching is self-explanatory; stippling is shading by placing dots ever closer together until a black is obtained. Both are mechanical in aspect, insensitive and generally inexpressive though they may be of use at times and in moderation.

MISTAKES. Mistakes in engraving are easily made. On wood they are practically irretrievable, but on copper anything and everything may be scraped and cleaned away. But though correction is relatively easy it is always hard work. When copper is cheap, and not too much work has been put into a plate, the impulse after making a really bad mistake is to throw the whole thing out of the window. In these days this is not likely to happen.

THE BURNISHER. Fine lines and scratches can be smoothed out with the burnisher. This tool varies in shape but in principle it is a smooth rounded piece of steel with a high polish set in a handle. It is important to keep it free from

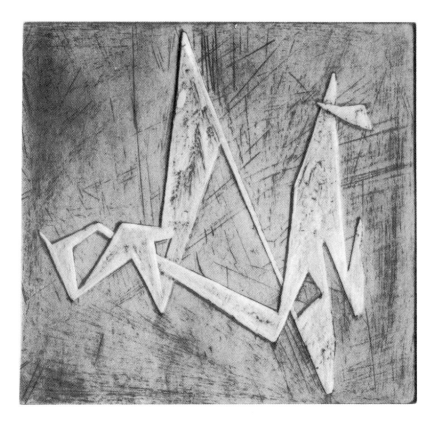

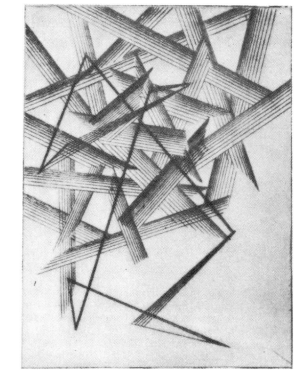

above:
COURTIN
*Abstract*
line engraving
and gouged whites
$4\frac{3}{4} \times 5$ inches

ANTON
*Abstract*
line engraving
$5\frac{1}{4} \times 4$ inches

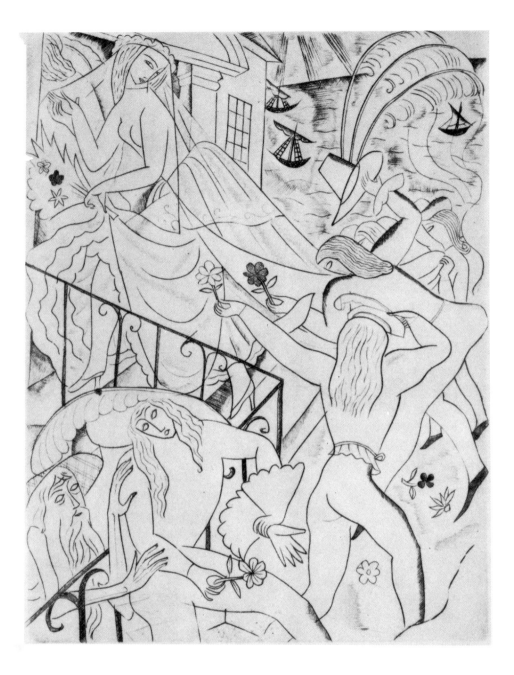

DAVID JONES *The Ancient Mariner* line engraving $7 \times 5\frac{1}{2}$ inches

EDWARD BAWDEN
*Decoration for the Orient Line*
line engraving
$7\frac{5}{8} \times 4\frac{3}{4}$ inches

ROGER VIEILLARD
*Nature Morte*
line engraving
$5\frac{1}{2} \times 3\frac{3}{4}$ inches

43

PASIPHAË

*A Poem by*

A. C. Swinburne

JOHN BUCKLAND-WRIGHT *Title page* line engraving, actual size

44

MAURICIO LAZANSKY *Self portrait* line engraving

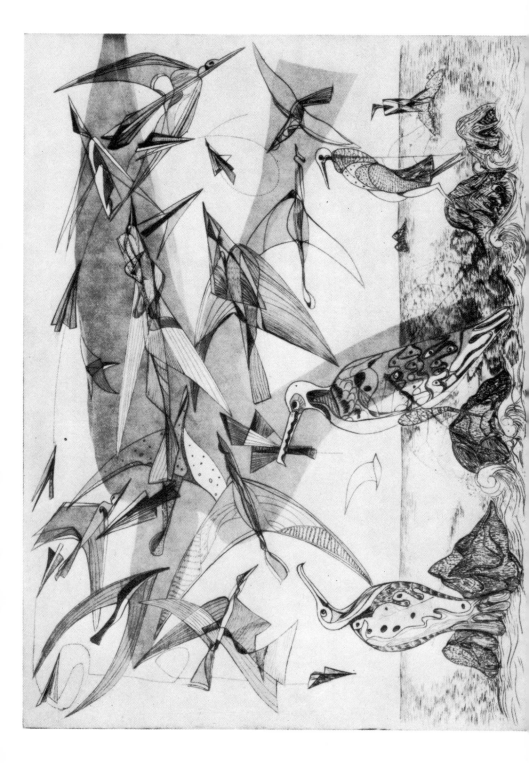

RU VAN ROSSEM *Bullfight* line engraving and soft ground etching 9¾ × 15 inches

OPPOSITE: DOLF RIESER *Flight Forms* line engraving and soft ground etching 11¾ × 15½ inches

47

RICHARD HAMILTON *Reaper and Binder* line engraving and roulette $7 \times 10\frac{3}{4}$ inches

corrosion and in perfect condition or it will do more harm than good. Knife powder or the finest emery paper, 'blue back' and other fine polishing powders are useful for this purpose. With a little machine oil, finer mistakes and scratches can be rubbed and smoothed away much in the same way as pencil is rubbed out from paper.

THE SCRAPER. For deeper cuts the scraper must be used. This is a knife, triangular in section, and consequently having three cutting edges. When properly sharpened on the aloxite and arkansas stones it will shave the copper off like a plane does wood. When blunt it scratches and makes cuts and ridges which take some time to eradicate, and has, therefore, acquired a very unsavoury reputation. When shaving away an error with this tool, as large an area as possible should be attacked. In this way the depth in relation to the area will be small and when polished will not retain ink when printing. If, however, due to other work in the area the depression made is necessarily deep in relation to the area cleared, the surface must be levelled up again to avoid the retention of ink. The best way to do this is to mark the exact area of the depression on the back of the plate with a pair of pointed callipers. Failing these take a print and, placing it face down over the back of the plate, after pinpointing the area on the proof, mark the area through the pin holes. Then cut out a few pieces of paper to fit the depression and, sticking them on to the back in position, run the plate through the press with a piece of paper over it. The pressure of the pieces of paper under the depression will bring it up level again. Beginners have proved this method to their cost by leaving a hard lump of ink or varnish on the back of their plates when printing; the result is a pimple on the front which prints whiter than the surrounding copper.

Scrapers should be razor sharp for correcting mistakes but it is extremely useful to have a second and comparatively blunt one for cutting off burr and spikes of copper. A really sharp scraper is apt to shave off the surrounding surface at the same time.

SNAKESTONE AND CHARCOAL. However sharp the scraper it is bound to leave irregularities on the surface after a mistake has been shaved off. These will print a dirty grey and must be removed and the whole area polished before a good print can be obtained. To do this take the snakestone and, using plenty of water, scrub the area until completely smooth. But as the tiny scratches left by the snakestone also need removing, the same process should be repeated with the hard engraver's charcoal. This will still leave a surface that will print a faint grey, but it is easily removed by polishing with a good non-gritty metal polish.

49

Drypoint, the mere scratching and cutting of the surface of a plate with a point would seem to be one of the simplest and easiest forms of engraving. In fact it is the reverse. It requires an extremely strong wrist to control the movement of the point through the metal and to raise, where required, sufficient burr to retain the ink. The point sticks and catches, or slips if its cutting edge is not sharp enough. The result when printed is often spotty, the light greys of the scratches alternating with the heavy velvety blacks produced by the raised ridges of metal called the burr. Students and amateurs, unaware of its difficulties, often take up drypoint mainly because of its apparent simplicity, but the unsatisfactory results obtained are generally sufficient to persuade them that etching, with all its complications, is a more tractable technique.

Under these circumstances it is amazing what complete and intricate work may be done in the medium. But generally such work is the result of a careful and uninspired mind; one who will take the necessary pains and time to correct all mistakes and go over and over a drawing until the desired effect is obtained. If drypoint has any original expressive qualities it is not seen in such work, which might just as well be done by one of the tonal processes; it is more in the quick, direct notation made at white heat by an artist who can put down his statement with authority, and control the point sufficiently to do so without hindrance to the drawing.

The first known drypoints are a few by Albrecht Dürer, notably his *Saint Jerome*, of which a first state is in the British Museum. But Dürer was obviously unhappy with the medium and returned, probably with relief, to engraving, whose effects he could control with far more facility. The heavy blacks obscured the detail in his shadows and in themselves provided accents which he would not have used in engraving. Rembrandt, as is well known, used the technique extensively for supplementing his etchings, increasing their tonal qualities and the richness of the blacks. Drypoint has been mainly used for this purpose throughout the centuries and as such it has proved extremely useful. But there were few pure drypoints in existence until modern times, probably because until it was possible to steelface a copperplate, which prevents the burr from wearing away or being broken off in the press, it was impossible to obtain more than a few prints. This circumstance added to the mastery of drawing, and control needed for the making of a plate meant that the technique was unpractical to any but a few original spirits. In recent times, however, it has been quite extensively used,

though the number of first-class drypoints remains small. When the lines are cut deep enough and the burr is completely removed it is extremely difficult to tell from a print whether the plate has been drypointed or etched. The only telling character it may have in these circumstances is a certain angularity, a harshness, a feeling that the line has been cut into the intractable metal rather than easily scribbled over the grounded surface of the plate. The landscapes of such an artist as Jean Frélaut are a case in point. Without previous knowledge it is quite impossible in some cases to tell whether they are etchings or drypoints, as all tell-tale burr has been carefully removed. This applies as well to the delicate and sensitive illustrations to Æsop's Fables by Fischer. There is no trace of burr on these prints, and had the artist not labelled them distinctly the natural supposition would have been that they were etchings. In many of Picasso's drypoints, with which he has used sugar aquatint, for the Poems of Gongora, of which *Girl Rougeing her Lips* is reproduced as a frontispiece, there is so little burr at times that at first glance they give the appearance of slightly crude engravings. But on closer inspection they are obviously drawn and the erratic trace of the point through the metal is evident.

De Segonzac in his *Two Girls Sunbathing*, page 56, has made full use of the qualities of the burr and achieved an admirable sense of colour in the variation between the dark shadowed trees and the illuminated bodies. Except for these examples of quick notation, drawings often done at white heat, there would seem to be as little use for the drypoint today as in the past, save as a useful adjunct to etching or composite plates. The former activity, which Sickert described as a 'by-product', referred to in the section on etching, could almost as well be done in straight etching except where the quality of the burr is employed. This last in the hands of an adept such as de Segonzac is the only reason for, and the only true characteristic of, drypoint. For the drypoint which is carefully built up and laboured to produce a variety of tonal qualities is surely a contradictory *tour de force* and it would be more logical to use a direct tonal technique in these cases. As a pure line technique with a slight burr for variation it can be used creatively in the sense of the medium. But the moment a strong burr, with its heavy black 'woolly caterpillars' as they have been aptly called, is used it takes a master to control it and co-ordinate it to the fine greys of the lighter work. It is like trying to make a drawing with an H pencil and soft charcoal and achieve a unity.

Most original artists are likely, therefore, to use drypoint intermittently as a quick method of putting down an idea or recording an emotion; otherwise they will reserve it for the subtle passages, for reinforcing the darks of an etching or for a plate of composite techniques.

# Technique

## MATERIALS

| | |
|---|---|
| Point: steel, diamond, ruby or sapphire | Aloxite stone { for sharpening |
| | Arkansas stone ⊰ steel point |
| Copperplate, or other materials (see text) | Machine oil { and scraper |
| Scraper: for removing burr | Carbon paper { for tracing on |
| Burnisher: for corrections | Fixative { plate if required |

## TECHNIQUE

THE POINT. Drypoint is merely scratching on a metal plate with a point and these are the only materials required if no corrections are made. The point can be of steel or stone, the stones used being the hardest such as diamond, ruby or sapphire. Steel points are made in various forms and provided they are strong, of good steel and comfortable to hold, one is as good as another. An engineer's scriber makes quite a good one, though some artists prefer them thicker than this. Home-made drypoints are often excellent, but they must be wholly of steel, as a point fixed in a handle is apt to give way under pressure if any real force is used. The point should be sharpened without facets which cut and are liable to remove the copper rather than turn up a burr. A faceted point is far more difficult to manage.

Stone points, being of precious stones, are very expensive. The stones are in metal settings in wood or metal handles. The setting should be carefully scrutinized and should be of steel, as the stone is apt to drop out after vigorous use if set in softer metals. The stone must also project sufficiently from the setting or it will only be possible to use it in an almost vertical position.

The advantage of stone points is that they travel more easily in all directions over the plate whereas steel often travels easily in one direction and catches and stutters in the metal in another. Stone points yield a stronger and broader line than steel used at the same pressure.

THE PLATE. If possible it is preferable to use copper for drypoint, though steel, brass, zinc and aluminium can be employed. Steel requires a very strong wrist to keep the heavier lines steady and flowing. Zinc is easy to work but too soft and the burr disappears very quickly when printed. But it can produce some very delicate silvery effects.

Artists' colourmen sometimes supply sheets of celluloid composition for dry-point and there are some very hard plastics, all of which give results which are generally unsatisfactory. There can of course be no burr, which is the essence of true drypoint, and the line, though black if deeply cut, is uniform and inexpressive. The same applies to end-grain boxwood and hard-surfaced linoleum which

HANS FISCHER *Æsop: The Heron* and *The Wolf and The Crane*

drypoint $5\frac{1}{4} \times 4\frac{3}{4}$ and $3\frac{3}{4} \times 5\frac{3}{4}$ inches

above:
DAVID JONES
*The Wounded Knight*
drypoint
8 × 6 inches

left:
JOHN BUCKLAND-WRIGHT
*Jeune fille se séchant*
drypoint
5¾ × 4 inches

left:
**PEDRO RIU**
*St Raphael*
drypoint
8½ × 6 inches

below:
**LEON UNDERWOOD**
*Bathers Disrobing*
drypoint
7 × 5 inches

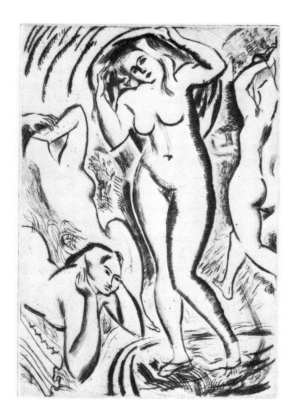

DUNOYER DE SEGONZAC  *Girls Sunbathing*  drypoint 10¾ × 16 inches

have also been used. There are, in fact, countless materials which, when scratched with a point will produce a line that will hold ink and print after the surface has been cleaned. But the essential quality of traditional drypoint is the great variety of line from the thin faint grey of a light scratch to the rich, soft, full black of a line with a good burr on it which holds the ink. And for this purpose metal would seem to be the only possible material.

DRAWING ON THE PLATE. As in line engraving it is often useful to mark the main lines of a composition or 'place' a drawing on the plate before starting to cut: the same procedure should be used and the reader is referred back to the corresponding section on page 39.

CUTTING. As anyone who has ever practised engraving on metal knows to his cost, the smallest scratch on a polished copperplate will print, though not necessarily for very long. So that the faintest scratch made with a metal or stone point will be reasonably durable. This is one end of the scale of possibilities. At the other is the deep line which has turned up a strong burr which will hold plenty of ink. Between these two extremes are an infinite variety of stronger or weaker lines which can be varied either by the cut itself or by scraping and burnishing down a burr which is too strong. As the point passes through the metal it turns up, like a plough, a ridge of displaced copper, which may stand up straight or turn over inwards or outwards.

THE BURR. This flange of metal is the burr and when the plate is wiped clean after inking, the ink will lie behind the raised copper exactly as snow in windy weather lies behind a hedge. This is surface ink and is, or should be, peculiar to drypoint. If the burr is cut off, the line itself will print either grey or black in relation to its depth. Unfortunately, by its very nature the burr is extremely fragile, and in inking and printing wears down or is broken off so that if more than a dozen or so prints are needed the plate will have to be steel-faced.

The raising of the burr does not depend only on the amount of pressure used but far more on the angle at which the point is held. Generally speaking there are three positions: vertical; high angle, about 60°; and low angle, say 30° to the plane of the plate. Held vertically the point will generally throw out a burr on each side which in some circumstances may print as a double line, but this is unimportant. What does matter is that a sharp point when held vertically or at a high angle will produce good lines with a strong burr, but that when the angle is too low the point will either remove the copper thrown up or produce a 'rotten' line where the burr is torn and breaks up. This is also produced by blunt points. A good rough working theory of drypoint is that the more upright the point is held the finer the line, and the lower the angle the broader and stronger the line. If lines of equal value are required it is essential, when cutting, not to change the angle, and for this it is necessary to have a strong wrist and keep it rigid.

WORKING PROOFS. Owing to the extreme fragility of the burr it is vital to restrict working proofs to a minimum. It is better not to take any at all until the work is finished, and then have the plate steel-faced as soon as possible. It is, however, very easy to see the exact effect of the work done by rubbing copperplate ink into the lines and cleaning it off with the palm of the hand. Better still, perhaps, is black powder and a little Vaseline, which has the advantage of not drying in the lines and can be cleaned off without any damage.

CORRECTIONS. Corrections in drypoint are easily made. Either the burnisher used judiciously can flatten or break down a burr which is too insistent or the burr can be completely removed with the scraper. It is easier to do this when the plate has been inked, as then the exact effect of the correction can be estimated. To delete a passage completely the burr should be smoothed back into the lines and these closed up with the burnisher. Where the burr has been removed and the line is deep it will be necessary to scrape away the metal and repolish the surface as for corrections in line engraving.

# MEZZOTINT                  *Theory*

MEZZOTINT is rarely practised today. It was invented as, and has always remained, a reproductive process. It is well named 'mezzo' for it is halfway between the artist and the camera and its disappearance is due to the technical advances of photographic reproduction.

Mezzotint was invented in the seventeenth century by a certain Lieutenant-Colonel von Siegen who communicated his discovery to Prince Rupert. There is a portrait by the Colonel of the Princess of Hesse dated 1643. It was Prince Rupert who introduced the technique to England where it was at once taken up by amateurs and others. It has been said that if the prince had not introduced it we should have had to invent it for ourselves, so well did it suit the English temperament and so perfectly did it correspond to the somewhat naïve taste of the English upper classes. Their favourite portraits could be translated by tonal values and by a less laborious means than line engraving, which was still apt to

retain a certain harshness from the burin, into a pure *photographie à la main*. So quickly did it become naturalized that it was known abroad as the 'English manner'.

The plates of the early mezzotinters are of interest on account of the varying techniques they used for roughening the plate and producing the 'ground'. Rollers, roulettes and files all came into play and engraving and stipple were used to accentuate the drawing especially in the lights. For the early mezzotinters did not ground the whole of the plate but only where the darks were wanted. If used today it would perhaps be of more use to employ the technique as these early men did rather than in the later and more traditional manner. Rouault used it in this fashion in many of his early black-and-white plates.

But about 1672 a Dutchman invented the 'rocker', though there is evidence that this type of tool had been used before though not for laying a ground over the whole plate. From this moment the English craftsmen were able to develop the technique at their leisure and the great periods of mezzotint are in the eighteenth and nineteenth centuries. It is believed that though the medium was invented under Rembrandt's very nose, he never used it, which he might well have done considering some of his overworked early plates. Some artists consider that he did so, as the texture in the blacks of some of these plates is too regular to have been obtained by any other method. Certainly the *Jan Six* of 1647 has, superficially, all the effect of a mezzotint and it is difficult to believe that an artist of Rembrandt's character would ignore any new technique which he could usefully employ. In any case, if he did use it, he used it as an adjunct and not a main means of expression, which is where its mechanical qualities become too evident.

The fact remains that no original work of any value has ever been carried out in mezzotint. Turner used it for the ten plates which he himself completed for his *Liber Studiorum*, but they are not preferable to his line etchings before the mezzotint was put on.

It is a meticulous, long-winded and difficult technique, suited to the man who loves work for its own sake and whose inspiration is mechanical rather than aesthetic. After a long spate of reproductive line engraving, which even at its worst had to be a decisive statement due to the uncompromising character of the burin, here was the answer to the copyist's prayer. Something that would translate the countless tones of painting, with brilliant high-lights, velvety darks and soft juicy modelling. According to Blake this is the very antithesis of art.

At its best it is, of course, better than any photographic process, for it is an interpretation of a creative work by an artist craftsman: and an inspired interpretation is often to be preferred to a mechanical copy. Before the invention of photography it was an excellent substitute, as Constable was not slow to realize when he got such a man as Lucas to copy his paintings. But in the end it remains

a mechanical technique, unpleasantly soft and smoky, and it would seem doubtful if it could ever lend itself to any really creative work.

Consequently, a curious light is thrown on the principles of the Royal Academy when it is realized that at one time mezzotinters and reproductive engravers were admitted to exhibitions and membership when original etchers were not. There is, however, no reason why the principle of mezzotint should not be employed very usefully in modern creative work. A rich velvety black is always useful, and the subtle modelling obtainable might work very well as a foil to cruder work. The principle of scraping out greys and whites from a dark ground, which is that of mezzotint, has always been used in aquatint and there are many instances of it in Goya's prints. There are many other occasions when it might be used to advantage as suggested in the technical section. But it is doubtful if any really creative work will ever be done in the traditional manner. There are few artists today who would care to give the necessary time and concentration to a medium which is inherently inartistic and which has so close a relation to the soft tonality of a photograph; even if he were paid on such a scale as to cover the long and laborious work entailed.

# *Technique*

## MATERIALS

| | |
|---|---|
| Rocker: for laying mezzotint ground | Burnishers |
| Copperplate | Roulettes: for replacing ground |
| Scrapers | Machine oil |

## TECHNIQUE

The principle of mezzotint is to roughen the surface of a plate to such an extent that when inked it will print a deep velvety black, and then to burnish and scrape away the roughness until the whites and all the tones from light to dark in the design have been obtained.

THE ROCKER. The roughening of the plate is done with a tool called a rocker, a curved, toothed, steel chisel with a handle in the centre. When rocked over the plate the teeth indent and tear up a line of minute burr. This is done in close regular lines, both ways diagonally, vertically and horizontally until the result is an even texture printing complete black. The work can be done all at once or piecemeal as the work proceeds, or the darks alone of the design can be rocked. The main lines of the composition are generally etched or engraved on the plate before rocking. If they are too faint they disappear under the burr. The ground is then scraped, burnished and polished until every conceivable tone between black and white has been obtained in accordance with the requirements of the

design. If the plate is inked before starting it is easier to see the progress of the work. To produce a white it is not sufficient to scrape away all the ground until the bare copper is reached, as the scraper naturally leaves its own scratches and though the result looks clean it will print a dirty grey. The bare patch produced must be so highly polished that it will print white amidst the surrounding tone. This is a long process, difficult and only possible after considerable practice.

SCRAPERS AND BURNISHERS. It follows from the intricacy of the work that the scrapers and burnishers used for mezzotint are far smaller and different in shape from those normally used. The scraper, especially, is small and flat and must be kept extremely sharp. There are a great variety of types of both instruments.

MISTAKES: THE ROULETTE. Mistakes are remedied by simply restoring the ground. This is done by means of roulettes. These are toothed wheels or drums set in handles; bearing down on them with a good pressure and rolling backwards and forwards in different directions will produce a good mezzotint ground. There is no reason why whole drawings should not be made with roulettes. It has been done in the past but the result is generally mechanical in effect in the same way as a wood engraving made entirely with the multiple tool. Used with discretion, however, it will obviously have its uses in modern technique. The roulette is extremely useful in mending an aquatint ground where the aquatint has been bitten away.

OTHER GROUNDS. As the principle of mezzotint is to work from black to white as in wood engraving, there is no reason why other means of producing a ground should not be used to obtain certain effects. There are several means of darkening the printing surface of a plate and working towards white and lighter tones with the scraper and burnisher. It can be sandblasted, rubbed with a carborundum stone, pitted with sand paper under pressure or bitten with aquatint or soft ground textures. All of these can be a means of enriching a technically composite plate, and scraping and burnishing an aquatint to lighten the tone is a well-known process used by all aquatinters. Another method is to rule close-set parallel lines on a plate covered with hard etching ground in at least four different directions. The whites can then be stopped out and the texture bitten like aquatint in any series of values. This method allows one to draw in white or grey on a black ground, and also to burnish and cut away the etched portions if necessary as in mezzotint technique. The same thing can be done by brushing a hard grounded plate in one direction with a wire brush and then again biting the plate as in aquatint. But any of these techniques used on their own over a whole plate are apt to suffer from the usual disadvantages inherent in mezzotint and produce a photographic or mechanical result.

# STIPPLE ENGRAVING · *Theory*

STIPPLE engraving and the 'crayon manner' which is closely allied to it, were invented as a means of reproduction in common with mezzotint, and have been used entirely with this object in view. Before the invention of photography, engraving was the only means of reproduction and dissemination of pictures famous and otherwise. And though on the continent the professional engraver remained true to the burin for this purpose, using it with incredible dexterity, the standard of taste in England preferred the more mechanical and softer effects of tonal engraving such as mezzotint and stipple.

The crayon manner was an invention purely to imitate chalk drawings and a typical example by William Blake is reproduced on page 68. Stipple, that hand-made half-tone process, was invented in France in the eighteenth century and taking root in this country flourished, in common with mezzotint, as nowhere else. It can be said that without the British both these reproductive processes would have died a natural death or at any rate only been used as subsidiaries to other forms of engraving.

Stipple was introduced into England by the engraver to George III, William Ryland, the man of whom the young Blake said, after being introduced to him, 'I do not like that man's face. He looks as if he was born to be hanged'. And hanged he was, the last man to be hanged at Tyburn, for trying to retrieve his dissipated fortunes by forging a bank note; a natural temptation, it would seem, for a reproductive engraver in difficulties.

Ryland taught the technique to Bartolozzi, a young Florentine brought over by the keeper of the King's pictures, whose name will always be associated with the medium. Only fifty years ago it was said that his name could hardly be mentioned by the connoisseur and the print collector without a little 'thrill of emotion', and as much as £600 was being paid for one of his rarest states.

It is amusing and revealing in these times of abstract aesthetics and self-conscious expressionism to recall the reasons given for Bartolozzi's widespread popularity at the turn of the century. He appealed, we are told, by his qualities of softness, his luminous effects, his grace, tenderness, and above all by his 'elegant sentimentality'. He was acclaimed as being 'completely characteristic of the culture and taste awakened in England and expressed by that old-fashioned word *chaste*'. In quite a chaste way the English people 'allowed themselves to take pleasure in the beauties of the human form, though they still preferred it decently draped! Cupids were not thought to be *too* shocking and these with beautiful

nymphs, slightly robed, were subjects permitted, even copied, in young ladies' academies'. Bartolozzi gave the English nymphs and cupids and they loved him for them. Poor William Blake! No wonder his life was spent doing hack engravings while his original engravings made so little headway. His magnificent designs for the *Book of Job* and *Dante* remained ignored while Bartolozzi with his delectable insipid reproductions was famous, rich and though strictly ineligible, was hauled into the Royal Academy by no less a person than Reynolds himself, without even submitting a painting.

These reproductive processes today are completely extinct. But there is no reason why the technique should not be of use in composite plates. Stipple engraving is certainly of use as a means to certain ends. So too is the hand punch, or punch and hammer, one of the traditional means for decorating a plate which has been used by goldsmiths and others from time immemorial. Chisels as well as punches might be used to make a texture. The principle of technique is to avoid the purist attitude and use everything that comes to the hand if it can be employed to obtain a desired effect. Picasso when doing his first line engraving took out his pocket knife to get a broken serrated grey on his background. Almost anything can be of use to a creative talent in a technique where invention has always played so great a part in personal expression.

# *Technique*

## MATERIALS

Roulettes: of various types, including wheel and drum roulettes, the 'chalk roll' and 'matting wheel'
Stipple burin: with curved blade
Drypoint
Plate: copper and other metals
Etching needles: single and multiple points
Etching materials: see page 92

## TECHNIQUE

Stipple engraving and its allied process, the crayon manner, are composite techniques; that is they make use of etching, line engraving and mezzotint processes to some extent. The crayon manner is a direct reproduction and imitation of a chalk drawing and was so used until the invention of lithography. The same effect can, of course, be obtained by soft ground etching and the two are often confused but a careful inspection will show irregularities in the latter which it

would be impossible to obtain with the mechanical tools of the engraver. A hard etching ground is laid on a properly cleaned copper or steel plate. Other metals can be used provided they are sufficiently hard to withstand printing or softer metals, providing not more than a few proofs are required.

The main lines of the design are first dotted into the ground with a needle, which has one or multiple points and the darker shading is then put in with the various types of roulettes, the 'chalk roll' being used to imitate single lines of the crayon. The plate is etched lightly for the middle tones which are afterwards stopped out while the darkest tones are bitten and the work continued directly on the plate after the ground has been cleaned off, strengthening the drawing with stipple burin, drypoint and roulettes. The lightest tones are laid with the burin and drypoint alone. This technique was sometimes used in combination with soft ground etching to achieve a less mechanical result.

Stipple engraving is an unqualified tonal process, the essential element being the production of a tone by means of a conglomeration of dots, flicks and short strokes, sometimes combined with line. The outline and main contours are lightly etched in dots in exactly the same way as for the crayon manner. When this has been done the stipple burin is used to dot, flick and cut the texture in combination with the roulettes until the required depth of tone has been obtained. The stipple burin is the same tool as that used for line engraving save that to get the correct angle necessary for dotting and flicking the blade is bent into a curve, as though for pecking at the plate. A normal straight burin can be used almost as well for the work which requires immense dexterity and concentration but little else. All burr from the graver and drypoint must be scraped away as soon as made and ink should be rubbed into the dots so that the progress of the work can be estimated.

LUCAS–CONSTABLE *Old Sarum* mezzotint

REMBRANDT
*Jan Six*
etching
9¼ × 7½ inches

below:

JACQUES BOULLAIRE
*Tahiti*
line engraving
and roulette
5⅞ × 6 inches

GEORGES ROUAULT *Le Père Ubu* combined processes 12 × 7½ inches

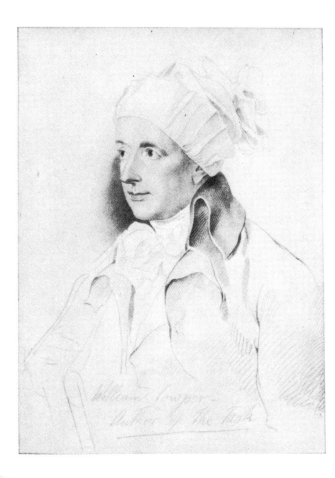

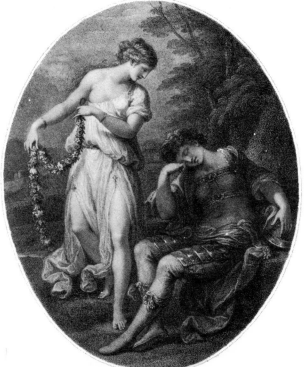

WILLIAM BLAKE
*Portrait of William Cowper*
crayon manner
$9 \times 6\frac{1}{2}$ inches

BARTOLOZZI
*Renaldo & Armida*
stipple
$7\frac{3}{4} \times 6\frac{1}{4}$ inches

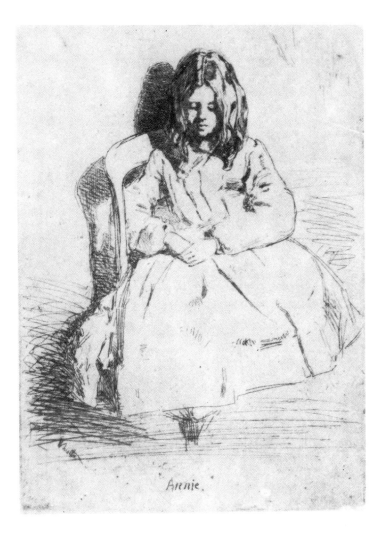

Annie.

JAMES MCNEILL WHISTLER *Annie Hayden* etching, actual size

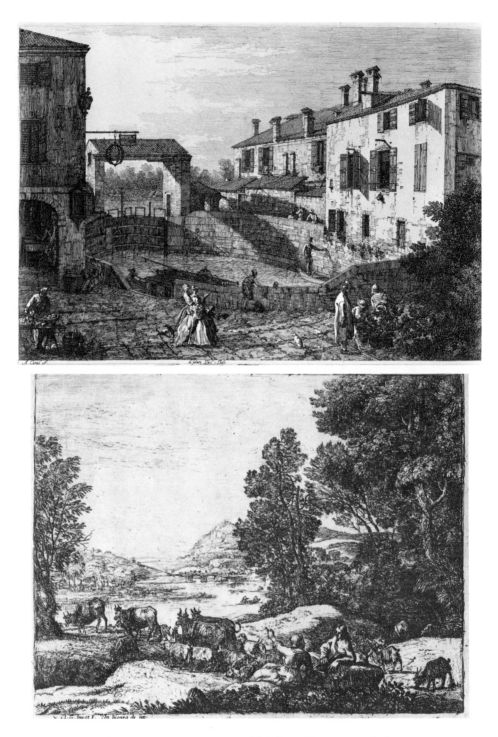

above: CANALETTO  *Le Porte del Dolo*  etching $11\frac{1}{2} \times 17$ inches

below: CLAUDE  *Paysage*  etching

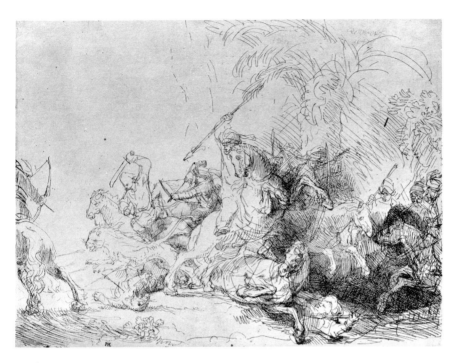

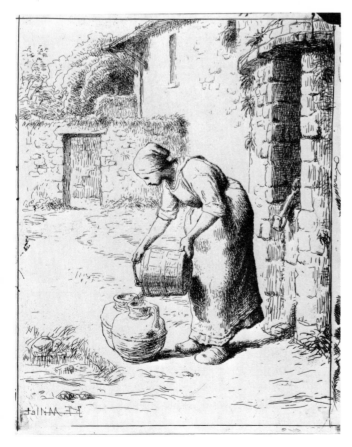

above:
REMBRANDT
*The Large Lion Hunt*
etching
$8\frac{3}{4} \times 11\frac{3}{4}$ inches

left:
JEAN FRANÇOIS MILLET
*Woman Pouring Water*
etching
$11\frac{1}{4} \times 8\frac{3}{4}$ inches

71

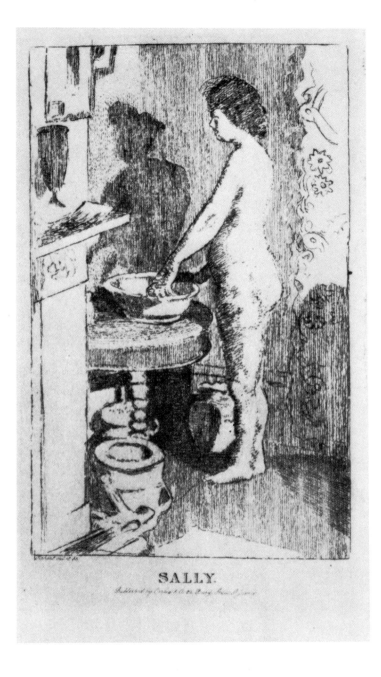

SALLY.

WALTER SICKERT *Sally* etching 5½ × 3½ inches

opposite above: CAMILLE PISSARRO *Bather and Geese* etching 5 × 6¾ inches

opposite below: DUNOYER DE SEGONZAC *Nu au Parasol* etching 4¾ × 6¾ inches

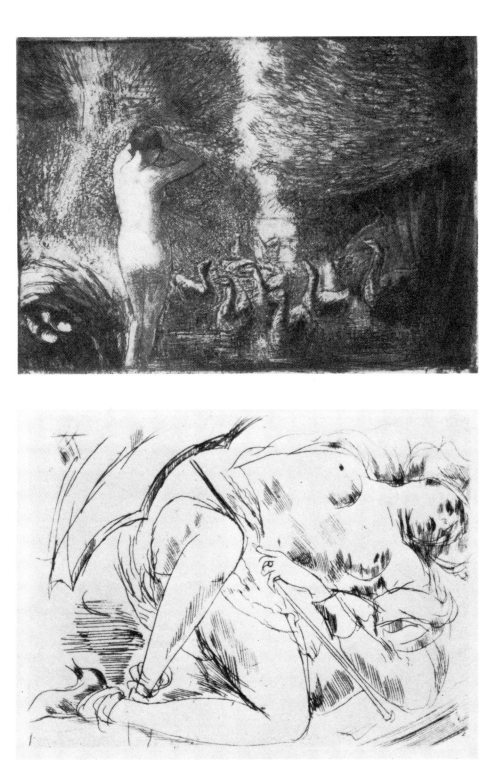

PABLO PICASSO  *Le Chef d'Oeuvre Inconnu*  etching 7¾ × 11 inches

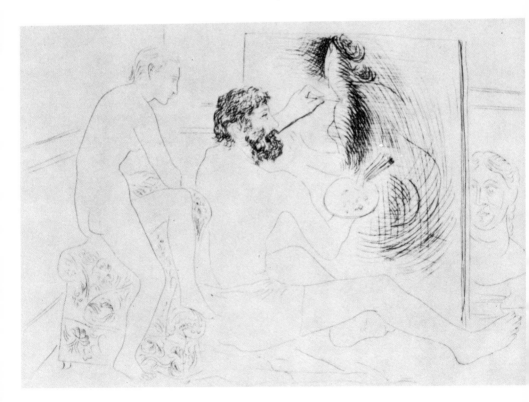

DUNOYER DE SEGONZAC *Cuisine Laroche* etching $13\frac{1}{2} \times 10\frac{1}{4}$ inches

above:
GEORGES BRAQUE
*Doris*
etching
$14\frac{1}{4} \times 11\frac{3}{4}$ inches

right:
KANDINSKI
etching
$9\frac{1}{4} \times 7\frac{3}{4}$ inches

MARC CHAGALL
*Les Ames Mortes*
etching
$11 \times 8\frac{1}{4}$ inches

HENRI MATISSE
*L'Après Midi d'un Faune*
etching

ANTHONY GROSS *La Maison du Poète* etching 6½ ×9½ inches

DUNOYER DE SEGONZAC *Ceres* etching $11\frac{1}{4} \times 9\frac{1}{4}$ inches

HANS ERNI *Cows Fighting* etching 9 × 12¼ inches

# ETCHING                    *Theory*

ETCHING is technically simple but one of the most difficult of the arts. It was invented as a less laborious method of line engraving and is essentially and intrinsically a line technique. Dürer's well-known etching on iron of *The Cannon* is not an etching in the true sense of the medium, but a line engraving carried out by means of etching. Here is no freedom of a needle running easily over a grounded plate, no facility and expressive power, but the slow precise discipline of the engraved line. It remained for Rembrandt to discover and utilize the full possibilities of the technique. Ruskin, who thought little of Rembrandt, disliked etching. He considered it 'indolent and blindfold': indolent because it eludes the manual difficulties of the burin: and blindfold, because when drawing on a grounded plate the lines are negative, that is they show as light on a dark ground instead of the reverse as in the print. It is also blindfold because of the accidents and adventures to which the plate is subject in the acid bath.

He considered that artists who wanted to etch should learn to engrave, which was a superior discipline, and that if etching be done at all, shade or tone should be indicated only and delicate bitings avoided. He believed that in engravings of all kinds, but in etching in particular, chiaroscuro should be eliminated as far as possible. Ruskin, who was courageous enough to say what he thought, was often wrong, but in matters of engraving he was curiously and profoundly right. Etching is a technique of line and line alone, divorced from all tonal considerations such as colour, modelling and light and shade. These matters should be suggested by line and not rendered. The great etchers have suggested more colour and tone with a few lines than others have done with a mass of tedious elaboration. It is drawing at its most expressive. It suggests and interprets but does not describe. It is an abstraction appealing immediately to the mind. The etcher knows that he cannot imitate, and resorts therefore to bold and expressive interpretation. It is as easy to make a good etching as it is to write a good poem and the number of really good etchers are sensibly comparable to the number of good poets.

But this is the highest form of etching where line, and line alone, expressive, suggestive and interpretative, is the only means employed. Where tone if it is used at all is still evocative line, and is used, not to render colour or light and shade, but in a functional and constructive sense, enhancing the meaning and suggesting or enforcing the pattern and composition of the picture. Where, too,

there is not only the value of the etching as a drawing but the intrinsic value as a revelation of a sense of the medium.

There are few etchers who come up to this standard and to try consciously for it is to adopt a hit and miss theory. That is, you may etch fifty plates before you make one that is reasonably good. This was the theory that the etchers of the so-called 'revival' period from 1865 onwards worked on to their confusion. The theory for which Rembrandt at his best, and Whistler at all times were largely responsible. But there were none who could compete with Rembrandt's draughtsmanship and few of the 'Penny-Whistlers' who had the latter's ability and power of rapid selection on the spot, which allowed him to avoid all that was not suitable for expression in the medium. The whole spirit of the period was inartistic and amateurish. There were Haden and others who believed that a true etching was only to be done direct from nature; and Hamerton, who even advocated etching in the acid bath *sur le motif*, as Cézanne would have said. They thought that to spend too much time on a plate was to weaken its conception.

Even Pennell, who had a great deal of sense, when he was not talking about Whistler, is apt to fall into the error that as the greatest etchings often have an almost incidental and ephemeral look, due to their being done spontaneously and at white heat, it was, therefore, necessary to work only in this manner, which is psychologically impossible. The matter is excellently put by Sickert in *A Free House* when he says: 'There are two distinct and different intentions with which a man may set out to etch. He will do well to follow either or both at different times, but it must be at different times. There is firstly the draught from nature, made as it were at white heat with a current reed. And secondly, there is the deliberately built-up composition, which relies on an accumulation of studies on memory or on spontaneous invention. The great masters have spent their lives in the pursuit and culture of the second of these intentions, and have constantly achieved the former as a by-product.'

This is the crux of the whole matter. It is the carefully considered and carefully constructed picture, which should always be the aim and not the brilliant sketch, the perfect etching, which can only happen and which nothing in the world can induce to order. It was to counteract this erroneous idea of the principle aim of etching that Ruskin advocated engraving. And there is no less a person than Sickert to back him up: 'Let the student keep in mind, first of all, that etching is a branch of engraving, no more and no less. That just as the best painters in oils were those who had either practised the more austere and exacting medium of tempera, or who were near enough to the practice of tempera to retain, directly or indirectly, the traces of its salutary discipline, so the best etchers were those who were either themselves engravers or were near enough to the tradition of engraving to proceed from an engraver's conception of the art of etching. That there were bad, as well as good, engravers is no refutation of this truth. All

engraving, as Wedmore has reminded us, is not lozenge and dot. A certain decadence in engraving sprang largely from the same very natural error as has made most modern etching so impossibly bad. The engraver, grown above himself through excess of skill, was tempted on to differentiate between the light in its breadth and the high lights; and he was tempted on to differentiate between the values of colour in the light—two capital errors to which I would implore the close attention of students. It is precisely these errors that have become also the stumbling block of the modern etcher, and the modern etcher has not even the excuse of the patient thoroughness of the decadent engravers.'

Sickert, who at his best was a first-class etcher, was not always innocent of the very errors he castigates in others. But when he did differentiate between the values of colours in the light he did it with the purpose of obtaining the necessary variation in the pattern of his composition. The main criticism which can be levelled against his work is his mechanical and insensitive cross-hatching, very often at right angles, which is in direct contrast to his sensitive delineation.

It would seem perfectly obvious that etching is purely a matter of line, line free and unimpeded as the passage of the needle over the surface of the grounded plate. But this fact is too often forgotten. Etching is delineation, the most essential element of the visual arts. Delineation starts with the first attempt of the child towards self-expression and is the final test of the artist. Line is a pictorial shorthand, an abstraction, having no reality and no relation to nature. Yet it can be evocative, rhythmic, with a nervous sensitiveness to the edge of things, instinctive and swift, continuous or broken, selecting and suggesting infinitely more than it actually states.

These qualities of line are the qualities of good etching. They are, and should be, the only qualities of Sickert's 'by-product'; but they are also the qualities of the more deliberately built-up composition. And if we return to the origins of engraving we may find exactly what he means by 'an engraver's conception of the art of etching'.

A line engraver *pushing* his burin through the metal is subject to a far more severe discipline than the etcher who can scribble with the greatest of ease through the ground on his plate. His hand and mind are concentrated on the point of his burin and the infinite variety of line which he can produce. He is not likely therefore to cut any line which has not been thought out and studied by itself and in relation to the whole. No line engraver ever did a quick sketch or cut an ephemeral idea. His initial emotion would cool long before he could get it down. His object is a finished picture which will stand the test of time: a picture which is the result of as much thought and as many studies as he might use for an oil painting. Typical of this type of engraving are those of Mantegna and the early Italians. This, according to Sickert, is the true aim of etching and should be the aim of every modern etcher. That the facility of the technique

83

should allow him to throw off from time to time some brilliant notation, fired by immediate observation or imagination, is entirely beside the point. It should not be his aim. That is the composed, built-up imaginative picture. Such are the etchings of Claude, the larger but not over-worked plates of Rembrandt, the landscapes of Canaletto and the compositions of Tiepolo and Goya. These prints are all strongly imaginative even when they are pure landscapes. How entirely different are they from the meticulous topographical and architectural prints by modern etchers of what Sickert calls the 'amateur revival' of 1865 onwards. Most of these are purely descriptive and their main appeal is to the man who can admire the dexterity of engraving the Lord's Prayer on the back of a six-pence.

Today there is little appreciation for etching, especially in England. There are two possible reasons for this state of affairs. The first is the mass of bad etching which we have inherited from what Sickert calls the 'amateur revival' from 1865 to 1929. For when people think of etching they rarely think of the best work of the past, which is mainly hidden in print room and private collections, or of the best work of today which is rarely shown. They think of the mass of second-rate work published during the revival period with its long line of tedious subject matter and its distressing and superficial technical efficiency. This is a legacy that is hard to eradicate. Secondly, the British have in the past always shown a preference for tonal qualities. It was from them alone that mezzotint and stipple engraving found any real encouragement and flourished as reproductive methods. Their place has been taken by the photograph, a pure tonal process, which has almost destroyed our understanding and appreciation of line. The history of engraving is, practically speaking, the history of reproductive pro-cesses which were killed by the camera. Etching itself, original etching, is too abstract, too cerebral for the majority. It has never been popular in any country though from time to time it has been fashionable. It was fashionable forty years ago, but even then it was often a form of speculation.

Speculation and fashion are two of the most prevalent considerations in the sale of works of art. They are naturally the antithesis of what the artist desires, which is genuine appreciation, more seldom met than might be supposed. Rarity value has the greatest appeal to the collector, who seldom has the intelligence to appreciate modern work and whose aim is the old master in his rarest states. Hamerton has pointed out that in the unique first state of Rem-brandt's *Sleeping Dog* there are six square inches of blank paper which Rembrandt thought injurious to the etching. He cut the plate down before reprinting, with the result that the British Museum paid £20 per square inch of blank paper to possess this unique first state. As a collectors' item the print may retain or even increase its value: as a work of art it is obviously not as good as the later proofs.

Speculation in etching went out with the crash of the markets at the end of the 1920's. And it is no longer fashionable to buy etchings or consequently to etch. The student who must, whether he likes it or not, make a living somehow in these difficult days may be forgiven if he asks why he should. There is at any rate no financial reason. But etching happens to be intrinsically one of the most beautiful and easy mediums ever invented. And most of the greatest artists have turned to it for the simple reason that it provides them with a medium whose results are unobtainable by any other method. As Oscar Wilde said: 'The highest art rejects the burden of the human spirit and gains more from a new medium or a fresh material than she does from any enthusiasm for art, or from any lofty passion, or from any great awakening of the human consciousness. She develops purely on her own lines.' Painters turn to etching as to a fresh material and every great etcher has used the medium anew, finding fresh possibilities and fresh potentialities for expression. No student until he has tried every technique can tell where his powers lie. Art is drawing in every conceivable form, whether it be with the brush, the crayon, the needle or the burin. Nor have the greatest artists ever limited themselves to one stop on the keyboard.

The fear of the student that he may become jack of all trades and master of none is the terror of the little man with a superficial knowledge of art in an age of specialization. Drawing in one technique with its inherent limitations increases the power of drawing in another. The best painters invariably make the best etchers. Keene, the greatest artist of the Victorian era, was first and foremost a draughtsman—and a draughtsman for a threepenny periodical at that—but he produced some of the finest etchings of the period and his one painting, his self-portrait, was superior to most that the specialists could produce.

French painters have nearly always etched, though the medium in France has passed through the vicissitudes of fashion and neglect much as elsewhere. In the first half of the nineteenth century all engraving had become merely a means of reproduction until it was resuscitated in the 1860's by the Impressionists. Baudelaire aided in its revival, but even then was forced to admit 'that etching, so subtle, so simple and yet so profound, so gay and yet so severe, a type of engraving which, paradoxically, can unite qualities the most diverse and express so well the personal character of the artist, has never enjoyed much popularity with the common multitude'. And Gauthier in the preface to the catalogue of the exhibition of French Society of Etchers for 1862 wrote, 'Every etching is an original drawing. Success, however, can only be achieved by a steady hand, a firmness of touch and a fore-knowledge of the result, which are not always found among the honest and painstaking practitioners of the art. There is nothing finite or laboured about an etching. It never belies the spirit in which it was conceived. It conveys its meaning by a hint, by a suggestion. If any of these plates appear to your judgment to be harsh or truculent, you should not forget

that it is in the nature of every reaction to go to extremes, that the Society has been founded precisely with the object of combating that automatic routine which cramps the work and disfigures the true ideas of the artist, and that it is the intention of its founders to speak directly to the public.'

Unfortunately, the public were not inclined to listen even though such men as Manet, Daumier, Whistler, Degas and Pissarro sent in their work. The hoped-for revival misfired and the artists in most cases were thrown back upon themselves to etch as Corot did, for amusement and relaxation and as a means of personal expression. The fact that in spite of the apathy of the public the best artists continued to etch is a proof of the validity and expressiveness of the medium. And perhaps this apathy provides in the end the most healthy conditions for the art. For when it is fashionable and money can be made, etching is apt to become a trade for the inept and the second-rate. A mass of inferior work is induced by the exaggerated popularity which ends by putting collectors against the movement. Unbalanced appreciation swings too easily to unwarranted disparagement. Prices are inflated and sooner or later the inevitable crash takes place, as it did in England in 1929, with the result that even a normal, healthy appreciation is ruled out, sometimes for a considerable period.

This is what we are still suffering from today though there are signs that the tide is slowly turning. In France, where the revival was still-born, a normal healthy appreciation is still alive. This is not to say that the French do not go to excesses. Theirs have been more in the production of 'de luxe' editions illustrated with engravings and etchings of every conceivable character and lavishly produced in limited editions. And each phase of this activity has brought its own inevitable crash. But these books have served the purpose of keeping the art alive and the market for the 'free' print has remained reasonably healthy.

But if etching is to regain or retain any normal, healthy appreciation from a public, however small, it must follow the rhythm of every vital human activity and renew itself from the contemporary idiom. Conservative etching is still based on Rembrandt and Whistler. The result is literal representation more than an expressive and imaginative design; sentimentality and the picturesque rather than a forceful and personal expression. The conservative etcher has little to say and has found no new way of saying it. If an artist chooses to work to well-known formulas he must express himself with unusual creative intensity. Only thus can he overcome the indifference which is apt to be evoked by familiarity. Today, when the camera can give us every variety of actuality that we can possibly want, art must necessarily be poetic and imaginative or it is nothing. The forms of art are the forms of imagination and the representational is simply the unimaginative. Nature is, and must remain, the source of all inspiration and study, but a literal transcription, even subject to the selection which is inevitable, is not art. Nature which enters at the eye and comes out at the finger-tips is little

more transmuted than when filtered by the lens. It must, after entering at the eye, be transformed by the brain, by the sensitive reactions, by the feelings and emotions which it evokes in the personality of the artist before being expressed as a human activity. Expression in this sense is the basis of all forms of art, of idealism, of expressionism and of what is implied by realism, such as the work of Constable and the Impressionists.

We come, therefore, to the conclusion that a good etching should be an imaginative composition, carried, if necessary, to its furthest limits and relying on pure lineal delineation which suggests and interprets but does not describe: where shadow and colour and other purely tonal qualities are only suggested or used in a constructive sense to enforce the idea or strengthen the composition. An artist who works on these lines, if he is a true etcher will be apt, as Sickert says, to throw off the by-product from time to time: the brilliant graphic masterpiece which is only attainable by the greatest masters. And these can be almost counted on the fingers of one hand: Rembrandt, Whistler, Sickert, de Segonzac and Picasso. There are, of course, others who come within easy reach of these but they are not numerous and these five suffice as examples.

De Segonzac works almost entirely from nature, taking his grounded plates about with him as Whistler did. This would appear like a contradiction of what has just been said, for this was the practice of the etchers of the 'amateur revival', but it is not everyone who can compete with Whistler's genius for swift improvisation, his inimitable placing and his instinctive omission of what was not suitable to the medium.

As for de Segonzac, he is one of the most lyrical draughtsmen alive. His line seems to dance over the paper with enormous speed. He scribbles, but his scribbling is intensely evocative and there is never a meaningless or useless line. He has said, 'If you are not quick enough to draw a man throwing himself out of the window in the time that it takes him to fall from the fourth storey to the ground, you will never be able to do very much'. And there is a hard and uncomfortable truth in this assertion which would-be etchers of the by-product would do well to bear in mind.

On glancing through Picasso's etchings the large majority of them are so slight that it would seem as if he were entirely preoccupied with the by-product. This, again, would seem to deny the validity of the conclusion arrived at above. But, firstly, it must be admitted that Picasso is an exception to any rule. Secondly, there are many of his etchings which are carried to their logical conclusion as considered compositions. His well-known plate of the *Minotauromachia* is an obvious example. And lastly Picasso uses the metal plate for throwing off the by-product of pictorial preoccupations and problems which he is in process of working out in other mediums. So that he, too, falls into line and above all he never misuses the medium. His plates are first and foremost intensely graphic,

relying entirely on pure expressive line. They are always imaginative, and probably the only etchings that he has ever done from nature are a few portraits. It has been said that Picasso's swift notations on metal are more in keeping with the pace of life in this era than the carefully built-up and long drawn-out compositions of earlier masters. This is a purely superficial and meaningless idea. The latter are just as much appreciated today as they have ever been. The reason is in the artist's temperament, for there are artists whose ideas come slowly and painfully, and who can carry each to its conclusion; and there are others whose ideas come tumbling out so fast and with such variety, be it distinct ideas or variations on a theme, that each must be dashed down at once in the shortest time possible. Of the second type is Picasso whose imagination is as fertile as any artist that ever lived. He looks upon the process of etching as of secondary importance and most often leaves it to others to do his biting and printing. And although he seems never to have taken the trouble to become proficient in the technique, his slightest draught on metal reveals such power and decision, such a sense of his material that it would seem he knew everything by instinct.

The very antithesis of this type are such men as Degas and Rouault. Degas told a friend that etching was to him both a source of amusement and a means of expression and not merely a method of transposing his work from one medium to another. 'But there is no art', he said, 'which is less spontaneous than mine.' And certainly he used every process, every formula and trick of the trade. He etched and re-etched his plates countless times, working slowly and methodically towards greater precision and expression until he had got exactly what he wanted. Rouault worked in the same way. Vollard met him one day with a mass of etching and engraving tools under his arm, including files and other unlikely instruments. When asked what they were for, Rouault replied 'They're for your blasted plates, etchings, aquatints, call them what you like. They give me a plate and I just dig into it'. Rouault did, in fact, use every conceivable method to get his results in the same way as Degas. The work of these two artists is the exact opposite to the 'by-product'. They are heavily worked, long drawn-out compositions, and yet how imaginative, how fresh, and how the lights in Rouault's prints stand out against his heavy sombre blacks.

Matisse is more like Picasso. His etchings are never carried very far; a quick notation, an arabesque of a nude drawn in the heat of the moment with an unerring sense of pattern. Chagall, on the other hand, takes infinite pains. He enriches his plates with aquatint, drypoint, soft ground and other textures and produces a dreamlike quality in harmony with his paintings.

The French have often been accused of neglecting technique. This is because they invariably treat it as a means and use it directly, with emphasis and gusto, in exactly the same way as they would use a pencil, a pen or a brush. And in consequence the majority of good etchers today are to be found in the School of

Paris. One of them is an Englishman, Anthony Gross, who lived in Paris before the war and whose reputation is deservedly high on both sides of the Channel. His etchings are direct, lyrical line of great graphic quality, alternating with deeply bitten dotted accents, giving emphasis and variety. His compositions have the spontaneity of true etching and a fanciful charm allied to keen observation.

# *Technique*

The principle of etching is to draw through an acid-resisting ground laid on a plate so that the acid will attack the design and etch it. In most technical treatises on the subject this appears to be an extremely complicated procedure. In actual fact it is extremely simple, and it is simpler when the process is watched than when it is learnt, as it were in the abstract, from a book. In theory, any acid-resisting substance which can be laid on a plate and drawn through to bare the metal in the lines of the design will act as a ground. But in fact only certain types of acid-resist are really serviceable and then only under certain conditions. In theory there are a number of acids that will etch a metal plate. It is possible to etch with lemon juice or vinegar. A plate was once used as a weight to press a cooling sheep's tongue. The acid fumes from the meat etched the plate very nicely in the texture of the cheese cloth covering the tongue over-night. Unfortunately, there happened to be a good line engraving on that particular side. But in fact it is better and quicker to use the acids prescribed in the textbooks and to use the information with common sense. The beginner should not be discouraged by the mass of instructions and the apparently complicated procedure with which he is usually overwhelmed. The process is, and should be, kept extremely simple, and provided the correct materials are used and a few obvious rules observed the technique is easy and straightforward. It is only later when the subtleties of etching are encountered, when mistakes have to be corrected and disasters remedied, that the technique becomes at all complicated; and even then it is mainly a matter of common sense.

One of the main points about etching which every beginner should bear in mind is that the technical process, though only a means to an end, should excite the executant and be part of the pleasure of etching. The artist whose only aim is the finished print is not an etcher at all and it is problematic whether he should ever have taken up art, let alone etching. And certainly the man who uses the technique as a reproductive process for multiplying a drawing is not an etcher. The true etcher may start with or without a drawing. But if he starts with one he should realize that it is only a motive, an inspirational starting point and that he has no conception of what the finished work will be. The result may be

something entirely unexpected. The man who can do just what he wants in etching is not an etcher but a print-manufacturer. No etcher really knows what he has done until he pulls a print from his plate and then he has a shock, which may be pleasant or otherwise, but it is always exciting. Professional etchers and photo-engravers can bite a plate perfectly. The artist is a mass of nerves every time the acid touches the plate.

If the artist has started with a drawing it is not a bad principle to abandon it once the first working proof has been pulled. The result will either be perfect, a disappointment, or a complete mess. If it is perfect there is nothing more to add. But in most cases it will be one of the other two. Corrections and alterations will have to be made and it is the proof of the plate that should suggest these and not a reference to the drawing. And each subsequent state should indicate further steps in procedure until the plate is a success or has been taken to its furthest limits. Thus the etcher, like the painter in many cases, creates as he proceeds and the end is not necessarily visualized until achieved. Some of the plates which have started as the greatest messes have turned out to be the greatest etchings. As Roger Lacourière says, 'There is always hope—so long as you have not reached the back of the plate'.

An example of this type of etching is Camille Pissarro's lovely *Bather and Geese*, page 73. Pissarro started off with a slight drawing, but when he started etching his ideas altered, as so often happens with a creative artist, and he felt that what he wanted was the pattern and whiteness of the girl's body and the geese against the dark masses of foliage and water. But in obtaining this effect he found that he had lost the directness and luminosity of the sketch and so started working back to it. In consequence the plate went through no less than twenty states before he got back to the original idea. In this seventh state there is a lovely texture in the trees, which could only be got by scraping down heavily bitten passages. Starting as a disaster this is one of the finest of the many beautiful etchings made by one of the greatest of the Impressionists.

Only the professional etcher – and no artist is a professional – knows that no accidents will occur and that the acid will do exactly what he wants. The artist always works to a certain extent in the dark and, though long experience will give him confidence in certain reactions of his materials, every new plate is, and should be, an adventure. Original etching is always a chemical experiment. The print-manufacturer, who knows what he is doing, can be diagnosed from a long series of etchings with the same inspiration, the same character and the same effect, where only the subject varies, ending in a long line of dull and uninteresting prints.

It is pleasant to work in a magnificently equipped etching room with every material to hand and every contraption in working order; no dust, no dirt, and all in a state of polished efficiency. But it is not out of such surroundings that the

best etchings come. This is not to say that the etcher should make difficulties for himself. He will, of course, use the best he can obtain but perfect conditions as suggested in the textbooks are not the *sine qua non* of good work. Rembrandt, it is said, got magnificent results with abominable materials and there are many of Rembrandt's etchings which suggest that the conditions he worked in were anything but perfect. Goya in 1792 had suffered a serious and prolonged illness which had sapped his strength and left him completely deaf. In this state, alone in his workroom, without any of the advantages we may possess today, he produced his series of *Caprices*. And Hamerton, writing in 1868, says 'Goya was original in manner because he took up the process without profiting by the experience of his predecessors; but ignorance is generally original, for it has no traditions. As a practical *aquafortist* considering the technical side alone, I cannot admit that he was an artist at all; I cannot admit that he ever got beyond a rash and audacious dilettantism.' Nor was Mr Hamerton alone in this condemnation of one of the masters of etching.

In the heart of many a would-be artist lies a technician, who is only too ready to be awakened by such a technique as etching. If he is, the artist is doomed. The best etchings are not the result of a great knowledge of technique or necessarily of a technique practised under the best conditions. A good artist seems to take technique in his stride, use it purely as a means, and throw off his results, seemingly, with a minimum of effort. In actual fact, being capable of great pains and more concentration, he is able to absorb just what he requires from the process with extraordinary rapidity and, regardless of rules, apply it to his requirements. It is always, and only, a means to an end. He respects the technique sufficiently, but not too much, and his whole attention is fixed more on questions of aesthetics than on the redundancies of a technical process.

The principles of etching can be taught in a morning, but it may take a lifetime to make an etcher; not because of the technique, but because it may take that time to become an artist. Ingres said that it takes thirty years to learn to draw and three days to learn to paint. Views may differ on this opinion but it is certainly true to say that once you have learned to draw it will take a very short time to learn to etch. If you cannot draw, etching will only give your drawings a meretricious importance. There is Sickert's story of the student who was complaining of the poor quality of his drawing: 'Well, why don't you etch?' said his girl friend. In the early days of the century when etching was fashionable there were many etchers of this type and the remark was very good advice. For unfortunately etching, or any form of engraving for that matter, gives an authority to a drawing which it would not possess otherwise. The power of a good drawing is accentuated by the medium and the weaknesses of a bad one emphasized. But in between are a vast quantity of mediocre drawings which benefit enormously from the qualities of the technique. And when these qualities are

stressed by a clever technician, the mediocre drawing is apt, to the uninitiated, to look far better than it really is.

Etching in France is often the normal adjunct to painting, an additional means of expression which comes as naturally as other forms of drawing. This is as it should be. It is not, and should not be, a specialist technique but a normal means of expression available to every artist.

## MATERIALS

Metal plate: copper, zinc, iron etc.
Ground: hard etching ground
Detergent: ammonia and whiting, 'Tide' etc.
Heater
Needle
Stopping-out varnish
Brush: soft

Acid: nitric, Dutch mordant or perchloride of iron, dishes etc.
File: flat for bevelling edges
Scraper
Burnisher
Polishing materials: machine oil, snakestone, charcoal, metal polish

## TECHNIQUE

THE PLATE. Plates for etching can be of copper, zinc or iron. Copper is the best for all-round purposes. For open, free-line etchings zinc is as good but is likely to foul-bite from the nature of the metal, and the possible number of prints are limited on account of its softness. It is also very subject to attack from air, and chemicals in materials with which it may come in contact. Iron should be kept varnished to protect it from rust when not actually in use. In nitric it bites more regularly and less capriciously than copper. Before grounding, plates should have all scratches and blemishes polished off, as it will not be easy to do this once the etching has been made. Some artists prefer or do not object to blemished plates whose pits and scorings give an occasional pleasant background texture. Backs of old plates often have this quality and in view of the expense of metal should be used when possible.

The best thickness for a plate is 16 or 18 gauge. Plates which are too thin are apt to buckle in the press and are not then easy to wipe. Thick plates serve no purpose and as metal is sold by weight are more expensive. The edges will cut the blankets of the press unless bevelled, and even then are apt to burst the paper at the plate-mark. 18-gauge plates need not be bevelled so long as their edges are rounded off and sufficient backing is used in the press when printing. The bevelling in this case can be done when the plate is a success and before the edition is pulled.

BEVELLING. To bevel the edges of a plate, place it flat on a table with the edge overhanging a little and file down each edge in turn to an angle of 45° with a flat file, rounding off the corners. Then smooth away the file marks by scraping them with the scraper and polish with the burnisher.

CLEANING THE PLATE. Before the plate is grounded it is essential to remove all trace of grease from the surface, as otherwise the ground will lift where the plate is dirty when it is in the acid. If water is poured over what looks like a perfectly clean plate it will generally break into globules and runnells. But when a plate has been properly cleaned the water will spread over the whole surface in an even unbroken film.

To clean a plate the best method is perhaps to use diluted ammonia (half ordinary household ammonia to half water) and household whiting, though whiting and methylated spirits or whiting and spirits of turpentine are also used. A piece of cotton-wool saturated in the ammonia solution and a small lump of whiting when rubbed vigorously over the surface will clean a plate perfectly. The advantage of ammonia is that as the whiting has to be washed off under the tap, it is possible to test the cleanness of the plate by seeing the unbroken film of water spread over the surface. No whiting should be left on the plate, as it is apt to render the ground porous. 'Tide' and other strong household detergents are also useful for cleaning, but the water test should always be applied. When clean the plate should be put on the heater.

HEATER. The best type of heater is an iron box with a removable gas ring or Bunsen burner inside or an iron plate on four legs used with a gas burner. Where such appliances are unobtainable the kitchen stove will serve, or better still, the electric heater for household use which can be plugged to a light switch.

GROUNDS. Etching ground is sold in balls or in flat round cakes. It is hard and black in colour and easily distinguishable from soft ground, sold in the same form, which is softer and greasy. There are numerous recipes for grounds which can be found in the textbooks, but that usually sold by reputable firms, such as Rhind's, is perfectly reliable. The usual composition of etching ground is two parts beeswax, two parts bitumen and one part colophon resin. The bitumen and resin should be well pounded and mixed, and added slowly while stirring to the melted wax in a container over the gas. When thoroughly melted and mixed it can be poured into water and moulded into balls.

Liquid grounds are also serviceable. They are best bought ready made. Enough to cover a plate should be poured over the cleaned surface and the plate turned about till it is completely covered. The residue can then be poured back into the bottle. Dust is more dangerous in the case of liquid grounds and is apt to produce foul-biting. There are also grounds that can be painted on with a brush, mainly used in the United States, and the French produce a ground in a tube which can be rolled on. Almost any acid-resist can be used, but most of them, such as stopping-out varnish, will crack and lift under the needle if they have had time to harden. The qualities of a good ground are that it should spread evenly and thinly over the plate and that on hardening it should retain its resilience and not flake off. Properly grounded plates can be kept for years

provided nothing is allowed to scratch the surface and they are not subjected to excesses of heat.

Ground can be spread on in two ways, either with a dabber or a roller. The dabber can be made of kid, with a wooden handle, such as those obtainable in etching stores, or home-made of fine silk with as little texture as possible, tied round a well-packed ball of cotton-wool. It is not easy to lay a good ground with a dabber but care and experience will soon achieve satisfactory results. Too thin a ground will be penetrated by the acid where any dust occurs and a thick ground is apt to crack. The easiest method is to lay the ground with a leather roller. A piece of ground, preferably wrapped in fine silk to prevent any possible grit from sticking to it or coming through the silk, is rubbed round the edges of the plate on the heater and it is then rolled out evenly in both directions over the whole surface. The colour should be dark brown and the surface smooth. When held up to the light it should be impossible to see any glint of bare metal. If too hot the ground will begin to smoke and bubble and, once the ground is burnt, acid will penetrate and the whole process must be recommenced. In ideal conditions there will be little or no dust in the ground but in normal conditions this is almost inevitable. Dust weakens the ground and if necessary the larger motes should be touched with varnish.

SMOKING. It is not necessary to smoke a plate after grounding, but it is useful for two reasons. Firstly, the carbon renders the ground black so that the drawing with the needle is more visible, and secondly, when the plate is completely cold, if the palm of the hand is passed smoothly over the surface any defects, such as holes in the ground, will be visible as the carbon is wiped off them. Any such defects may be mended with a soft brush dipped in turpentine and rubbed on an etching ball till thick and sticky. Any holes or scratches may be lightly painted over with this mixture. To smoke a plate, two or three tapers should be twisted together and lit and the flame passed to and fro over the hot grounded plate held upside down in a hand-vice. The teeth of the vice should be protected with a piece of stiff paper or card so that they do not mark the plate. The top of the flame should touch the plate but must be kept moving or it will burn the ground. If sparks or grease from the taper touch or fly on to the ground a new ground will have to be laid. When finished the plate should have an even brilliant black surface which dulls as it gets cold. When completely cold it can be tested with the palm of the hand for imperfections. A good practice is to leave newly grounded plates for twenty-four hours for the ground to set.

DRAWING ON THE PLATE. The ideal way of drawing is to start straight in with a needle and draw in the ground. But there are few artists who have sufficient confidence to do this and generally it is as well to place the main lines of the composition before starting the needling. These can be traced on with a red or yellow carbon, or if the drawing is made in soft graphite pencil the paper

on which it is made can be damped, placed over the plate and the whole passed through the press. The graphite will come off on to the ground in reverse, which is generally what is required. If the drawing comes right up to the edges of the plate it is better to use carbon, as the paper when damp expands and the drawing will overlap the plate, sometimes to a considerable extent.

NEEDLING. Some of the best etchings in the world have been done with one needle and one immersion in the acid. But that is no reason why variety of line should not be obtained if required. There are two ways of doing this: the first is to employ varying thicknesses of needles and bite the plate once: or stop out during the biting so that some lines are fine and thin and others deeper and coarser. Needling is a matter of personality and each artist will sooner or later adopt his own method. It is best to start straight in on a composition as a trial plate. It is so easy to produce any sort of variety when just scribbling or doodling and this gives a false confidence which rapidly evaporates when an attempt is made to carry out some definite design.

Needles should be blunt and round so that they travel easily over the surface of the plate without cutting the metal. If the metal is cut in places and not in others the former will bite faster and an unfortunate inequality of line may result. Callot, to imitate the variety of burin line, used an *échoppe*, or point, bevelled off so that as he turned it he could produce thin and thick lines at will. A heavy needle keeps a constant pressure on the plate of itself, whereas with a light needle the etcher is obliged to exert some pressure or the ground will not be completely removed. This is a pitfall for beginners, for it frequently happens that the etcher, absorbed in drawing, forgets that he is not using a pen or pencil and omits to keep up full pressure, with the result that where he has not bared the metal the lines refuse to bite.

It occasionally happens that grease from the hand covers the worked lines in places and prevents biting. This will be avoided if, after needling, the plate is washed in acetic acid or vinegar and salt, both admirable detergents for dirty or oxidized plates.

STOPPING-OUT. Any correction needful in the drawing can be stopped out with black or transparent stopping-out varnish and the correction redrawn before the varnish is really hard, or painted over with hard ground and a brush dipped in turpentine. Before the plate is put into the acid the edges and back must be stopped out. The usual stopping-out varnishes are good for this but cheaper ones are a saturated solution of common resin and methylated spirits, good hat varnish or Brunswick black. These, diluted with their component liquids, turpentine or methylated spirits, can be sprayed on the back with an ordinary fixative diffuser to save time. Asphaltum dissolved in petrol also makes a good acid-resist for the back of plates but it should be at least one part asphaltum to two parts petrol.

ACIDS. The usual acids for etching are nitric, Dutch mordant and perchloride of iron. The first two are dangerous if carelessly used, the last perfectly safe if it does not get into eyes or cuts. Acids are best obtained from etchers' supply stores or from commercial chemical suppliers. They should be chemically pure.

NITRIC. Nitric, usually supplied at 40 per cent, gives off nitric oxide gas which is dangerous if breathed into the lungs. It burns the skin and rots clothing. When mixing it should be poured into the water, for water poured into the neat acid is likely to generate sufficient heat to crack the bottle. Nitric on the skin should be washed off at once and on the clothes should be immediately neutralized with ammonia or soda. It is generally only from full strength or strong acid that fumes are given off and in this case a window should be kept open, and if coughing starts, a glass of water and bicarbonate of soda should be drunk.

The normal working strength for nitric is half water, half acid, or the proportions of seven to five. It bites with a boiling action and is therefore inadvisable for close fine work unless further diluted. It undermines small islands in the surface and creates a *crevée* or break-through, which will print grey and not black. Bubbles are formed by the action of the acid and these should be wiped off with a feather or cotton-wool as soon as well formed, as where the bubble sits the metal will not bite. For zinc the mixture should not be stronger than three parts water to one of acid. New acid should be started by dropping copper filings or a penny into it until it has a faint bluish tinge.

DUTCH MORDANT. Dutch mordant is made by boiling up four parts of chlorate of potassium in a little water and adding it to a solution of twenty parts hydrochloric acid in seventy-six parts water, where it should be allowed to dissolve and mix with a little shaking. When mixed it is not particularly dangerous but the same precautions should be taken with the pure hydrochloric as with nitric. Dutch mordant gives off chlorine gas which is dangerous in a closed area. It bites regularly and cleanly and may be used for all fine close work, aquatint and soft ground. The lines darken as they bite but no bubbles are formed. For zinc use two parts chlorate of potassium, ten of hydrochloric to eighty-eight of water. Pure hydrochloric may be dropped or feathered on for strongly accented portions and washed off when it has done its work.

PERCHLORIDE OF IRON. Perchloride of iron also bites cleanly and smoothly and is excellent for all close fine work, aquatint and soft ground. It is curious that it is not more used, as it is the safest. It is, however, necessary to put the plate in the bath upside down so that the sediment formed will drop out of the lines and not obstruct the action of the acid. It also darkens the lines and forms no bubbles. The saturated solution, as obtained from chemical suppliers, is 45 per cent. It can be used at this strength but 25 to 30 per cent is better for general work. Chemists stock this acid but usually at a strength of 20 per cent, which is too low.

All acids work faster in warm weather than in cold, and warming the acid by

placing the bath on the heater for a little will hasten results. Acid, either pure, diluted or old, should never be poured down waste pipes without a large amount of water to dilute it. Where it collects it will erode the metal of the pipes and eat them through.

BITING. There are three methods of biting a plate with acid. Either it can be immersed in a porcelain, glass or plastic bath, such as used for photography, which is not affected by acid, or, if the plate is too big, or a dish unobtainable, a wall of bordering or beeswax can be built round the sides to make a receptacle for the acid. The wall should start at the back of the plate and be well pushed into the edges so that the acid does not percolate underneath. Thirdly, there is Whistler's method of dropping acid on to a plate and feathering it about. Sometimes the aid of a little spit is necessary to make it run easily. As it dries or weakens it should be renewed. It can also be painted on with a swab of cotton-wool on a stick. This is useful for etching in accents with strong or full-strength acid. Whistler's method is more suitable for plates where the design is concentrated well inside the margin.

Only long experience will tell the etcher when the plate has been sufficiently bitten. There are too many varying factors at work for any certainty, such as temperature, strength of the acid, the character of the lines and the different qualities of the metal. There are, however, two rough tests; a needle may be inserted into one of the lines and moved about. If the line grips it strongly it is possible that the biting is deep enough. If it slips out it is certainly underbitten and any scratch should be repaired with a brush dipped in turpentine and rubbed on an etching ball, which makes a good stopping-out varnish for delicate passages. The other test is to use a strong magnifying glass or linen-tester to gauge the depth of the lines by eye. But as Pennell has said in his book on etching 'No great etcher has ever mastered the art of biting'. It is a matter of luck and experience, but mainly luck.

Each time the plate is taken out of the bath, which can normally be done in safety with the fingers or a plate-lifter, it should be washed immediately to avoid dripping acid over the clothes and floor.

An over-etched plate can always be scraped or burnished down but an under-bitten plate is another matter, once the ground has been removed. To re-etch it, roll out a ground on to a new heated plate till it is thin and smooth and then transfer it to the half-etched plate. With luck a good ground can be laid leaving the lines bare. Another method is to fill the lines with white poster or water-colour paint and after regrounding the plate put it in the acid. This will cause the paint to lift out of the lines and they can be re-bitten to the required depth.

MISTAKES. The same procedure should be used to delete mistakes in etching as for burin work, that is scraping, burnishing and polishing with snakestone, charcoal and metal polish.

# SOFT GROUND ETCHING
## *Theory*

SOFT ground etching came into use in the second half of the eighteenth century. It was invented as a reproductive process for obtaining a crayon or pencil texture and so was perfectly adapted for the imitation of drawings in these media. The results are often so like the 'crayon manner' that they are almost indistinguishable and easily confused. But soft ground always shows irregularities and softnesses which would be almost impossible to reproduce in the other technique. As such it has little interest, though Rowlandson made some excellent *Imitations of Modern Drawings* after Gainsborough's landscapes in 1784–8.

The best known examples of original work are perhaps the soft ground etchings of Gainsborough and Cotman. The former used soft ground alone or soft ground shaded positively with sugar aquatint. These prints are extremely free, lively and brilliant. It would seem to be an ideal way of working, as the two processes are homogeneous. The line with its pencil half-tone quality combines perfectly with the texture of the aquatint. But generally speaking aquatint requires a bolder contrast, as provided by line etching in Goya's prints or burin as in those of Hayter, if it is not to have an unpleasant over-soft reproductive effect. Cotman's prints, pleasant as they are, are far too reminiscent of chalk or pencil reproductions to be of interest as an original method. Sooner or later it becomes evident that soft ground used directly in this way is extremely unpleasant and unlikely to produce anything of any value today. There seems to be no point in its use unless the artist's conception would be better expressed in tone than clean bitten line. It is easy to imagine how magnificently Seurat might have used it. His drawings are eminently of this tonal quality, relying on masses of luminous dark opposed to brilliant lights and delicate greys, built up into rigid abstract architectural compositions of the most satisfying kind. Satisfying in every sense, for not only have they all the qualities and mathematical excitement of pure abstraction, but being founded on careful observation they are intensely evocative of vital and sensitive emotion. A student's interpretation of one of Seurat's paintings is reproduced on page 106 as evidence of the suitability of the medium for this type of vision.

There is, however, a use for soft ground as a linear technique which does not suggest a reproductive medium and that is to use it as an ordinary etching ground. Its softness and the fact that the hand cannot be rested on the plate makes for

direct drawing. There is no necessity to use anything so pointed as an etching needle; a pencil, chalk, a match-stick or anything that comes to hand can be used to make the drawing. The lines are necessarily heavier and coarser, with more variety and punch in them than those obtainable with hard ground. The finger-tips can be used to make tonal qualities, or other materials such as paper and gauze can be pressed in by hand to give accent and tonal variety. Used in this manner soft ground is an original medium capable of very varied effects. Nigel Lambourne has used it in this way on the backs of used lithographic zinc plates, adding aquatint from time to time and biting them in hydrochloric acid. The zinc used in this forceful manner will give some twenty prints, which in these days is often enough.

Pennell, in his book on etching, refers to the fact that textures can be etched by placing silk or canvas or other materials over a plate covered with soft ground and running it through the press, thus exposing the metal in the texture of the material to the action of the acid. Although his book was published in 1919 there does not seem to be any evidence of the use of soft ground in this manner. This is perhaps because textures of this type have a mechanical aspect which is rarely suitable to the naturalistic type of etching in vogue in the 'twenties. They are, however, extremely useful when used in abstract, semi-abstract, surrealistic or expressionistic themes. It was in this connection that Hayter made use of them in his Atelier 17 in Paris in the late 'twenties. He has used these textures himself extensively and brilliantly in the majority of his plates and others have followed his lead with success. His Christmas card with the impression of his son's foot shows the sensitiveness of soft ground to impression. An example of the two techniques is seen in *Torso* where the body was drawn with the thumb through tissue paper, the pencil lines drawn with a pencil through tissue and etching gauze used for the textures, which were repeated and show the transparent effect obtainable. The double pencil line is due to the fact that the first trace was not etched deep enough and was repeated (page 108).

# *Technique*

## MATERIALS

Plate
Soft ground

Roller (leather)
Acids and other materials as for
etching

## TECHNIQUE

The principle of soft ground, which remains soft after the plate has cooled, is that it adheres to paper or any other material pressed into it, thus freeing the metal to the action of the acid once the paper or material has been removed.

The original method was to place a piece of thin paper over the grounded plate and make a drawing on it. Where the pressure of the stylus or pencil occurred the ground was removed in the texture of the paper, thus producing a fine or coarse pencil or chalk effect according to the quality of the paper used.

SOFT GROUND is sold ready made by suppliers of etching materials. But it can be easily made by mixing one-third of tallow, Vaseline or axle grease with ordinary etching ground, melted and stirred well together and rolled into balls.

GROUNDING. As the ground itself is greasy it is not necessary to clean the plate as for hard-ground etching, though some authorities recommend it. Cleanliness in etching is always an asset, but in this case it is not vital. The plate is heated and some ground melted on to it and it is then rolled out evenly with a leather roller. If the plate is too hot the roller will slide over the plate and refuse to roll. It is best to remove the plate from the heater and complete the rolling as it cools. The ground should be even and thin but of a definite brown colour, as brown as well-cooked pastry. Darker than this it will be too thick and normal pressure will not entirely lift the ground and either the plate will remain sealed or the result will be patchy and irregular. The surface of the grounded plate should never be touched with the hand and, when working, a hand rest is advisable. Both the roller and the ground should be kept wrapped in an old piece of silk as the greasy ground is very liable to pick up dust. Lacourière recommends melting the ground on one plate and rolling it out to obtain a thin even coat on the roller before grounding a second warmed plate. This makes it easier to obtain a good smooth ground of the correct thickness. He also recommends warming up the plate after it has been grounded so that the ground, melting again, will cover up any small holes that have been left by irregularities on the roller. Once the drawing has been made, the plate should not, of course, be reheated on any account.

DRAWING. To obtain the traditional pencil or chalk effect a thin paper such as tissue, tracing paper with sufficient grain or other thin slightly grained paper should be used to cover the grounded plate and the drawing should be made upon it. When a tracing has been made and is reversed it is advisable to use a second piece of thin paper under it so that the graphite will not interfere with the lifting of the ground. When lifted the paper will show the amount of ground under the drawing which has been lifted off. Too light a pressure is apt to leave the plate sealed though some ground may be lifted. If there is any doubt about this the lines can be inspected under a magnifiying glass or a spot of strong nitric can be dropped on and washed off again as soon as it starts to bubble, which will be a proof that the ground has lifted.

A better method than the imitation pencil technique is to use soft ground for straight etching. The ground can be drawn into direct with a pencil or a piece of wood. If the drawing is faulty all that is necessary is to rewarm the plate and

pass the roller over it again, thus re-laying the ground. This can be repeated until a satisfactory drawing has been obtained.

TONAL PROCESS. One of the most useful techniques for soft ground is as a tonal process, in the sense of aquatint. Any degree of texture can be obtained by the use of different papers, and any range of tone from light grey to black by stopping out and controlling the biting by exactly the same method as for aquatint. Any paper with a sufficient grain, from thin tissue onwards, should be placed over the grounded plate on which the design has previously been etched or engraved and with a smooth stiff piece of paper on top to prevent the texture of the blanket interfering, the whole should be passed through the press at light pressure. If in doubt as to whether sufficient ground has been lifted the same tests should be applied as for line work. When stopping out the whites before etching it is advisable to use transparent stopping-out varnish or resin varnish; in this way the plate held against the light will show the stopped-out portions as white and work can be done in a positive manner instead of negative, which would be the case if black stopping-out varnish were used. If the paper used for the texture is very fine the ground laid should be as thin as possible, provided the plate is sealed, or the texture will not penetrate.

TEXTURED EFFECTS. Any texture can be reproduced on a plate by pressing it through the ground and etching it. Crinkled paper, gauze, silk, nylon, cotton, string, leaves, wood shavings, etc. There is no end to the possibilities for use in this respect. The material can be placed over portions of the grounded plate or over the whole of it, and with a piece of stiff smooth paper on top run through the press with a light pressure. When the material is peeled off the ground its pattern will be found in bare metal, the ground being lifted where the texture of the material is pressed in. All that is necessary is to stop out the rest of the plate except where the pattern is desired. It is still necessary to do this when only a small portion of the plate has been covered with the material, as the backing paper, the smooth stiff paper used to cover the whole and prevent the nap of the blanket from sticking to the ground, may have left its own impression. When several different textures are required it may be possible, by placing them carefully, to achieve the desired result in one impression. But generally it is easier to deal with one material at a time, etch it and repeat the process. It is useful to remember that most textures, especially gauze, silk, nylon, etc, are transparent and may be used one on top of another, by repeating the process, giving a transparent effect. Twisted or pulled they create an illusion of torsion and strain. The possibilities of this method are almost limitless.

White elements in these textures can be got by painting over them with varnish before biting and variation in depth can be obtained by stopping out portions as the biting proceeds. This process and the tonal process, described above, is far stronger than aquatint and will last longer in that the texture is

etched in a series of microscopic pits, leaving a large percentage of the surface untouched, whereas in aquatint the surface is bitten away round a series of points protected by the resin and these have far less resistance to wear.

ACIDS. The best acids for soft ground are the clean biting mordants such as Dutch, and perchloride of iron. Nitric can be used provided the strength is not more than half water, half acid. In all cases, the ground being relatively light, the lines or bitten areas show up darker and their relation in tone to the ground is roughly relative to their printing value.

MISTAKES. The plate is so easily grounded that any mistake made before the plate is put into the acid can be best rectified by rolling up the ground again. Also the ground is so sensitive that a mistake can only be varnished out, which means that a mistake can be erased but not corrected, as drawing through the varnish will not give the same effect. When the tonal process is used, errors can be scraped and burnished away and a new tone can be added by laying another ground and rebiting. But to obtain the exact value of the first tone in a second biting is extremely difficult and perhaps the best way is to bite it a shade deeper and burnish it down rather than risk under-biting. In complicated passages where textures are used there is often no remedy for an error and in this case it is best to attempt to use the error rather than try to correct it.

# AQUATINT · *Theory*

AQUATINT, as its name suggests, is a tint obtained by means of *aqua fortis* or acid, and is a pure tonal process. The plate, by one means or another is covered with a porous ground of even texture, which can be fine or coarse, according to the technique used. The whites are stopped out with varnish and the plate etched until the lightest greys are obtained. This process is repeated until the blacks are etched, the length of exposure to the acid regulating the depth of the tones.

Aquatint is supposed to have been invented in France in the eighteenth century by Le Prince and was introduced into England in 1775 by Paul Sandby. Le Prince used the resin-dust box in which a cloud of resin is blown up and allowed to settle evenly over the plate, where it is later melted. Sandby invented the spirit ground. In this case, resin dissolved in spirits of wine is poured over the plate; the spirit evaporates leaving the resin to crystallize in a reticulated effect. It gives greater luminosity than the dust ground but is more difficult to manage.

This tonal process, in common with other reproductive tonal processes was immediately popular in England. There is, of course, nothing against the use of tone in etching, provided that it is used creatively, and provided the means used is a tonal process and consequently suitable to this form of expression. Tonal effects, such as aquatint, had been attempted as far back as Claude, but it was not until the eighteenth century that a satisfactory solution was discovered. The English, however, did not use it as a means of creative expression, but as a purely reproductive medium. It was employed to imitate the wash drawings and water-colours so much in vogue at the time. The aquatinting was not even done by the artist who made the preliminary etching, and sometimes the whole drawing, both etching and aquatinting, was copied by other hands. Examples of this type of work, practically entirely devoted to typographical subjects, are well known, as are the numerous aquatinted illustrations of Rowlandson and Gillray and many others. Aquatint became the favourite method of reproduction for illustrations and prints of every description both here and abroad. It was easier and quicker than mezzotint or stipple, and its position was unassailed until partially ousted by the lithograph.

As an original and creative technique it was, to all intents and purposes, neglected until recent times. The one great exception was Goya, though Turner used it a little in combination with soft ground. In the *Caprices* Goya produced plates in straight etching, etching combined with aquatint and in one magnificent

example, *Por que fue sensible*, page 112, aquatint alone. In this last there is no etched line to guide the stopping out of the various tones. With a brush and varnish he has drawn in the whites on the bare grounded plate and worked in reverse towards the blacks. Admittedly he was working from a drawing, but even so the skill would be paramount even if the result was not a masterpiece. It is in fact one of the marvels of aquatint. It is an example of passion, perfect skill and incredible luck, the sort of thing that may happen once in a century. Yet Hamerton was capable of saying that Goya, in his etchings, was 'not an artist at all'; that 'his power lay in his satanic hate and scorn, not in the mastery of a refined and delicate art'. And again that 'His etchings have no artistic value whatever and owe their great fame entirely to the fascination of their incomparable horror'. Nor was Hamerton alone in his opinion of Goya. The late Sir Frank Short dismissed *Por que fue sensible* as 'rough stuff'. Sir Frank was an aquatinter himself and achieved a considerable reputation. But his work today leaves us cold. To quote a contemporary, 'This master of copper-plate craftsmanship perceived that, with its infinite capacity for tone-gradation, aquatint in the hands of a sensitive artist, could draw unexpected beauties from the copper, expressive pictorial beauties, of which others had never dreamed'. The trouble was that he was a second-rate artist though admittedly a master of copperplate craftsmanship, which Goya was not. And this is the very knife-edge which separates the artist and the craftsman, where, in fact, they part company and can never be reconciled. To the artist, technique is purely a means to an end, a language to be used for his creative purposes. Goya used aquatint as such. Except here and there his technique, as technique, is not remarkable nor of superlative excellence, and in consequence he has had few imitators. But it is completely adequate to the expression of his idea and as such it is sufficient. There is no point in technical perfection beyond the purposes necessary for the complete realization of the subject. It is apt to obscure the purely aesthetic qualities and lessen the evocative and emotional expression.

There are two things in engraving. There is its value as a drawing, and there is its value as a revelation of the medium. The most perfect plates combine these two values but if the first is inadequate the second has only a meretricious importance. The work of the 'master technicians' is of this type. They know their medium thoroughly and understand its beauties. They appeal to the public who admire precision, delicacy and subtlety of rendering and are often hailed as masters. Whereas the truly creative artist, whose expression is infinitely more valid, is often neglected because he only uses the technique as a means. His work may, therefore, be rough and crude, and he is inevitably inept in the eyes of the technician. This is the case of Short and Goya, and of many others. We are, however, unlikely to err very much in this today. The pendulum has swung a little far, and in the reaction against the technical excellence and aesthetic emptiness

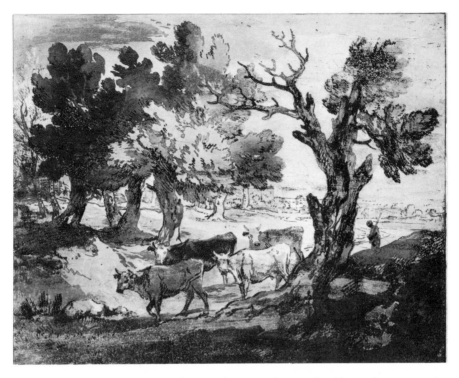

THOMAS GAINSBOROUGH *Landscape with Cows* soft ground etching and sugar aquatint
$10\frac{1}{4} \times 12\frac{3}{4}$ inches

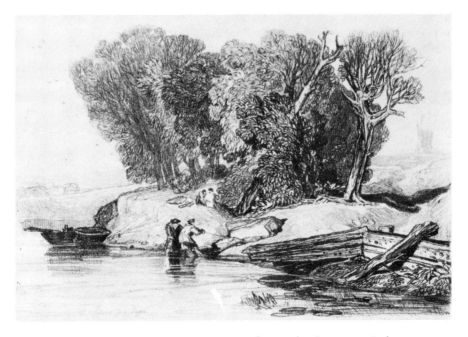

JOHN SELL COTMAN *River Scene* soft ground etching $6 \times 8\frac{3}{4}$ inches

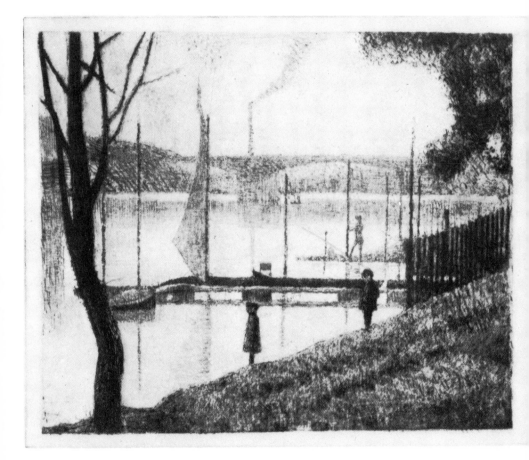

SUSAN BENSON *Le Pont de Courbevoie* after Seurat 9½ × 11 inches

right: ANN DIDYK *The Mother* soft ground etching

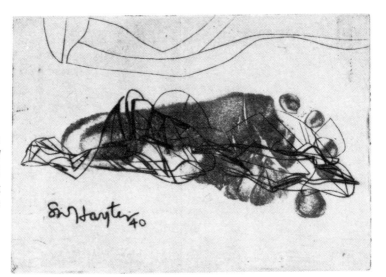

S. W. HAYTER
*Christmas card*
line engraving and
soft ground etching
actual size

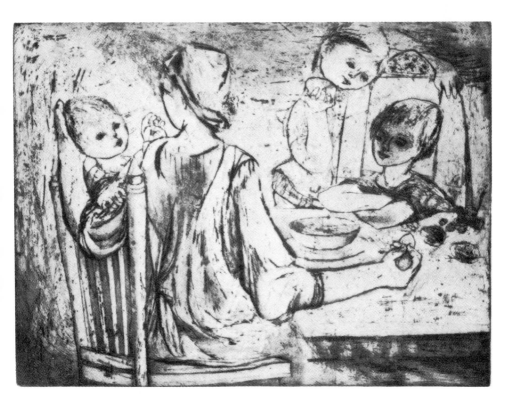

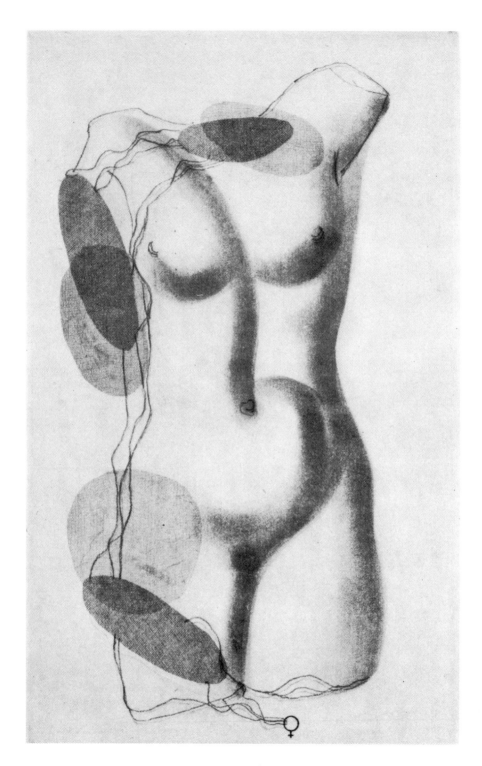

JOHN BUCKLAND-WRIGHT *Torso* soft ground etching 12¼ × 7½ inches

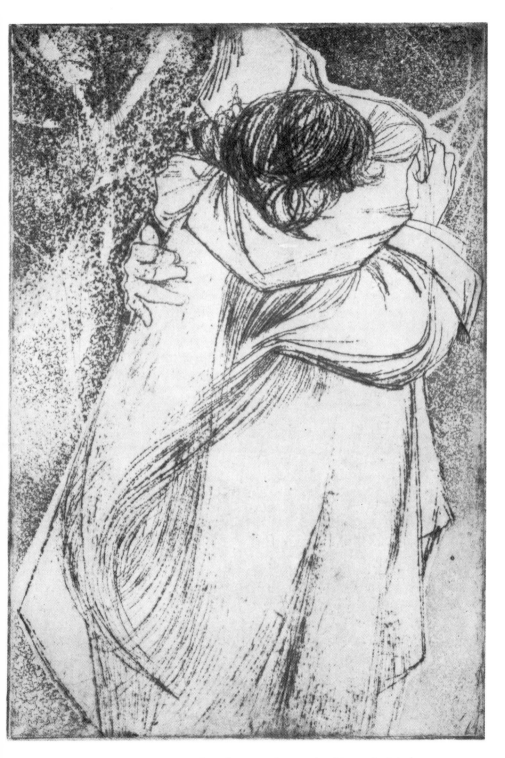

NIGEL LAMBOURNE *Couple Embracing* soft ground etching $11\frac{3}{4} \times 8$ inches

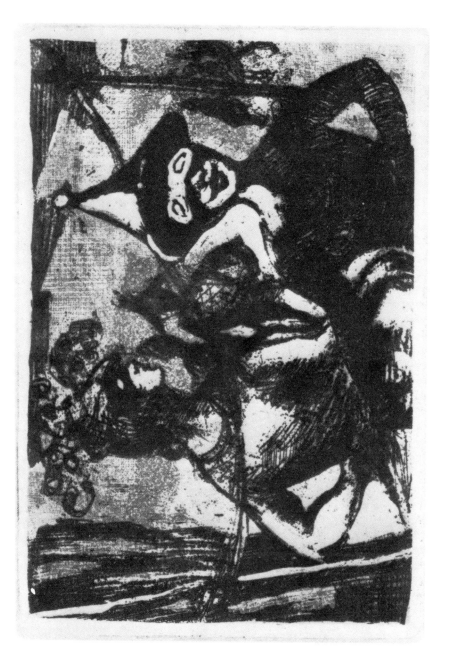

ED SMITH *The Clown* soft ground etching $8\frac{3}{4} \times 12\frac{3}{4}$ inches

EMIL NOLDE *Steamer* aquatint

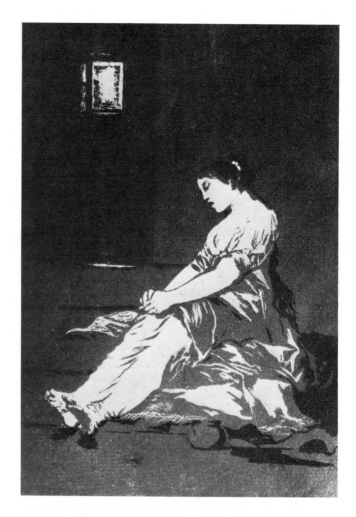

right:
GOYA
*Por que fue sensible*
aquatint
7 × 4¾ inches

below:
TAUROMACHIA
etching and aquatint
8 × 12 inches

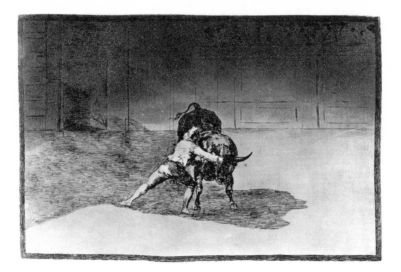

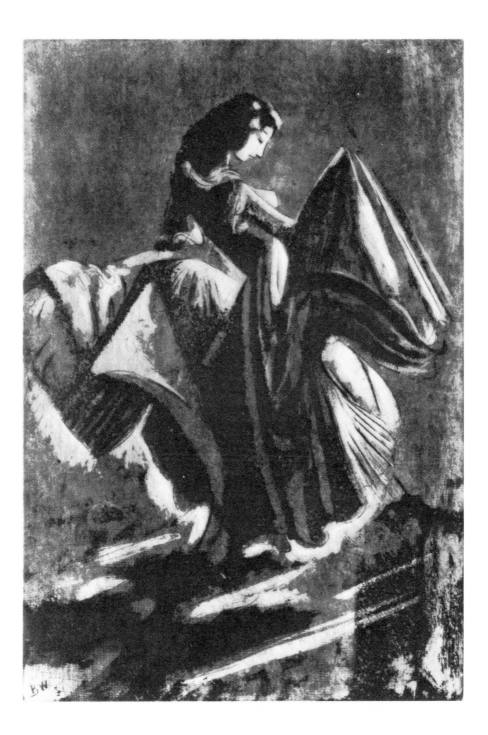

JOHN BUCKLAND-WRIGHT *Dancer* aquatint 10 × 6⅞ inches

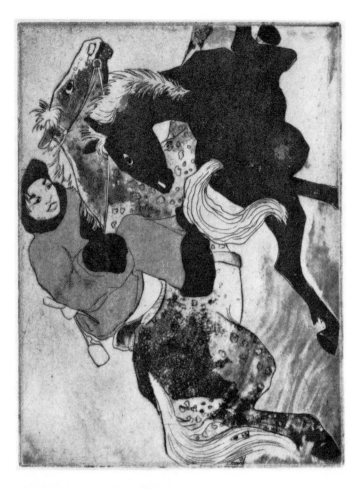

above: PEDRO RIU *Summer* aquatint $4\frac{1}{2} \times 5$ inches

right: OROVIDA *Mare and Foal* aquatint $6\frac{1}{4} \times 8\frac{1}{4}$ inches

below:

ALFRED HACKNEY *The Puppet-Maker* aquatint $9\frac{1}{2} \times 12\frac{3}{4}$ inches

ANDRÉ MASSON  *Les Conquérants*  sugar aquatint 12½ × 7½ inches

PABLO PICASSO *La Biche* sugar aquatint 10½ × 8¼ inches

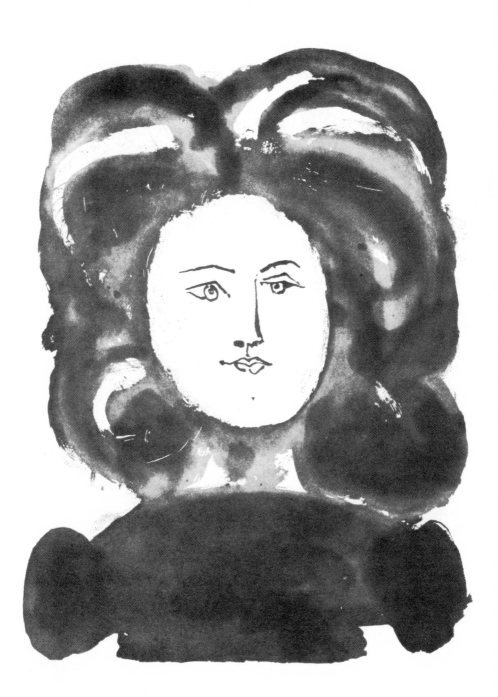

PABLO PICASSO *Gongora: Girl* sugar aquatint 15 × 11¼ inches

KLEEGE *Jungle* aquatint 9 × 6½ inches

GEOFFREY CLARKE *Man and Nature* sugar aquatint $14 \times 6\frac{1}{2}$ inches

GEOFFREY CLARKE *Man* sugar aquatint 14 × 8 inches

NORMAN JANES *Navy House, Tobruk* aquatint $8\frac{1}{2} \times 13$ inches

JOHN PIPER *Stowe* aquatint $7\frac{1}{4} \times 10\frac{1}{4}$ inches

JOHN PAUL JONES
*Connecting Rods*
aquatint

CHARLES QUEST  *Etching Equipment and Press*  aquatint 8 × 12 inches

of our predecessors we are apt to overvalue the roughest and most childish experiments which give a superficial appearance of creative expression. The mis-use and misunderstanding of a medium is often worse than over-emphasis and virtuosity carried to extremes. It is easy for us to condemn technicians such as Hamerton and Short who have shown themselves insensible to Goya as an artist because his technique did not coincide with their views. It is less easy for us to pick out a good engraver today, who uses the medium in a creative sense. There are too many who follow the accepted ideals of the nineteenth century, using it to enhance an unimaginative and purely topographical drawing. There are admirable practitioners whose vision is commonplace or whose drawing is inexpressive and dull. The qualities to look for are the same as in every medium, the expression of a personality, a personal vision or point of view, if not a new vision. The prints reproduced here show some of these. In some the technique is crude, in others it is meticulous, but in all it is adequate to the vision and the statement. Though aquatint today is often used more as an incidental adjunct to composite prints of multiple techniques, all the prints in this section can be said to be true aquatints in that the medium predominates. They present, to a certain extent, the possibilities of the technique as applied to the modern idiom.

# Technique

## MATERIALS

Plate

Resin: powdered

Stopping-out varnish:
  black or transparent

Brush: fine, soft

Acid: Dutch mordant or
  perchloride of iron

Other materials as for etching

## TECHNIQUE

Aquatint is a tonal process for producing flat tones on a plate to print much as wash drawing with black water-colour or ink. Students often make the mistake of thinking that if they etch out an area in a plate by the application of acid it will, if etched deep enough, produce a black; forgetting that there must be a tooth in the metal to retain the ink which will otherwise be cleaned away in the wiping. In fact an untreated area on the plate etched by acid will produce a light grey, for as the acid dissolves the metal it leaves a slight grain which will hold a film of ink. The edges of such an area will print black, as there alone the ink will hold in the corner between the lowered area and the surface of the plate. This principle can be of use in certain circumstances but the effect is that of the *crevée* or burst-through in etching.

Aquatint is the name usually applied to the tonal effect obtained on a plate

by etching it through granulated resin, pitting the plate evenly but in varying depths according to the amount of biting. But the term is applicable to almost any tonal etching. There are several ways of producing a tooth capable of holding ink in the surface of a plate which is the process of aquatint.

DUST GROUND RESIN. The method most in practice is that of laying an even film of resin dust over the plate and melting it to form a porous ground through which the acid can etch the metal.

AQUATINT BOX 1. The ideal method is that of an aquatint box, some eight feet high in which is a revolving, two-flanged fan fitting a semi-circular container. As the fan is revolved it throws up a mass of powdered resin into the air which ascends to the top of the box. Above the fan is a wire screen on which the plate is laid, after the dust has been blown up, to catch the falling resin. The plate is placed on the screen through a trap-door and, if this is done immediately after fanning, the resin received will be the heavier larger grains which will produce a coarse ground. If, however, the heavy stuff is allowed to fall before the plate is inserted and only the very fine dust is still in suspense, a fine ground aquatint will result. When the plate is well covered, and for this it may be necessary to insert it in the aquatint box several times, it is taken out and gently heated until the dust melts into transparent globules of liquid resin. When cold the resin hardens, adhering to the plate and forming the ground. The plate must, of course, have been well cleaned from all traces of grease or the ground will not adhere properly and will lift when in the acid.

AQUATINT BOX 2. Another method is to make a box about four or five feet high with a wire tray and trap-door about one foot from the base. A hole is made in the centre at the bottom to allow bellows or a foot pump to be inserted which will blow the dust up into a cloud from a trough at the bottom. It sometimes happens in a box of this type, especially when it is air-tight, that the dust, instead of falling evenly over the whole plate, seems to blow in from the edges in uneven lines. To avoid this the plate for aquatinting should be placed in the middle of a larger plate and it will then be properly covered.

AQUATINT BOX 3. A simpler method is to use a large hat-box, shake up the powdered resin well inside, open the lid and insert the plate and allow the dust to settle on it for some minutes. This can be repeated until the plate is covered. To facilitate the removal of the plate it is best to place a block of wood under it as it is put into the box.

DUSTING. The simplest way of all is to place the plate on a wire screen on a piece of newspaper on the floor away from draughts and shake the resin on it from a silk or gauze bag. The finer the mesh of the material used for the bag the finer will be the aquatint ground. If the bag is struck against a pencil or the hand it will fall in a more even fashion. Bitumen powder may be used in place of resin dust and some artists prefer it as being more adhesive.

If the plate is tapped against anything it will cause the dust to clot and the ground will have to be relaid. Too much dust will melt into a solid coat and prevent the acid from etching the plate. Too little will make a weak ground which will print grey and will quickly wear away. With less than 20 per cent of the surface covered, a weak, coarse ground will be obtained, with more than 50 per cent the ground will also be coarse but will be exceedingly strong and wear well. For fine grounds about 40 per cent is needed but only experience will indicate the exact amount required. If the plate is so covered that the reflection from the metal can only just be seen when held up to the light, it will produce a good strong ground a little on the coarse side.

COOKING THE RESIN. In heating the plate to melt the resin over a gas burner or an electric plate, great care should be taken not to overcook the dust. When just cooked it retracts into globules, but when overheated it spreads again and forms a solid impervious coat. As soon as the resin becomes transparent it is melted and if the plate is held up to the light at eye-level unmelted dust can easily be seen as white or light brown opaque matter. Melted resin has the same colour as the plate. Fine grounds are better melted over the flame from a taper, as the heat of a gas burner is likely to overcook them.

STOPPING OUT. It is not every artist who can produce a plate such as Goya's *Por que fue sensible* with no previous indication of the drawing as a guide to stopping out. It is therefore advisable to etch or engrave the design on the plate before the aquatint ground is laid. The lines so made will be clearly visible through the melted resin. The stopping out should be done with a fine soft brush and any good dark stopping-out varnish. If this is too thick it can be diluted in turpentine. Resin dissolved in methylated spirits is unsatisfactory in that the ground is soluble in this spirit and the brush strokes tend to spread. Stopping out should be done with great care or portions are likely to be missed. As the ground is gritty in texture it is often easier to stop out the whites on the plate before the ground is laid. Any acid-resisting substance may be used for stopping-out, according to the effect required, such as varnish, litho chalk, grease pencil or etching ground dissolved in turpentine.

OTHER GROUNDS: LIQUID. In the nineteenth century a liquid ground was used for aquatint. This consists in dissolving resin in alcohol in such proportions that as the alcohol dries the resin will granulate out and the amount of resin in the solution will determine the fineness or coarseness of the ground. The early aquatinters were able to produce the finest grounds by this means. The recipe given by Fielding in 1841 is to dissolve five ounces of powdered resin in a pint of spirits of wine. When this is completely dissolved one-third of the result is mixed with two-thirds spirits, and more spirit is added if the ground formed is found to be too coarse. The liquid is poured over the plate, which has been previously well cleaned and polished, into a dish. If the liquid is too thin it is

run backwards and forwards over the plate two or three times. Excess of heat and cold prevent granulation. To prevent etched lines from biting when the aquatint is in the acid they should be filled with copper-plate ink twenty-four hours before laying the ground. Liquid grounds are notoriously difficult to achieve and when bought ready made are extremely erratic.

SAND GRAIN. Another satisfactory method of obtaining aquatint is to ground a plate normally as for etching and to press through the ground fine sandpaper, thus opening it in a series of tiny dots. This can be done in the press with a light pressure. The plate should be passed through several times, altering the position of the sandpaper each time to increase the number of perforations. It is difficult to achieve perfect results by this method, as the grains of the sandpaper are apt to be forced into the plate, making the whites print a dirty grey. A better method, perhaps, is to sprinkle common powdered salt evenly over a hot, thin etching ground. The salt penetrates the hot ground and, later is dissolved away in water, leaving a porous ground.

SPATTER. Still another method, advocated by Pennell and used by Lambourne and others, is to dissolve resin in alcohol and spatter it over the plate with a toothbrush and a stick, or better still to spray it on with a fixative diffuser. Dissolved asphaltum or etching ground can be used in place of resin.

OTHER METHODS of obtaining a tonal ground are dabbing a clean hot plate with a coarse material, such as gauze, impregnated with etching ground. In this case the texture of the material used is, of course, transferred to the plate. Still another is to dab or brush a plate covered with hard ground with a wire brush or to use a method sometimes called the *manière noire*. This consists in ruling a hard grounded plate in at least four directions. The effect is much harder than ordinary aquatint and it is very resistant but often has a too mechanical aspect.

ACIDS. The best acids for aquatint are the slow even biting mordants such as Dutch and perchloride of iron. The boiling action of nitric is apt to undermine the plate beneath the globules of resin. But it can be used if the solution is not too strong. Fielding advocates one part nitrous acid to five parts water and judges the biting from the bubbles formed. It is a useful practice to use one end of the plate for testing the depth of the bite. A small portion can be cleaned off and the actual bite seen after each period of immersion. Otherwise only experience can regulate the different bitings.

BITING. As soon as the lightest greys are bitten the plate must be taken out and dried, and these greys stopped out and the biting of the darker greys continued until the blacks are finally bitten. Each time the plate is taken out the back should be inspected to see that the varnish is intact, as most plates can be used back and front to save expense.

REBITING. Should the ground be cleaned off an aquatint and it is found to be inadequately bitten, there are but two remedies and neither will be satisfactory

in a complicated design. The first is to spread some etching ground on a hot plate with the roller and, when the ground is rolled out thin, gently to roll up the bitten aquatint so that the surface of the plate is covered and the pitting remains free. It can then be rebitten. But it is not an easy method. Another, advocated by Lacourière, is to dust the plate with bitumen powder and melt it. The bitumen powder, when melted, has the property of clinging only to the heights, leaving the pittings free to rebite.

BURNISHING. Aquatint which has been too strongly bitten may be scraped or just burnished down with a burnisher and machine oil. It does not take long and soft effects can be obtained in this manner. An aquatinted plate may be used as a mezzotint, when bitten dark, and all the desired subtleties can be obtained by the use of the scraper and burnisher.

GRADATIONS of biting over a corner, part or half of the plate can be obtained by tilting the bath with a little acid in it and rocking it occasionally so that no hard edge is formed. Again a dark centred patch can be got by immersing the plate in water and dropping neat acid on to one spot. Where the acid is dropped it will bite dark, less and less so where it mixes with the water.

STAINS. Portions of a bare plate may be stained to print a faint grey by painting or dropping acid on to it and washing it off after a minute or two.

OROVIDA'S TECHNIQUE. Another technique which produces some curious and extremely interesting effects is that invented by Orovida and used in her *Mare and Foal*, page 114. The liquid staining in the bottom left-hand corner and all over the mare is obtained by floating liquid aquatint ground, resin dissolved in alcohol, over the plate: just before it dries the plate is heated: the ground runs, forms into spots and waves, spreading away from the etched lines but sometimes across them, producing a great variety of texture. The advantage of such a method is that the heated ground, as it forms these textures, can be clearly seen and it is obvious how it is going to etch. So that if the effect is not what is wanted it can be cleaned off and redone.

# SUGAR AQUATINT · *Theory*

SUGAR aquatint is aquatint in reverse. In normal aquatint the whites are varnished out from the grounded plate and, as the etching proceeds, the artist works in reverse from dark to light. This is a negative way of working.

Various methods have been tried at various times to discover a means of etching what was drawn or painted on a copperplate with black pigment, in other words to discover a positive method. For this a 'lift' substance was required; something which, when immersed in water, vinegar or acid, would lift the thin coat of ground or varnish, protecting the whole plate, off the drawing and allow the acid to attack the design while the rest of the plate remained sealed.

It has been found that ink, sugar or gum with various additions will act as 'lifts' or bursting-through substances. Lalanne describes the 'pen method', where a thin, hard etching ground is laid over a pen-and-ink drawing on a clean plate. Immersion in water for an hour or so causes the ink to lift the ground and the bare lines of the drawing can then be etched. But sugar or gum, or a combination of both, are infinitely more efficient. These substances dry more slowly than the ground or varnish covering the whole plate and the ground above them remains porous. Consequently, when the plate is immersed the lift absorbs water, swells and bursts off the ground above the design.

There is no point in using this process for pure line which can be better obtained by straight etching. It is, however, extremely useful for any form of brush work. As even thick lines require to be aquatinted if they are to hold the ink and print properly, and as sugar is probably the most efficient lift, the process is generally known as sugar aquatint. It must have been invented very much at the same time as aquatint itself, for Gainsborough used it in several of his plates before the end of the eighteenth century. The proof that he did so is that in these plates it is the darks which show the brush marks, whereas in normal aquatint they are seen in the whites. References and descriptions of the method can be found in etching manuals published in the early nineteenth century and professional etchers used it throughout that period. In fashion plates, for instance, which were etched before lithography came into general use and in many cases afterwards, it was obviously easier to work positively when aquatinting blue ribbons or pink flowers on a white dress, than to work negatively and have to stop out the whole drawing except where these items occurred.

The Atelier 17, under the guidance of S. W. Hayter, experimented with lifts of various types before the war, but it was only on the publication of Picasso's plates for Buffon's *Natural History*, page 117, that the process was generally brought to the attention of artists. Roger Lacourière, Picasso's master-printer, showed it to him. The former had learnt it from his father, who was one of a family of professional etchers responsible for many of the fashion plates referred to above. Picasso used the process with inimitable brilliance and his illustrations for the Buffon repay the closest study. To obtain the blacks and greys in these plates the process has been repeated, a drawing in sugar being made and etched for the greys and a subsequent drawing made and etched for the blacks. Picasso has used the sugar with pen, brush and finger-tips and returned to normal

aquatint at times, stopping out in the ground over the lifted areas. After etching he has used sandpaper at times to produce light tones, and burnisher and scraper to vary the values in the greys where necessary. Considering the summary way in which Picasso often throws off his plates there is an immense amount of work in these illustrations and among them are some of the most beautiful plates he has ever produced.

His next use of sugar aquatint was for his illustrations to the *Poems of Gongora*, where he did a series of female heads and wrote out the text. This latter was reproduced on copper by Lacourière, and Picasso then decorated the margins with drypoint and sugar aquatint. One of the girls' heads is reproduced on page 118. The technique is more direct than in the Buffon, though pen and brush are again used. But this time there was no repetition for the greys and blacks. The drawing was etched grey with weak acid by floating on the mordant with a swab. When the required grey tone had been etched the blacks were painted in with a swab of acid at full strength. If the weak acid on the plate was still wet the blacks merged softly with the surrounding tone; if it was dry they gave a harsher and more definite effect with hard edges. In some cases he has painted the sugar through gauze to get a textured effect; in others he has stopped out the aquatint ground in the midst of black or grey to obtain whites or pressed sandpaper through the varnish for a tone. In the plate reproduced here as a frontispiece he painted the sugar on an improperly cleaned plate, causing it to retract into irregularities and spots on the greasy surface. Here again he has used any and every means to obtain his results, but they are more direct, more loose and more spontaneous than the Buffon plates and on the whole perhaps less successful.

Masson has also used the sugar process to excellent effect both for free plates and for the illustrations to *Les Conquérants* by Malraux, of which a plate is reproduced on page 116. This is a two-colour print, one plate being grey and black and the other dull olive. Masson has first painted on the greys on the black plate, using it direct or painting the sugar through gauze. When these portions were grounded he stopped out dots and patterns with a brush full of varnish and then bit the result to a delicate grey. He then repeated the process for the black drawing, biting it deeply without any additional work. In the green plate he has bitten the drawing lightly and then spattered on varnish to get the textured effect in this colour before etching it to a dark.

These plates show how successfully sugar can be used, but they also show that the work should be as direct as possible.

Another plate reproduced here is Piper's landscape with etching and sugar aquatint, page 123. The heavy lines of the trees so obviously brushed in are characteristic of the sugar process, but the broken quality of the foreground looks as if the usual procedure of putting the aquatint ground on the plate after lifting the drawing had been reversed. There is no reason why this should not be done

but when the ground is put on before the sugar is used it means painting, not on the polished surface of the copper, but on the rough surface of the melted resin grains, which would account for the broken effect.

Though sugar aquatint has been known for so long it is new as a creative medium and has not been extensively used. Another exponent who has achieved some remarkably successful results is Geoffrey Clarke, pages 120 and 121. His vision is extremely personal, creating a world of his own that is as strange as it is vital and expressive. He uses sugar and black pigment as a lift ground and etches on steel scrap from old cars, using nitric acid. This is one more example showing that etching is not a matter of expensive materials and meticulous scientific procedure, but a normal process that, once understood, can be carried out with almost any materials that come to hand. The only essential is the purpose and inspiration which transmutes, in this case, the base metal into gold. Geoffrey Clarke's aquatints possess the same disturbing magic as his iron sculpture to which it has a strong relation.

# *Technique*

## MATERIALS

Sugar solution                                     Light varnish
Brush or pen                                       Other materials as for aquatint

## TECHNIQUE

Successful sugar aquatint relies, apart from the accidents normal to ordinary aquatint, on two factors—the sugar solution or lift ground and the varnish with which it is covered. If these work satisfactorily the process is simple and easy. If either is ineffective the result is disaster and the process must be repeated with improved materials.

SUGAR SOLUTIONS. There are various formulas for the sugar solution. Fielding in his book published in 1841* suggests equal quantities of whiting, sugar and gamboge mixed with water to the consistency of cream, with lamp black added to give colour. He advocated the method, used by Gainsborough, of painting this over the aquatint ground, covering the plate with turpentine varnish and lamp black diluted with spirits of turpentine, put on with a flat camel-hair brush, and immersing it for an hour in water after it has been allowed to dry for a like period. Every part covered with the sugar solution will then, according to him, come up leaving the ground ready to bite.

It is obvious that gum arabic or gamboge, which is made from gum is added to intensify the 'lift' qualities and to make the solution stick to the plate. But if

*The Art of Engraving by T. H. Fielding (Ackerman & Co., London)

the plate has been thoroughly cleaned it should do this without difficulty. Lacourière, who advocates sugar, gamboge and black gouache mixed with water to an agreeable consistency, recommends cleaning the plate with the sugar solution in the event of the sugar not taking properly to the cleaned plate. There are some plates which, owing to a high polish or some other cause, are difficult in this respect, and this method can then be employed, remembering that any actual traces of solution left on the plate will lift the varnish. There are a number of solutions but most of the mixtures depend on the fact that sugar, gum arabic, gamboge and glycerine do not dry completely, so that the varnish covering them remains porous allowing the water to penetrate, swell the solution and lift the varnish. Soap and such detergents as Tide have been recommended for mixing with the sugar, but the simpler the solution remains the more easy it is to operate. As sugar is the principal lifting agent, all it requires in fact is colour so that the drawing can be seen. From experience the best results would seem to be obtained from the solution used by the Atelier 17, which is equal parts of a saturated solution of sugar and indian ink. The plate should be properly cleaned and the drawing made with this solution by means of a brush or a pen or both. When this is dry (and to speed up the drying the plate can be gently heated) the varnish is laid over the whole plate. The commonest error here is to lay the varnish too thickly, in which case it either takes hours to lift or else does not lift at all. It should be immersed in water as soon as dry; a delay of twenty-four hours may harden it until lifting becomes almost impossible.

VARNISHES. Various varnishes have been recommended: liquid etching ground, resin dissolved in methylated spirits, stopping-out varnish diluted in turpentine, or transparent stopping-out varnish if sufficiently thin. Thin copal varnish has also been used. All these vary in efficiency though all are capable of producing good results under the proper conditions. The main principle to remember is that the varnish must be an efficient acid resist and must be thin. Consequently, perhaps the best method is to lay a good thin ordinary hard etching ground over the plate. This seems to produce the best results of all and is subject to fewer errors.

When the varnish or ground is dry the plate should be placed in water. Quicker action is obtained if the water is slightly warm or if acetic acid or vinegar is added. In recalcitrant cases the lift ground can be helped off with a little cotton-wool.

When the sugar has lifted the varnish over the design all that remains is to lay an aquatint ground and etch the plate. If necessary when a strong varnish such as resin in alcohol has been used, it is possible to lay a soft ground over the drawing and press textures into it. When a drawing in two or three tones is required it is better to repeat the whole process two or three times rather than rely on scraping and burnishing.

# RELIEF PRINTS & DEEP ETCH
## *Theory*

Surface or relief printing from metal plates was done in the early fifteenth century when soft metal plates were engraved with the burin and punched with a hammer and punches of various descriptions to obtain a decorative and pictorial effect. It is known as the *manière criblée*. There is a strong relation between this type of work and the modern wood engraving of today. The sense of the cutting is white line on black in both techniques and not black line on white which was the contemporary practice of woodcut, obtained by cutting away most of the surface and leaving only the black lines of the drawing to print in an imitation of pen work.

There are cases among the known *manière criblée* prints where part of the plate has been printed as intaglio, with the ink rubbed into the lines, and part printed as a relief print from surface ink, while the intaglio lines remain clean. There have also been modern prints in which these two forms of printing have been exploited. The gouged-out whites, described in the section on line engraving, and seen in Hayter's engraving on page 36, are cleaned out before the print is taken and are therefore relief prints, while the etching and engraving round them are intaglio.

Surface prints from intaglio work on metal may have been made in the centuries subsequent to the *manière criblée* but the only well-known examples are the relief etchings of William Blake. Of these there are two distinct types. There are those of the category of *Jerusalem* or *Famine* on page 141, where the plates are essentially normal etchings in reverse, that is the whites are drawn and etched on the plates instead of the blacks. This type of etching was used by some artists of the Atelier 17 in Paris before the war and has also been used by Lambourne and others.

A further development of this is to give an etching or an engraving an added interest by printing it with a surface colour. This is simply done by inking the plate in the normal way with black intaglio ink and rolling up the surface with any desired colour of typographic or litho ink and printing the plate. Or the plate may be inked with a colour intaglio ink and rolled up with a second surface colour producing a complete colour print. A further variation, which has been often used is to print the plate in black as intaglio, clean it, roll it up with colour and print it as a relief print on to the first. If the plate at its second printing is

registered slightly to one side of the first print the result is a curious 'dither' or double image. The white lines of the design from the second purely surface print come just alongside the black lines of the intaglio print which gives a somewhat unexpected third-dimensional effect. This can be seen in Lambourne's *Two Figures* on page 142.

Blake, however, was not content to discover the method of relief printing but proceeded to invent deep-etched plates for printing in relief. Of these there are two categories. There are the broadly designed plates for the magnificent illustrations to *Jerusalem*, page 144, where a great deal of black background is left and there are the others such as the more delicate type for such books as *Songs of Innocence and Experience* where the design is in black line and the background etched entirely away. Both of course are combined with his written text deep etched on the plate. The method of reproducing the beautifully written text, which must have been done by transfer, has up to the present completely defeated artists and experts. Blake said that the process was revealed to him by his brother in a dream and he died without communicating it. In 1947, however, at the Atelier 17 in New York, Hayter, Ruthven Todd and Joan Miro, after studying Blake's prints, made experiments which were entirely successful. If they did not discover Blake's original process they found one which appears to be as good. A relief print from one of their plates reproduced on page 155 shows a poem written by Ruthven Todd with decorations by Joan Miro.

Blake's purpose was, of course, to produce something which would combine with his etched manuscript and which he could subsequently colour by hand. What he invented was, in effect, the forerunner of the modern process line block. By drawing with varnish on the metal and etching away the remainder of the surface deep enough not to take the ink in relief printing, he was doing what the camera and the process engraver do for an artist's pen-drawing. There is no reason why this technique should not be used today. If the artist took the trouble to make his own line blocks in this manner he could supply originals which would obviate the many disappointments that mechanical reproductive processes often provide.

Students of both the L.C.C. Schools of Arts and Crafts have lately produced such work. Using zinc plates and drawing with varnish and grease pencil with aquatinted surfaces, they have shown that remarkable effects can be obtained. The etching, especially in the case of the aquatint, is not deep and normal hand inking with a surface roller and a little too much pressure in a hand press produce very indifferent results. But the typographic ink used in the high-speed rotary presses of today is so thin and the action so fast that the most delicate surfaces are printed to perfection if suitable paper is used. This, of course, is obvious to anyone who has tried to print a modern half-tone block inking it and printing it by hand.

Artists would do well to consider this technique seriously as it obviously offers enormous possibilities. The bane and curse of the artist working for reproduction today are the reproductive processes and the high speed of modern printing. The art of the blockmaker has deteriorated disastrously since the beginning of the century, and even when the blockmaker's work is satisfactory, bad press work and high speed often ruin the results. With this technique the artist can make his own blocks and have little to fear from high-speed presses.

But there is another use for deep etching as invented by Blake which has only recently been put to use. Sam Kaner went to Paris from the United States to study with Roger Lacourière, Picasso's master-printer and a professional engraver. Lacourière does not take pupils, but like all good artist-craftsmen who love their work, he delights in showing artists any technique of which they are ignorant or uncertain. However, in Kaner's case, he made an exception, and while under Lacourière's instruction Kaner perfected a method of combined intaglio and relief printing which offers great possibilities. It requires, however, at least two colours and is therefore properly a colour technique. A design is drawn on a clean plate with varnish or grease pencil or any acid-resist and the plate deep etched. Where large flat areas occur in the deep etch further subtleties can be added to the design with aquatint, or the surface itself may be engraved, etched or aquatinted, as in the Christmas card reproduced in this section where the angel is engraved with a burin, page 152. The deep-etched portions, the intaglio, are then inked up with a colour; where aquatint occurs in the deep etch the tone will be strong and it will be strong round the edges of the portions left in relief where the ink clings. But elsewhere it will be wiped away to a faint tone. The surface, which has been cleaned by the hand in the normal process of wiping, is then rolled up with a second colour and the plate printed in a copper-plate press. The result is a two-colour print made at one printing. If desired, after the plate has been inked with the first colour, a second colour can be rolled on with a soft roller. The roller will penetrate the large deep areas and make a second colour by contact with the first. The surface of the plate is then cleaned and rolled up with a third colour, using a hard roller. Thus it would be possible to ink a plate with blue in the intaglio, roll it up with yellow with a soft roller and roll up the surface with red. The result would be a red surface pattern with blue lines round it where the first colour clings to the deep etch. Any small etched areas, too small for the yellow roller to penetrate would also be blue, but where the yellow roller penetrated the larger deep areas the colour would be light yellowy green and deep green where the blue was held by the aquatint. Where engraving or etching is done on the surface it would print blue on a red background. If inking by the roller is not overdone, any intaglio work of this kind will predominate, since being below the surface in the plate it is on top in the print.

Kaner has produced some excellent prints by this method and successful experiments were made at the Slade School by students such as Hawkins and Cohen, and an admirable print by Helen Phillips of the Atelier 17 is reproduced on page 147. The technique has an advantage over other forms of colour printing in that the colour seems to retain its intaglio quality and third-dimensional effect. Other methods of colour printing, unless the colour is very transparent, are apt to lose these qualities and return the print to the realm of gouache or pure relief printing. The technique lends itself admirably to evocative pattern and semi-abstract compositions. Its application to more naturalistic subject matter has yet to be investigated.

Another method of getting the effect of deep-etched plates such as the above, as well as some unexpected results, is to build up the surface of a plate instead of etching it down. The first exponent of this type of work was Rolf Nesch, who works in Norway. He calls his prints 'metal graphics' and he creates them by soldering on to the metal plate copper wire in various forms and shapes. Instead of the etching needle and burin, his instruments are metal scissors and soldering iron. The completed plate is even more three-dimensional in appearance than an ordinary deep-etched plate. He applies colour inks to the depths and rolls up the surfaces in the same manner as Kaner and achieves some very interesting and lively results, such as *Landing Stage*, page 152, and the mountain landscape called *Goats*, page 153.

Once the principle of deep etch is accepted there is, of course, no logical reason why a plate should not be built up as well as etched down, and there are several artists in this country who have already done interesting work in this manner. A variation on it is seen in Harry Cohen's colour print on page 148, where he has laid a thin second plate, inked in a different colour, on top of a first which gives the strong white line round the top plate, a white line which stands out in front of the picture plane as does the gouged out lines, printed in relief in Hayter's prints. When, however, such secondary plates are soldered on to the bottom plate the ink of course clings round them as in Clatworthy's print and the effect is the same as if the surface round this plate had been etched down.

# *Technique*

## RELIEF PRINTS

BLACK RELIEF PRINTS. A relief print of any intaglio plate can be made by the simple process of rolling up the surface with typographic proofing ink in the same manner as a wood block. All lines and textures sunk in the surface of the plate by whatever process will print white—the reverse to the normal procedure. Thin stiff ink should be used with a firm roller so that no ink will penetrate the lines and textures in the plate. The plate may be rolled several times till it is

properly covered. It should be obvious, however, that a plate designed for intaglio to print in black is not necessarily suitable for the reverse procedure. Occasionally, and especially in the case of imaginative or abstract subjects, a plate made for intaglio printing will produce an excellent relief print. Blake, of course, designed most of his relief prints to print in this manner, etching out the whites of his design, instead of the blacks. To do this he had only to use the normal technique of etching and remember, as he drew on the plate, that he was drawing in white on a black surface.

COLOUR RELIEF PRINTS. If, however, colour is used as a surface addition to an intaglio print any plate will print well. In this case all that is necessary is to ink up an intaglio design with black or coloured copperplate ink. The surface should be wiped perfectly clean, using a little whiting when hand wiping, so that no trace of black or colour is left on the surface. This would alter the tone or dim the brilliance of the second or surface colour. When the surface is rolled up, a reasonably hard roller should be used and the ink should be thin and stiff. It will, inevitably, as it passes over the inked intaglio lines or textures pick up colour from them. If, however, the ink is of the right consistency and the roller without holes, lumps or depressions, and of sufficient size to cover the whole plate with its width and circumference, one inking should be sufficient. Generally it is necessary to roll up the plate several times, as conditions are rarely ideal. In this case it is necessary to clean and re-ink the roller each time, or use several rollers to obtain perfect results. Otherwise either the second or surface colour will be tinged with the intaglio colour, or worse still, an offset of the intaglio design will appear on the plate.

## DEEP ETCH · MATERIALS

| | |
|---|---|
| Plate: copper, zinc or iron | Nitric, Dutch mordant, |
| Varnish and brush | Acids ⎰ perchloride of iron, or |
| Grease pencil or litho chalk | hydrochloric |

### TECHNIQUE

There are two methods of making a deep-etched plate. The first is to cover the plate with etching ground after well cleaning away every trace of grease in the normal way for straight etching. The white can then be drawn through the ground and the larger areas scraped completely away so that they etch cleanly. Retouching varnish or ordinary stopping-out varnish can be used instead of the ground, provided it is used as soon as dry. This, however, is a negative way of working, drawing whites on a dark ground. The positive way is to draw the design on a perfectly clean plate with varnish or any good acid resist and a fine soft brush or with grease pencil or litho chalk. When this is done and the back and sides of the plate have been protected with varnish the plate is ready for the acid bath.

ACIDS. If grease pencil or litho chalk is used it is best to employ a slow even biting acid such as Dutch mordant or perchloride of iron, otherwise the outlying points of grease or chalk will be undermined by the boiling action of nitric acid and disappear. If varnish is used nitric is perfectly safe in the proportions of two parts water to one part acid. The safest acid of all for deep etch is perchloride of iron and it can be used at full strength (45 per cent) always remembering that the plate must be laid upside down in the bath to allow the sediment to drop out. Its only disadvantage is that it etches the depths in a series of striations which radiate from the heights or from the sides of the plate and occasionally they are deep enough to hold ink. If it is important to avoid these, nitric or hydrochloric acid should be used. The plate will take several hours to etch, depending on the strength of the acid, which is another reason for not using nitric which requires attention to remove the bubbles.

HAYTER-BLAKE METHOD. Blake's method of producing writing on a deep-etched plate so that it will print in relief has never been used, as his process died with him. But it is obvious that a transfer was used, as Blake's manuscript is natural and not a *tour de force* of writing the wrong way round. The method developed by Hayter and his associates as a result of their study of Blake's prints is to write in a solution of asphaltum and resin in benzene, or simply in asphaltum and petrol, on a thin sheet of paper previously coated with an equal mixture of gum arabic and soap. A clean plate is well heated, the paper laid upon it face down, and passed through the press. The back of the paper is then well soaked with water and peeled off, leaving the asphaltum on the copper. The plate is then bitten in a solution of one part nitric to two parts water for about nine hours.

LAMBOURNE'S METHOD FOR RELIEF AND DEEP ETCH. Wherever possible the whole design, from the crudest idea onwards, should be drawn straight on to the metal. This direct method is the essential element of the technique, especially as the drawing in acid resists can be corrected or erased with solvents such as oil of turpentine, white spirit or even petrol.

The most useful acid resists for drawing are: pure beeswax, using a full brush of turpentine rubbed on the wax, which will give a broken texture; soft ground, used in the same way, will produce a less broken ground; and No. 0 litho chalk or stick ink, the former for drawing hard linear areas and the latter used with turpentine with large or small brushes. Stopping-out varnish is essential for reinforcing the finest lines drawn with litho chalk, and when thinned down with turpentine can be used for spraying on to large areas of the plate where a fine even texture of aquatint is required. This is often superior to resin texture, more controllable and capable of great variety.

Strong lines, which are to be intaglio, may be drawn into the soft wax or litho chalk areas. This gives a contrast to the relief and is often essential when two-colour printings are to be used.

Designs engraved on wood or lino, or texture from grained wood, can be etched by taking a heavily inked print with typographic ink, or better still Lorilleux and Bolton's 'Lackset' non-drying ink and offsetting it on to a plate previously scoured with steel wool to provide a key. The ink acts as an acid resist to medium strength nitric or hydrochloric and, if the design is broad and not too small, a little foul biting is of no importance.

METAL. The metal used is about 22 gauge zinc, as used for lithographic purposes. The backs of used plates are very often in sufficiently good state to be used in this manner. It is easy to cut and gives more varied, broader and often desirable fortuitous effects than could be obtained on copper, yielding from twenty to twenty-five prints. Surface scratches may be ignored but the plate should be evenly and firmly rubbed with the finest grade steel wool, which gives a key that will hold the greasy litho chalk and varnish. Polishing should only be done when the plate is ready to print.

ACID. Only pure hydrochloric acid should be used, the strength being at least twenty-five parts acid to seventy-five parts water and at most half and half, and should be kept tepid by placing it from time to time on the heater. Neat acid may be used on certain passages for accent or, by breaking down the surrounding ground, to produce a grey or corroded effect. The acid should be dropped on with a glass fountain-pen filler and washed off as soon as the etching is done. For deep biting it should be renewed as soon as it dries. The natural impurities of the metal used, which is often a zinc aluminium alloy, tend to give a slight irregularity in the biting which is often desirable for vigorous effects. Zinc filings should always be dusted into the bath to correct any seriously uneven biting. The advantage of using zinc with a fierce acid, is that it speeds the work and also makes the main relief masses stand out above the intense bubbling. New work can be added to these masses in the bath, drawing in slight linear passages last of all. After the final biting a graver or scrive can be used to define certain lines, giving a final emphasis to certain shapes, in deliberate contrast to the softer quality of the etched lines. The lines cut should not be deep but wide and crisp, and drypoint may also be used and the burr rubbed off with metal wool. Very fine work can be added by dropping perchloride of iron mixed with 10 per cent neat hydrochloric on to it from a glass pen filler. This acid bites regularly and deeply but is apt to clog the lines.

The purpose of this method is to obtain the most direct, telling and contrasted effects possible and to produce sufficiently broad relief and semi-relief areas to give contrast to the deeper, linear intaglio areas, where another colour is used in printing. There are certain limitations imposed by the more or less fortuitous chemical element which must be accepted. In fact, this element should be deliberately cultivated, even though it may lead to the ruin of one or two plates, in order to arrive at the most spontaneous and lively result possible.

WILLIAM BLAKE
*Europe: Famine*
relief etching
$9\frac{1}{2} \times 6\frac{3}{4}$ inches

WILLIAM BLAKE
*Jerusalem*
relief etching
$6\frac{1}{2} \times 8\frac{3}{4}$ inches

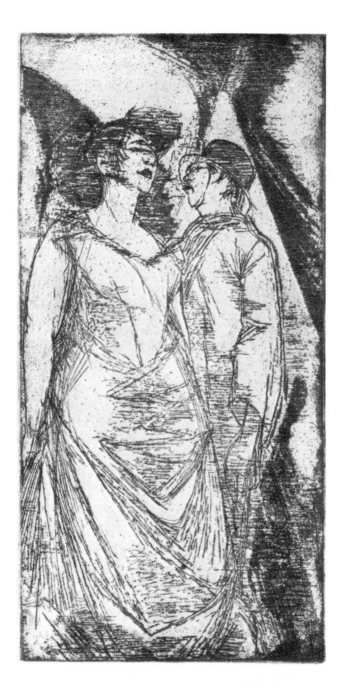

NIGEL LAMBOURNE *Two Figures*
etching: intaglio and colour relief print 11¾ × 6 inches

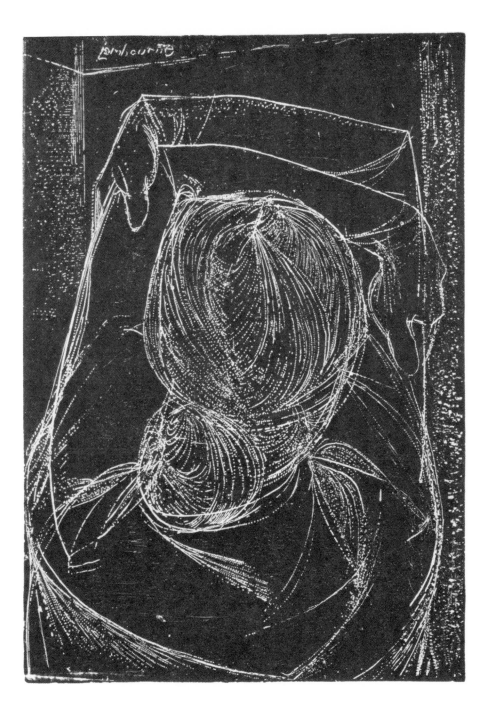

NIGEL LAMBOURNE *Figure at Rest* etching: relief print 12¾ × 9 inches

And the voices of Bath & Canterbury & York & Edinburgh Cry
Over the Plow of Nations in the strong hand of Albion thundering along
Among the Fires of the Druid & the deep black rethundering Waters
Of the Atlantic which poured in impetuous loud loud, louder & louder.
And the Great Voice of the Atlantic howled over the Druid Altars:
Weeping over his Children in Stone-henge in Malden & Colchester.
Round the Rocky Peak of Derbyshire London Stone & Rosamonds Bower

What is a Wife & what is a Harlot? What is a Church? & What
Is a Theatre? are they Two & not One? can they Exist Separate?
Are not Religion & Politics the Same Thing? Brotherhood is Religion
O Demonstrations of Reason Dividing Families in Cruelty & Pride!

But Albion fled from the Divine Vision. with the Plow of Nations enflaming
The Living Creatures maddend and Albion fell into the Furrow. and
The Plow went over him & the Living was Plowed in among the Dead
But his Spectre rose over the starry Plow. Albion fled beneath the Plow
Till he came to the Rock of Ages. & he took his Seat upon the Rock.
Wonder seizd all in Eternity: to behold the Divine Vision. open
The Center into an Expanse. & the Center rolled out into an Expanse

WILLIAM BLAKE *Jerusalem* deep etch: relief print $8\frac{3}{4} \times 6\frac{1}{2}$ inches

144

R. E. CLATWORTHY *Figure in Room* deep etch: intaglio print 15 × 12 inches

BRIAN BRADSHAW *Cotton Town* deep etch, etching and aquatint 4½ ×6 inches

HELEN PHILLIPS *Composition* deep etch: intaglio and relief print 4½ ×6 inches

HAROLD COHEN *Seated Figure and Still Life* deep etch: intaglio and colour relief print 5 × 12¼ inches

SAM KANER *Composition* intaglio and relief 8 × 6 inches

SERGE BRIGNONI *Academie No. 1: state* line engraving, etching and soft ground $5\frac{3}{4} \times 9\frac{1}{2}$ inches

opposite: E. ZANARTU *Soleil Glaciale* line engraving, etching and soft ground $14\frac{1}{2} \times 17\frac{3}{4}$ inches

above:
JOHN BUCKLAND-WRIGHT
*Christmas Card*
deep etch: intaglio and relief print
actual size

left:
ROLF NESCH
*Landing Stage*
'metal graphic'

ROLF NESCH *Goats* 'metal graphic'

PABLO PICASSO Etching collage: relief print $5\frac{1}{2} \times 4\frac{1}{2}$ inches

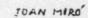

### JOAN MIRÓ

Once there were peasant pots and a dry brown hare
Upon the olive table in that magic farm;
Once all the showmen were blown about the fair
And none of them took hurt or any harm.
Once a man set his fighting bull to graze
In the strict paths of the forgotten maze.

This was that man who knew the secret line
And the strange shapes that went
In dreams; his was the bewitched vine
And the crying dog in the sky's tent.

Once he had a country where the sun shone
Through the enchanted trees like lace,
But now it is troubled and happiness is gone,
For the bombs fell in that fine place
And the magician found when he had woken
His people killed, his gay pots broken.

1937

JOAN MIRO *Poem by Ruthven-Todd with decorations*  relief print

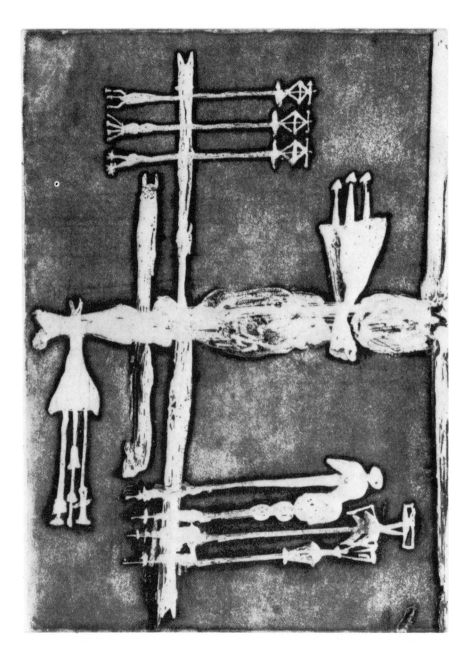

MICHAEL ROTHENSTEIN *Tree* deep etch: intaglio print $8\frac{1}{4} \times 11\frac{1}{4}$ inches

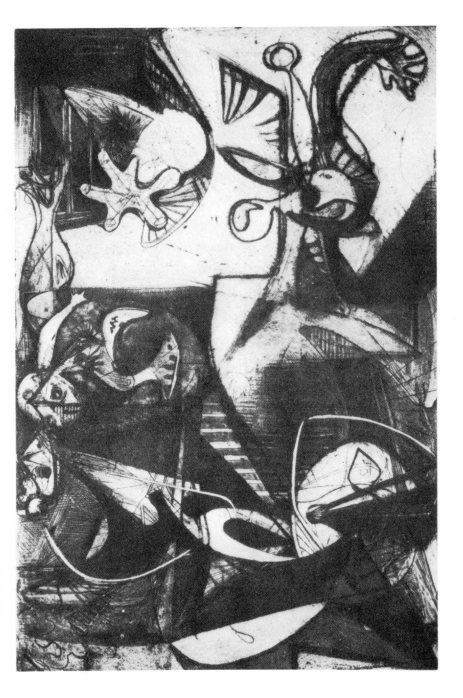

MAURICIO LAZANSKY *Dachau* combined processes

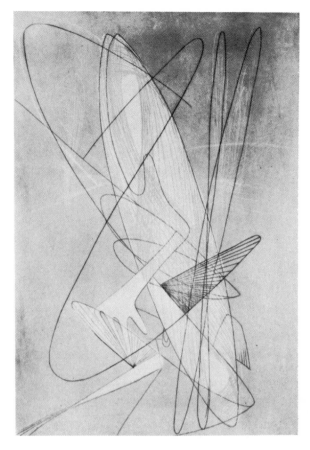

ROLOFF BENY
*Abstract No 2*
line engraving and lithography

below:
*Concept*
line engraving, etching
and lithography

JAMES STEG *Mystic at the Last Analysis* combined processes

left: ROLAND GINZEL *Equinox* combined processes 15 × 20 inches

S. W. HAYTER *Woman in a Net* line engraving, white line, relief, soft ground $8\frac{1}{2} \times 11\frac{3}{4}$ inches

below: PABLO PICASSO etching collage $5\frac{1}{2} \times 4\frac{1}{2}$ inches

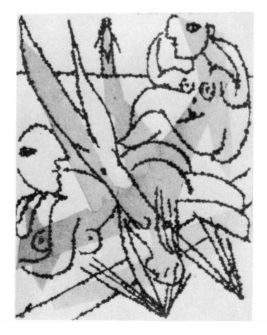

# COMBINED PROCESSES

$C$ONTEMPORARY vision and expressionism often require more means for realization than are offered by one individual technique. The tonal processes of aquatint and soft ground etching etc are improved by, and in fact require, as a rule, the decisive element offered by drypoint, etching or line engraving to make them truly expressive. It is natural, therefore, for the artist who uses, but is not hampered by, traditional technique to employ any and every means at his disposal to achieve his end.

Simplicity of means is an asset, but it is not a requisite, and complexity is perfectly justifiable provided the desired result is achieved and it possesses an ultimate unity.

There are, also, some artists who find it impossible to visualize with the necessary clarity the conception which springs from imaginative or emotional impulses, and find that it is only by laboriously working towards a dimly perceived aim that they are able to formulate on a plate, or a canvas for that matter, the expression of their vision. For such artists, engraving and etching offer a multitude of means and they are able, as the plate progresses, to bring into play almost any process of print-making in order to achieve the desired result. Each state of the plate will suggest, of itself, the next step to be taken or the next process to be used. To such artists as these, complex methods seem natural and obvious in their attempt to achieve a final unity and expression. Nor is there any valid reason, apart from purist dogma, why the whole range of techniques, including metal, wood and stone, should not be brought into play.

In 1835 George Baxter perfected a process which is the forerunner of contemporary practice in combined technique. Admittedly, he invented it as a purely reproductive method for making colour prints of masterpieces of painting and water-colour 'to increase, not merely the happiness, but the morals and good conduct in society' of the working people. His method consisted of a combination of an aquatinted or mezzotinted foundation plate with a large number of wood-engraved blocks all printed in colour, with oil inks. By this means he was able to achieve some results which were remarkable for the period, and later he designed original prints of a genuine and unsophisticated character which sold in thousands.

The practice of contemporary composite techniques was first initiated by Hayter in his Atelier 17 in Paris and continued and disseminated by him in the United States. Starting with the combination of burin and soft ground, further

experiments led to the combination of almost all the intaglio methods and relief printing. Such a print as Brignoni's state of his *Anatomy I*, page 151, is typical of the early combination of burin, etching and soft ground processes. A more recent example from the Atelier 17 is Zanartu's *Soleil Glacial*, page 150. Mauricio Lazansky, at one time also a member of the Atelier, and now professor at Iowa University, has continued Hayter's methods with some excellent results, of which his *Dachau*, page 157, combining burin, drypoint and soft ground is a good example. Other examples of his group are Steg's *Mystic at the Last Analysis*, page 159, and Roland Ginzel's *Equinox*, page 158, where etching, burin, soft ground and aquatint are employed.

But some of the most successful prints are those combining intaglio and lithography such as Roloff Beny's *Concept* and *Abstract No. 2*, page 158. The effect of the combination of the soft lithographic backgrounds with the superimposed line engraving give an extraordinary feeling of almost limitless recession, while the hard white at the crux of *Concept* seems to stand out in front of the picture plane.

There are immense possibilities here for experiment and discovery. Hayter is working in Paris on these lines and there are others who will follow his example. Meanwhile, the combination used by Baxter or an adaptation of his technique allied to contemporary vision and subject matter would, in all probability, well repay any pioneer in such combined processes.

# INTAGLIO PRINTING
## *Technique*

## MATERIALS

Copperplate press
Blankets: two thick swan-cloth
   felts and two fronting
Ink powders: Frankfort,
   French black
Copperplate oil: medium
Muller and palette knife

Ink roller or dabber
Printing muslin: stiff and soft
Paper
Blotting paper
Cleaning fluid: petrol or
   turpentine
Rags

## TECHNIQUE

A print from an intaglio plate, where the lines or pitted areas are sunk below the surface and form the design, is made by forcing ink into the depths and cleaning the surface; damp paper is forced into these ink-filled lines and areas by the press and then peeled off, taking with it the ink from the depths as well as a slight film of ink from the surface of the plate. A print is, in fact, a mould taken from an inked plate and this is at once obvious when the back of the print is inspected, for the damp paper will be moulded in the form of the intaglio design, especially where lines or areas are deep.

It is not difficult to obtain a reasonably good print from a plate. Students have been known to pull off such prints at a first attempt. But to be able to take a series of first-class proofs requires long practice in an art where many factors come into play. Such factors are the quality and dampness of the paper, the colour and consistency of the ink, the temperature of the plate, the final wiping with the muslin or the hand, the condition of the blankets and the correct adjustment of the press.

All engravers should know how to pull a good print and should either be able to print their own work or pull a print as a guide for the professional printer to follow. An admirable lesson can be obtained by watching a professional at work. The calm, unhurried way in which he inks and wipes the plate, getting exactly the desired result; the cleanliness he achieves; the perfect working of the press and the finished proof, are all a delight and an instruction on how to do well and cleanly what can be a dirty job.

When printing an edition of a plate a great deal of time can be saved by organizing the whole process before starting. All unnecessary movements should

be eliminated as far as possible and a system worked out whereby the plate is inked, wiped and laid on the press, the damp paper laid over it together with the blankets, the press turned and the print removed for drying in an effortless rotation. In this manner it is possible to pull twenty good proofs in an hour from a medium-sized plate. But this means that the paper must be properly damped and ready, the ink in good condition, the muslins laid out in the proper order and the press at the correct pressure.

THE PRESS. Presses are not easily obtained today as there are few makers and it is best to acquire a good second-hand press, guaranteed in working order, from an artist or an etching supply stores. The principle of a copperplate press is a bed, generally of metal, travelling between two heavy iron rollers with a direct or geared drive. Small table presses are obviously less efficient than the larger types but, even so, good results from small plates can be obtained from them with sufficient care.

Some engravers like to have a sheet of zinc on the bed of the press, slightly smaller than the bed, to ease the pressure, but it is not necessary. When the press is set up and the bearings well greased it is essential to adjust the pressure before starting to print. This is done by means of the adjusting screws that bear down on the packing above each end of the top roller. The best method is to tighten them down till they will no longer turn, then using both hands turn them back equally until the blankets, which have been stepped so that the roller will ease on to them, will grip and the bed will pass through the rollers easily. To verify that the pressure on both sides is equal and that there will be no shifting, draw a chalk cross on the bed or the zinc plate and placing a sheet of paper on it run it through the press. The paper should take off the chalk in the same regular lines in which they were drawn. If the paper grips one side and slips the other the chalk will be smudged and the screws will have to be readjusted. Next place a worked plate, an old one for preference, on the bed and with a sheet of damped paper over it run it through. If the plate will not pass, the screws must be turned back till it will do so. Then examine the paper, held level with the light, to see whether all the design has been embossed on the paper in the proper proportions. If this is the case the press is ready for use. Any surface shine means that pressure is too great.

BLANKETS. Press blankets are made of closely-woven wool of the best quality and are expensive. They are of two kinds, the thick resilient 'swan-cloth' felts and the thin fronting blankets. They should always be kept as clean as possible and handled only with clean hands or with paper or cardboard clips. They should never be left under pressure to flatten and when wet should be dried before use. If they become stiff with size, or dirty, they should be washed in soap and warm water with a little ammonia. The fewer the blankets, provided there is sufficient resilience, the better. As a general rule four are enough, two thick felts and two

fronting blankets, the latter nearest the plate. They should be stepped slightly so that the roller rides on to them easily. At the end of the day's printing they should be taken out of the press and hung up to dry.

INK can be bought ready-made from etching supply stores in tins or tubes. It should be a rich warm black, neither too oily nor too stiff, but nearly all bought inks suffer in some respect unless obtained from a good maker in fresh condition. The best procedure is to make the ink oneself. The blacks used are Frankfort black, French black and lamp black, one-third of French black to two-thirds of Frankfort being a satisfactory mixture. It should be ground up on a slab with a muller to crush all lumps and grit and medium copperplate oil slowly added and ground in till it is properly mixed. When made it should be of such a consistency that a lump will just not drop off a palette knife when held in the air. There are many recipes for making inks and some engravers prefer more liquid or stiffer ink than the above. It is a matter of personal taste and experiment. If bought ink is too stiff the addition of a little linseed oil or thin or medium copperplate oil, well mixed in, will correct it, and a little black pigment should be added to ink which is too liquid.

Another recipe for making ink, used by Joseph Hecht, is one-third Frankfort black and two-thirds French black ground up with one-third burnt linseed oil and two-thirds raw linseed. This ink, owing to the raw linseed, which takes years to dry, produces the golden glow round the lines which is seen in old prints, where the linseed has spread slightly on either side. The same effect is seen in old printed books. When made and not in use, ink should be kept in a covered jar with a little water on top to make it airtight.

INKING THE PLATE. The plate can be inked warm or cold. When warmed on the heater the ink will spread over and into the lines more easily. But it should be remembered that heat weakens the effect of the ink and that plates printed cold are more brilliant and deeper in tone. The ink may be spread on the plate with a felt roller, a dabber or a dolly, which is a strip of felt rolled up tight and bound with string. Rollers and dabbers should be kept soft either by cleaning them after use or by keeping them in a saucer with a little oil. Dollies can always be recut if the ink hardens on them. Hard ink in these cases is apt to scratch the plate and wear it. When the plate has been well covered with ink it should be turned against the light to see that all lines and pittings have been well filled. If there is any glint of metal from them the ink is best rubbed in with the finger.

WIPING is done with printing muslins and with the palm of the hand. It is supposed to take an apprenticeship of five years to achieve perfect results, but reasonably good proofs can soon be obtained with a little practice and experience. Printing muslins are sold either hard or soft in most etching stores. The hard muslin should never be hard enough to scratch a plate and in such cases should be well soaked, dried and rubbed. The whole wiping of a plate may be done with

a medium hard muslin but it is generally easier to do it with two varieties. The muslins should be made into flat pads, a little larger than the hand, and should all have a little ink on them if they are to work well. There should be three pads, two of hard and the third of soft muslin; the first will take most of the ink off the plate, the second will practically clean it and the third will finish it. A strong circular motion is used and the ink cleared away with the two first pads until the design is clearly visible through the surface ink. A little pressure may be used in doing this but too much pressure or a scooping movement will take the ink out of the lines. With the pad of softer muslin the ink on the surface is next cleaned away. It should be done with a circular brushing motion with hardly any pressure. When the plate looks clean it may be printed as a 'rag-wipe' but there will still be a considerable tone on the surface, and the even quality of this tone will be an indication of the efficiency of the wiping. If it is blotchy and streaky it has been ill done. For most prints it is best to end with a hand wipe, for which the dry palm of the hand is brushed lightly over the surface of the plate in all directions, starting and ending outside the area of the plate. Here again, no pressure should be used; even the weight of the hand is too much. If the hand starts this soft brushing movement inside the plate or bumps on the surface an impression will generally be left. When the plate is cleaned in this manner it will still print with a slight tone, which is desirable in that it gives the print a trans-parency, a third-dimensional quality which is often vital to its expression. If, however, the surface is to print white, a little whiting should be brushed on to the palm of the hand and brushed off again before passing it over the plate. Several wipings in this manner will take all the tone off the plate and the lines will print clearly. If the lines are underbitten or weak and need strengthening a soft muslin impregnated with a little ink should be lightly dragged over the plate in all directions with the lightest stroking movement. This will bring the ink out of the lines slightly and produce a heavier and richer effect. This is known as *retroussage* or dragging up.

Almost any effect can be obtained on a plate by the judicious use of all these procedures and the engraver, with a little practice, will be able to obtain almost any desired effect. Some etchers leave a considerable amount of surface ink on the plate to obtain dramatic effects. But this is difficult to do twice in exactly the same fashion and such vicarious effects should be avoided. It is what is in the plate that should print and not what is on it. When the edges of the plate have been wiped clean it is ready for the press. Muslins should be spread and hung up to dry after the day's work.

PAPERS. Almost any paper may be used for printing provided it can be properly damped. The stiffer a paper is the more size it contains and the longer it should be damped. Soft sized and waterleaf paper, without any size, are there-fore the easiest to use. Blotting paper will take very good working proofs but for

final prints a good hand-made paper should be employed. It should be thoroughly wetted and put between sheets of blotting paper and preferably between sheets of glass for twenty-four hours before using. Taken out as wanted and brushed up to lift the nap a little it should then take a perfect impression. Any water on the surface should be brushed off or it may refuse the ink and make an uneven print. Prints which are meant to last should only be taken on the best paper procurable, the weight of paper being in proportion to the size of the plate.

IMPRESSION. The inked plate must be put in the centre of the bed of the press, the longer sides of the plate to the length of the bed. If set margins are desired it is best to mark the bed of the press or a sheet of blotting paper with the position of the paper and the relative position of the plate upon it. Both can then be laid each time in their respective markings on the blotting paper. If the plate is not properly bevelled a backing of blotting paper should be placed over the proof paper to protect the blankets from cutting. This is also useful to absorb excess moisture and prevent the blankets from becoming wet and hard. But most engravers prefer the contact of the blanket with the back of the proof. The blankets must be pulled tight and straight over the plate and paper and the press turned slowly and regularly through without a stop. Then, folding the blankets back, the proof is peeled carefully off the plate from one corner.

Cleanliness is essential in handling prints and blankets, and as the printer's hands are bound to be dirty, a cloth should be kept handy for wiping off excess ink and all papers and blankets should be handled with a piece of stiff paper or card folded into a clip. After the print has been pulled it should be examined carefully to see that it is perfect. A shiny or glossy surface means that the pressure is too great and the screws should be adjusted to correct it. This may also cause the ink to spread out of the lines and smear. Wrinkling or folding is generally due to improperly damped paper or wet, stiff blankets. Missing lines or interrupted lines where the ink has not taken is due either to careless inking, dry paper, insufficient pressure, over-stiff or gritty ink or unsuitable paper. Such lines may be mended with a sharp pencil and a little printing ink but the cause should be eliminated before the next print is taken. If blotting paper is not used under the plate the bed should be cleaned after each proof is taken, as the back of the plate is often inky and ink left on the bed of the press may dirty the margins of the next print. When printing ends for the day the plate should be thoroughly cleaned. Dried ink is often difficult to remove. Turpentine or petrol should be used to clean the plate, with a soft rag which will not wear the plate. When the rag comes off clean on applying the fluid the plate is perfectly clear of ink. Dried ink can be removed with a rag and a little caustic soda in water, which should be kept in a glass-stoppered bottle. In extreme cases the plate will have to be immersed in caustic soda and the dried ink boiled out of the lines.

DRYING PRINTS. Prints should be laid out to dry for from twenty-four to forty-eight hours so that the ink will harden and not offset on to the blotting paper used for flattening. After this they should be redamped, carefully dried and placed between clean sheets of blotting-paper under a light pressure. As they dry, and the blotting-paper is changed, the pressure can be increased until the proofs are perfectly flat. In this way the lines and deep areas remain convex, which does not happen when fresh prints are taped down and stretched.

EDITION AND NUMBERING. Prints from a plate are usually limited for various reasons. Either, as in the case of delicate work, such as drypoint, the plate will not give more than a certain number of perfect proofs, or the artist wishes to limit the number to ensure a rarity value or for personal reasons. Working proofs pulled to observe the process of the plate and necessarily incomplete are called 'states' and should be numbered State No. 1, State No. 2, etc. Proofs of the final and complete state are generally known as 'trial proofs' or 'artist's proofs' and should also be numbered. The custom in France is to allow about five artist's proofs above and beyond the normal 'edition'. This edition constitutes the prints for sale and may be limited to any number fixed by the artist. For Customs purposes the British authorities consider that the moment an edition is over seventy-five prints, it becomes a commercial product and, ceasing to be a work of art, becomes subject to duty. When the edition is printed, or as it is printed, if the artist is pulling it in stages, each perfect print should be titled, signed and numbered according to the total number of the edition, generally in the manner of 1/30; 2/30 etc. Imperfect prints should be destroyed and, after the edition has been pulled, the plate should be indelibly marked to that effect or destroyed.

PROOFING WITHOUT A PRESS. It is not possible to take a good print without a press but a rough working proof can be obtained in the following manner. A sheet of very thin paper, a little larger than the plate, is covered with a thin layer of white wax. A little powdered lamp black is rubbed into the work on the plate with the fingers and the surface cleaned with the palm of the hand. The sheet of waxed paper is then laid on the face of the plate, waxed surface down with the edges folded under the plate, and burnished in all directions. The result will be a reasonably approximate image of the work on the plate. The process, however, depends on the correct amount of wax on the paper and is not always successful.

PLASTER PRINTS. A better method is the plaster print. The plate is inked as for printing in the press, but preferably with a more liquid ink than is generally employed, and leaving a distinct tone on the surface. It is then laid face upwards on a sheet of glass, and a wood frame at least three-quarter inch high is placed around it, leaving good margins. The frame should be weighted down to prevent it floating off position when the plaster is poured in. Plaster of Paris or cement

plaster is mixed with water to the consistency of cream and as it begins to warm (the first indication of setting) is poured into the frame from one corner, allowing it to spread evenly over the whole area. When covered, tow or other fibrous material may be laid over it to reinforce it. When the plaster is set and cold the frame is lifted off the glass and reversed and any plaster that has run round the edges of the plate on to the back is cut off with a knife. The blade of the knife should then be inserted under a corner of the plate, which should lift cleanly out. The result ought to be a perfect print which can be hung on a wall by screw-eyes screwed into the frame. Such plaster prints may be coloured with tempera or carved and coloured.

Another method is to use a piece of stiff paper instead of the wooden frame. This should be cut about an inch larger than the plate in both dimensions, the plate placed in the middle and the edges turned up half an inch all round and the corners taped. This will then form the container for the plaster, but as it would require special framing the other method is generally more useful.

## COLOUR PRINTING: A NOTE

Colour etchings in the past have generally produced some of the most appalling horrors known to art, apart from certain exceptions such as Camille Pissarro's few beautiful examples. The reason is that etched or aquatinted plates were printed with coloured inks either in an attempt to produce something more realistic than black and white or in direct imitation of an oil-painting. The latter were usually etched and aquatinted plates where the colours were applied with dollies or with the fingers, each colour being wiped as it was put on, starting with a brown haze to give unity into which the brighter colours were worked. The only successful colour etchings are those like Pissarro's, where a plate is used for each colour and superimposed, the drawing, in each case, being adapted to the purposes of the relevant colour, that is the colours themselves are constructive and are not used merely as tints to a black key.

Today there are several methods of achieving really good colour prints and these are mainly due to such engravers as Lacourière, Kaner, and especially to Hayter and his associates of the Atelier 17.

COLOUR AQUATINT. It is essential to remember when using colour worked into intaglio plates that not only the tone but the colour itself may change according to the depth of the intaglio. Deep-etched or engraved line will print far darker than expected, and lightly aquatinted portions extremely pale, to the extent of looking like a different colour. And it is only practice and experience that will overcome the difficulties that follow from these circumstances. Colour is best used in flat passages and to obtain a strong tone the aquatint must be bitten far deeper than would appear necessary. The number of plates used will depend, of course, on the number of colours, but it is not necessary to make a separate plate

for each colour. Several may be printed from one plate, providing each colour can be wiped in a direction which will avoid its mixing with a second colour. For instance, a blue might be wiped to the left, a red to the right and a yellow at right angles to them. When each colour has been separately wiped the whole plate can be gently wiped with a muslin. The colour should be mixed from powders with the same proportions of copperplate oil as for black ink.

When several plates are used they should be registered by boring two pinholes through the series of plates, either at top and bottom or in places where they will least show. When the first print is taken the proof is pierced with a pin through the holes in the plate and the second plate registered on to the pinholes. To register the key design on the second plate the key plate is printed in black and the damp proof registered on to the second plate by means of the pinholes and passed through the press. The ink from the proof is thus offset on it and it is then dipped for a few seconds into a weak solution of perchloride of iron and the ink cleaned off. The plate will have oxidized where there is no ink and the design will show clearly in clean metal.

When printing, proofs of the first plate should be stacked with tissue between them and a light weight on top to keep them damp until the second plate is printed. They should not be wetted or the register will be lost, but if necessary a damp sponge may be passed lightly over the backs before reprinting.

SURFACE COLOUR AND INTAGLIO. A plate inked with black or a colour may be rolled up with a composition roller and typographic or litho colour. This will produce a black or coloured impression of the design etched or engraved in the plate on a coloured background. When rolling up it is important to see that the roller does not pick up the first colour out of the intaglio or the second will be spoilt by it. If this happens the roller should be cleaned before each application of colour.

A plate may also be printed in black or a colour and then cleaned and the surface rolled up with another colour and reprinted on the first proof. If the register is a little out, say one-thirty-second of an inch up and to one side, a stereoscopic effect will be obtained, with a white line from the second and surface print alongside a black line from the first and intaglio print on a coloured background.

SURFACE COLOUR WITH DOUBLE INTAGLIO. Kaner's method of colour printing is to deep etch a plate around a design drawn on the surface with grease pencil, litho chalk or varnish and aquatint designs in portions of the deep etch. The plate is then inked for intaglio in one colour and rolled up with a soft roller, using litho or typographic colour which enters the more open areas of the deep etch and makes a second colour with the first. The surface of the plate is then carefully cleaned and rolled up with a hard roller and a third colour which is not allowed to penetrate the depths. The result is a three-colour

plate in one printing and a tonal design of the first two mingled colours in the depths where the aquatint occurs.

SURFACE STENCIL AND INTAGLIO. A further development of surface colour and intaglio printing used by Hayter, is to employ stencils cut out of paper, plastic or thin metal. These are hinged to a board in correct position round the plate whose position is marked. In this way perfect registration is obtained for each print. The thinnest and most transparent colours should be used or they will prevent the intaglio from printing through them. Three or four designs can be stencilled on to the surface of a plate in this manner before printing, and if the colours are sufficiently thin they will not pick up enough to cause trouble.

SILK SCREEN SURFACE COLOUR AND INTAGLIO. Another method invented by Hayter is the use of silk screens for stencilling colours on to the surface of an inked intaglio plate.*

OFFSET SURFACE COLOUR AND INTAGLIO. Hayter's more recent prints are often made by offsetting a colour design on to an inked intaglio plate and printing it. The design of the surface colour is cut on wood, lino or some other suitable material and inked up with a thin transparent ink. A large roller, the same size or larger than one length of the plate and whose circumference is at least equal to the dimension of the plate in the other direction, is passed over the surface colour design and picks it up and it is then offset on to the plate. Greater brilliance of colour can be obtained by this method than by any other.

For all surface colour printing the inks should be as thin and as transparent as possible or they will obscure the intaglio colour beneath them, which prints on top in the print. Also the second colour is more likely to pick up the colour already laid down.

Surface printing of colours has one disadvantage in that it is apt to kill the third-dimensional qualities peculiar to the intaglio print and return it to the realm of relief printing, lithography or painting.

---

*This process is fully described in Chapter 10 of Hayter's admirable book *New Ways of Gravure* (Routledge and Kegan Paul, London, 1949).

# WOODCUT & LINOCUT  *Theory*

The origin of the woodcut is lost in antiquity. It was used in the earliest times for printing repeat designs on cloth, but as paper was not made in Europe until late in the fourteenth century the earliest prints known are ascribed to 1418 or within a few years of that date. Prints were first used to make playing cards and religious mementos but it was not long before their obvious suitability as illustrations for the new printed books was recognized. They could be cut and printed together with the movable type which had just been invented in Germany. It was here that the first books illustrated with woodcuts appeared and it was only after the sack of Mainz, the birthplace of European printing, that the art spread to France, Italy and the Netherlands.

These early cuts were made on the plank with a knife and gouges of various sizes. They are pure black-line cuts of strong even contours, intended as the limits of the various colours to be applied later by hand. Some of them are extraordinarily expressive and have a stability of composition and a clarity of statement which was subsequently lost. The early Italian prints, and especially those of Florentine origin, while they may not possess the technical accomplishment of the German productions, are of far more aesthetic value. The drawing, composition and expressive qualities are all superior, and the use of black is more general. It has been argued that the black motifs which appear in these prints—sometimes a doorway, windows or a dress, a series of black books, a tessilated pavement or even the ground sown with white grass and flowers—were an economic device to save the labour of the colourist. But they are so carefully placed with reference to the design and give such perfect emphasis to the composition that it is far more likely that they formed a considered element in the Italian examples at least. The heavy decorated borders also added enormously to the general effect and acted as a counterpoint to the blacks, at the same time easing the difficulties of printing on the early presses.

About half-way through the fifteenth century, lines of shading were added, sometimes with the help of a pushed instrument, a sort of thick scrive, which is a hollow V tool with the point set back from the top edges. But the moment that shading is added the print loses the essential quality of cutting and is returned to a certain extent to the realm of drawing and pen-work. Provided the shading is simple straightforward hatching and used for emphasis and construction, there is little harm in it, but once naturalistic shading is followed and the pen strokes and cross-hatching imitated, the medium ceases to be creative and becomes

reproductive. Even in the early German prints this tendency is already visible and as time went on their superior technique led them inevitably towards the use of the material as a purely reproductive medium. Their preoccupation with reproduction is in direct relation to their use of cross-hatching. There is no simple directness in this technique. It is a *tour de force*, requiring immense skill and as the effect, the varying density of shadow, could just as easily be obtained by simpler methods more in character to the means, it is entirely useless. Its reason lies in the fact that the artist did not cut his own blocks but made drawings for the craftsman to cut. And artists, when it comes to the reproduction of their work by other hands, are notoriously inconsiderate of the reproductive medium and its limitations. To them their work is naturally paramount. They do not want an interpretation in the sense of the medium employed, but an exact copy. The conscientious artist, however, should in the circumstances consider the medium in which his work is to be reproduced and adapt his drawings accordingly. Holbein obviously did this for his series *Dance of Death* where the cuts are pure line and straightforward hatching with practically no crossing of lines.

Dürer is supposed to have cut the blocks for his *Apocalypse*, page 178, and it is noticeable that what cross-hatching appears in these prints is more feigned than actual. What we admire in the work of Dürer, his contemporaries and successors, is not the medium used in a creative sense but the design of the pen and the skill of the cutter in preserving it. The aim of the artist becomes naturalism with an increasing contempt for the normal limitations of the tool and the material.

There has always existed an immense admiration for Dürer and it is still prevalent. Only the other day an artist who said he detested Dürer was told in no uncertain terms by a colleague to 'look again'. If we do look again, with understanding, and refuse to be led astray by his brilliance and facility, it is his faults and not his qualities which become apparent. He has been criticized in the section on line engraving in this book and rather than incur the danger of repetition it would be revealing to quote from an authority who is a practising artist. Douglas Percy Bliss in his admirable *History of Wood Engraving* says, 'With his eye on the subject Dürer is an amazing draughtsman, but in that other kind of drawing which is evolved from the inner consciousness and is synonymous with linear design his talent is not of the highest. His very sleight of hand and his very knowledge and inventiveness are the cause of some of his defects and end in mere virtuosity on one hand and redundancy of detail on the other. He cannot conceive of a limb without tasteless indentations and convexities of the contour for each muscle that his knowledge of anatomy and his mathematical preoccupation with form taught him should be located at a certain place. In his free pen copies after Mantegna's engravings and Italian *tarocchi* cards it can be seen how the continuity of line is lost by his insistence upon fact and his greater knowledge of form, so that much of the charm of the originals vanishes

in his versions. His certainty and power seem to us often mere frigid brilliance and lack of taste, and it is quite maddening in looking over any number of Dürer's cuts to see how he cannot resist the temptation to give each line a flourish. His woodcuts show none of the felicity in the loose juxtaposition of data that is the charm of medieval design—ease, blitheness, good taste. He was too learned and ingenious an artist for that. Unerring, untutored instinct for style was as far from Dürer as any artist of the Renaissance, nor had he mastered the classical composition which his Italian contemporaries had reduced almost to a science. So that as a composer Dürer is not among the elect. He packs his designs with data till essential unity is lost in the wealth of elaborated details, of draperies wonderfully studied and insane with hooks and crinkles, or landscapes all crag and tree and curly weed in rank profusion.'

The Italians and the French have always possessed more sense of their material than the Germans and in the early days of woodcut they erred less towards using it as a reproductive medium. Among the French prints one series especially is worthy of study and that is the cuts for *Les Loups Ravissans*, page 179, published in Paris in about 1500. The last portion of the book is a type of Danse Macabre showing the triumph of death, and the print here reproduced shows a brigand murdering a traveller while death in the shape of a woman looks on. From the technical point of view it is astounding. It looks as if it had been drawn on the wood with the knife. The cutting is expressive in itself. It combines the colour of black-line and white-line cutting though the white line is perhaps more fortuitous than intended. It is not that the drawing is outstanding but the medium of the wood and knife work is used creatively and expressively without any reference to a design drawn with pen or chalk. It is as modern as a contemporary French woodcut. But this is really no more than a flash in the pan. From the sixteenth century onwards all woodcutting followed the trend of reproduction. The Italians, and above all the French, were the last to lose a sense of the medium and a great number of their cuts retain a feeling for the wood and the knife.

But the technique now became a trade plied by admirable craftsmen who reproduced with skill and vigour the designs that were given them to cut. The work is often extremely beautiful and the cuts, which were now used entirely for the illustration of books added enormously to their value. There is nothing which harmonizes so perfectly with typography as the black-line cut with all the subtleties which these craftsmen were able to produce in the manipulation of their tools. Set up in the same formes, inked and printed together with the type, it has the same character and the same colour as the printed page and has been responsible for some of the most beautiful books ever produced. But it is interpretative and reproductive and no longer an original and creative medium.

Papillon, the eighteenth-century French woodcutter, who published a treatise on the craft in 1766, was responsible for some five thousand cuts, mainly

headpieces and tailpieces. They are of great charm and dexterity and mostly designed by himself. But with their delicacy of line and curve they seem to imitate on wood a technique which is more applicable to metal. They were used in books illustrated with etchings and engravings and as typographical ornaments they are perfectly in accord with both the illustrations and the text, but as such the essential character of the woodcut is sacrificed.

The woodcut survived in the numerous popular cuts which were produced in quantities during the seventeenth and eighteenth centuries and peddled all over Europe. As these were more saleable when coloured they followed the original tradition and were purely in black line. But often enough they were shaded and made use of blacks. Crude and often badly drawn and poorly cut they were, however, expressive and the true sense of the medium is always present. Their production offered little temptation to the expert cutter, as the sale price was generally about a penny or so, and consequently the craftsmen who cut them produced their effects in the quickest possible manner with great economy of means. But they and they alone carry on the true tradition of the craft to modern times.

With the advent of Bewick, the end block and the graver, the woodcut in Europe came to an end and has only recently been revived as an aesthetic medium. As such the plank is not always used. Woodcuts are made on the end as well as the side grain. There is, in consequence, sometimes a difficulty in making a distinction between woodcutting and wood engraving. The characteristics of the woodcut are the knife, the plank and black line; the characteristics of wood engraving, the burin and other tools of the same class, the end-grain block and the white line. A certain coarseness and directness in the former is contrasted with delicacy and meticulous cutting in the latter. But there is no sharp line between the two. Woodcuts are sometimes almost entirely in white line, wood engravings can be pure black line.

It is in the cutting that the main distinctions are more obvious, and for our purposes it will be better to class as woodcuts all those prints where the knife and gouge have obviously been used or where the coarseness of the technique would seem to imply the use of these tools in the main body of the work. Where the use of the burin predominates, the prints will be classified as wood engravings.

Gauguin was one of the first contemporary artists to turn to the woodcut. In Tahiti he made his own blocks and tools and produced some of the most original and expressive work that exists. He not only cut the blocks but scratched, scraped and lowered the surface by various means to obtain his effects. Thus he combines black-line woodcut with white-line engraving. Gauguin believed that he was returning to the origins of the technique and this is true in so far as he used the medium as an original means of expression. There is some affinity between his work and that of the early Italians but his black areas are used in a different sense. What he did was to combine woodcut and white-line work,

adding the discoveries of the nineteenth century to the older technique. His cuts are a perfect combination of the two: the vigorous cutting with knife and gouge alternating with the delicate engraving, scratching and lowered grey surfaces provide the fullest contrast possible. They are, in consequence, extremely colourful and they were responsible for a better understanding of the medium with all its inherent possibilities and limitations.

Emile Bernard, Derain and Dufy, as well as Hermann Paul, have all produced original and expressive cuts in the true tradition. Maillol's illustrations for *The Eclogues of Virgil* and *Daphnis and Chloe*, page 187, are some of the most beautiful cuts of modern times. They are in pure black line which has wooden character full of expression which would be impossible to obtain in any other medium. The different treatment of foliage by Maillol and Hermann Paul makes an extremely interesting comparison. It has been objected that such black-line cutting today is a waste of time; that the same results could have been obtained with less trouble by making line blocks from pen drawings. To argue thus betrays a complete insensibility to the quality and character of cutting. No drawn line could naturally produce its harsh angularity and variety.

Masereel, a Belgian, used the woodcut with originality and vivid expression and invented the 'picture novel', a book consisting of a series of cuts without any letterpress and reminiscent of the primitive block books of the fifteenth century. The story moves with a continuity and speed characteristic of the early days of the cinema. His enormous output and lively imagination added to his direct simple statement achieved a world-wide reputation in the course of a few years. One of his cuts from his picture novel *The Idea*, reproduced on page 191, shows the extraordinary economy of means with which he achieved his results. Although the sense of these illustrations is essentially that of the woodcut, very little black is taken away and the expression relies on a minimum of white lines and planes in the black area of the block. This would seem to return it to the sense, if not the technique, of wood engraving but in fact it does not. The cuts remain essentially graphic, their power depending on the co-ordination of pattern and their expression on a purely arbitrary formula, which is nevertheless extremely telling. In all but Masereel's best cuts the result remains flat with a minimum of third-dimensional suggestion and in the end these picture novels become tedious. It is the story which counts and though here and there are brilliant cuts, the emphasis ceases to be aesthetic and the main interest lies in the movement.

The Germans have used the woodcut to a greater extent than other nations as it is more applicable to their expressionistic tendencies than the more delicate technique of wood engraving. The cuts by Munch and Nolde are well known and there are a host of others, sometimes admirable in their direct and vigorous statement. A good example is the cut, page 190, by Pietes, who is at present

Anonymous Italian woodcuts  above: *The Monk;*  below: *Æsop*

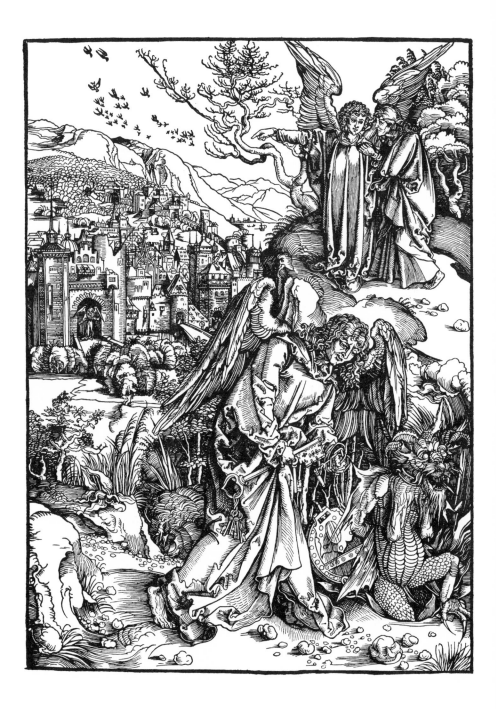

ALBRECHT DÜRER *Apocalypse XVI* woodcut $15 \times 10\frac{3}{4}$ inches

Anonymous French  *Les Loups Ravissans*  woodcut, actual size

BERNARD RICE *Rammuda* plywood printed on cotton 60 × 33 inches

living in England. Another expressionistic cut is Dykstra's lively print of the *Fête à Groningen*, page 193. Powerful and expressive as these cuts are, they are apt too soon to exhaust the emotion they arouse. Whereas one could hardly tire of the lovely print by Svolinský, from Czechoslovakia, where some exceedingly good work is done; or of Bernard Rice's magnificent *Rammuda*, page 180, cut on plywood and printed on cotton cloth. There is little to equal his rhythmic flow of line, the over-all pattern and the effect of light he obtains with underprinting. He has combined eastern and western techniques and has still managed to retain a unity of expression. The print by Pacheco is an example of the virile and direct work characteristic of much modern Mexican wood and lino cutting.

## COLOUR WOODCUT

Colour woodcut, as opposed to colour lino or colour wood engraving, is not much practised today. The reason for this is that wood is so far more expensive than lino unless the artist makes his own blocks. One of the greatest modern exponents is the Norwegian artist Edvard Munch. He was greatly influenced by Gauguin's work and, like the Frenchman, used the surface qualities of the wood in the broad flat printing areas to give texture and emphasis, as well as allowing the characteristic strokes of the knife and gouge to give expression to the drawing. His designs are conceived in terms of wood and the best way in which it can be worked so that the material itself dictates the expression.

He invented his own method of colour printing which was to saw the woodblock in pieces after it had been cut, so that the different portions could be inked and printed separately in different colours. The blocks were sometimes cut in two along the horizon or shore line or the figures cut out and a second printing of coarsely grained pine, lightly inked, printed over them. He sometimes used this method in combination with normally printed blocks and in his later work developed the method to virtuosity, using as many as seven blocks for a print.

Edgar Tytgat, a Belgian, after the first World War produced a long series of black-and-white cuts as well as many coloured examples. He is a natural primitive, unaffected and simple, and he cuts with loving sincerity the things nearest to his heart; scenes from his life in Belgium; his friends, children and imaginative and decorative illustrations. His colour work, where he mainly employs the three primaries, with overprintings for green and other combinations, contain a great deal of white paper. This simplifies the difficulty of colour relation and in a sense returns the print to the realm of the coloured line block. It is not colour block printing in the sense that the full range of the colours and their combinations are used to create a picture, but one where the blue line does duty for the black one and the effect is rather that of a line block with colour added. It is, however, a legitimate use and is capable of producing very beautiful results.

Derain's coloured woodcuts for Rabelais' *Pantagruel*, page 192, are by now

well known. His method is completely different from the normal one. In Europe it is usual to cut a separate block for each colour and print them as separate colours one over the other with more or less transparent oil colours. A yellow over a blue will thus produce a green and so on, so that a considerable range of colours can be obtained with a few blocks. It has been found, however, that when more than a few colours are superimposed the result becomes overloaded, oily and unpleasant. The artist is therefore apt to find himself limited to variations on the three primaries with a possible addition or two. With Derain's method it is possible to obtain any range of colour desired. Choosing a medieval formula of extreme simplicity for his designs, he cut them in white line with a knife or scrive and where necessary gouged the background away. The white lines, in general, delimited the areas of each colour or tone, which he then proceeded to paint in with a soft brush and oil paint, mixed with sufficient burnt linseed oil or varnish to prevent the oil from spreading. In this way it was possible to obtain any gradation of colour or tone and, by mixing sufficient colour beforehand, to ensure the same results over a long series of prints. The colours, of course, must be of the right consistency so that the first will still be wet when the last is laid and the printing must be done immediately before any colour has had time to dry. This method, obviously, does not lend itself to commercial production and for the few hundred copies of the Rabelais four girls were employed for two years colouring the blocks. The results obtained by Derain are astoundingly successful and beautiful but the method is really the old black line woodcut, coloured by hand, in reverse. In this case the white line is substituted for the black line and the colours are printed from the block instead of being added afterwards. However, even in Derain's blocks a tone of watercolour was washed over the whites of backgrounds and white lines to give more unity and add a suggestion of third-dimensional quality. There are great possibilities in this method for original work, its only handicap being the limitations imposed by the use of the white line between the colour areas.

There are in all seven different methods of producing colour woodcuts or linocuts if we include Derain's invention. Firstly, there is the Japanese technique, which is really a case of perfect co-ordination between three people, the draughtsman, the cutter of the wood blocks, and the printer. This type of co-ordination has, practically speaking, never existed in the West though the Japanese technique has sometimes been attempted by European artists, generally with disastrous results due, not to any fault in the technique, which is obviously sound, but to a complete lack of understanding of the underlying principles of Japanese art. The technique is to be found in many textbooks and water inks are now made for colour printing, hitherto the main technical lack in Western methods. The principles are best seen in their figure subjects, where the line is intensely graphic, with a rhythm and an abstract quality which is rarely met save in Eastern or Far

Eastern art. The result is never naturalistic but extremely formalized. The formulas, however, are never stereotyped and dead but always intensely alive, being constantly renewed and revitalized by acute observation from nature. So evocative are the Japanese prints, so vivid with a sense of reality and so full of an intrinsic life that we would expect to find their identical subject matter were we to visit Japan. Whereas, of course, they are as unnatural and as formal as the best Byzantine work and in some ways as powerful. This is true also of the best landscape subjects, but the underlying abstract poetry of these prints was completely misunderstood by the European practitioners of the technique. What they saw in it was a method of translating their own superficial problems of light and atmosphere with more natural truth than they could otherwise achieve. They generally picked on the one inartistic trick which the Japanese employed, that of graduating their colour on one block, to imitate, for instance, the lessening density of a blue sky; a practice which was in direct opposition to their normal use of flat colour which is the true application of the medium. The best Japanese work relies on the abstract qualities of rhythmic graphic line allied to flat pattern and colour, placed with unerring skill to create a complete aesthetic unity. The European examples, neglecting the fundamentals, aimed at a naturalistic rendering of atmospheric and ephemeral effects and are symptomatic of those unfortunate marriages of Eastern and Western conventions.

The second method of colour woodcut is the chiaroscuro cut in two or three tones of low colour value as practised in the Renaissance. These prints are, to our eyes, rarely satisfactory or of great interest. Their object was to create a greater illusion of modelling and the third dimension, which if necessary can be produced today with less trouble by wood engraving. There is nothing against the use of two-colour blocks of low value for producing a design in tone but the third dimension can be suggested by other means than the exacting method of modelling in two colours.

The third method is that of Edvard Munch, who obtained his effects by sawing up an engraved block and printing the portions in different colours, sometimes with overlays of lightly inked grained wood to form a background. Sensitively used the colours become constructive elements of the design and there is no necessity for a key block or one that supplies the drawing as in the majority of methods. It is curious that Munch's example should have been so little followed, as it is essentially one way of using colour constructively.

The fourth method is that initiated by William Nicholson in his series of *Twelve Portraits* and *London Types* produced at the beginning of the century. The principle of these cuts is their reliance on massive blacks. The black wood block is the main basis of the design and the colour, generally low in value or of small area is often merely an incidental addition. It is, however, possible to employ the most brilliant and varied colours provided there is enough black to

counteract any overpowering tendencies. The obvious example is the stained glass window which, even at its best, would often be unacceptable were it not for the heavy leading. Following the practice of Rouault there is a school of painters who surround their forms with heavy blacks or use black to counter-weight colour. Though at its best such practice is acceptable it is nevertheless an evasion of the main problem, which is to paint or print in pure colour, where black may have its place though a minor one.

In the same way the fifth method of colour block printing relies on the over-use of white as for example in the colour cuts of Tytgat. This also is an evasion of the problem. White isolates the colours and counteracts their force in the same way as does the use of black. The results of the use of black and white as counterweights are, of course, perfectly acceptable in these examples by Rouault and Tytgat, but intrinsically they do not present us with a solution of the problem and are two different forms of evasion.

The sixth method is that of Derain, and here again, though we are one step nearer the true colour block, there is evasion in the use of white lines limiting the colour areas and in the gouged-out backgrounds, though the addition of a water-colour tint on these is a tacit admission of the need for complete colour.

There remains the seventh and last method, which is to rely entirely on flat masses of colour, without shading, where overprinting supplies an infinite range of tone and value and where the sensitive juxtaposition of cold and warm, of brilliant and low-value colour can suggest the third dimension and where shape and pattern give the drawing of the constituent forms. There are many painters today who use colour in this sense. The names of Matisse and Klee will give the clue and suggest others who practise this type of painting. This is undoubtedly the true application of the colour block and in it lies its future. It is by far the most difficult of any of the methods, for to achieve complete success it is necessary first of all to be a good painter. But the painter has his whole palette from which to choose his colours whereas the artist who would produce a colour print in this sense has but three, perhaps four, and at most five, colours on which to play a complete symphony.

## LINOCUT

Linoleum today has to a great extent taken the place of the wood block for cutting. The technique is identical save that the wood offers more possibilities for delicate work, if this is the purpose of the artist. The same types of tool are used; knife, scrive and gouges; but the material is essentially different. It is softer, and, being of composite matter, can be cut easily in any direction. But it is friable; fine black lines unless carefully cut with good sloping sides break easily and unless the tools are perfectly sharp the edges of the cuts are ragged and fine white lines are apt to close up. It is used largely in schools for the artistic training

FERNANDO CASTRO PACHECO *Revolution* woodcut, actual size

HERMANN PAUL *Promenades* woodcut, actual size

right:
ARISTIDE MAILLOL
*Daphnis and Chloe*
woodcut
$3\frac{7}{8} \times 3\frac{3}{8}$ inches

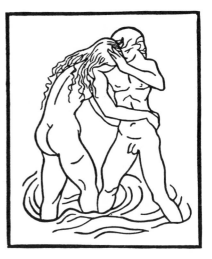

below:
ARISTIDE MAILLOL
*Eclogues of Virgil*
woodcut, actual size

187

HENRI MATISSE *Pasiphae* linocut, actual size

SVOLINSKÝ *Girl* woodcut, actual size          189

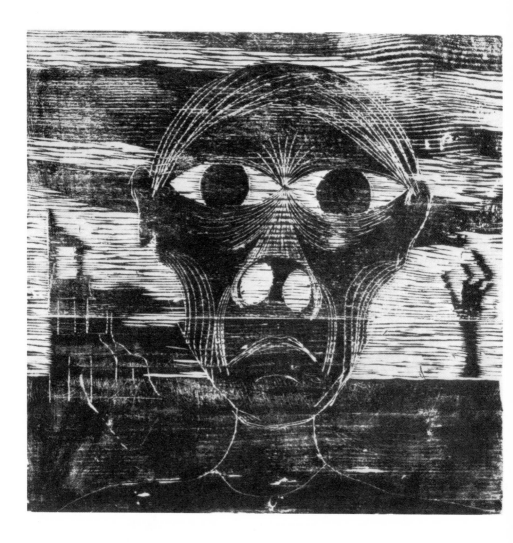

PIETES woodcut, $11\frac{1}{4} \times 11\frac{1}{2}$ inches

right:
FRANS MASEREEL
*The Idea*
woodcut
$3\frac{1}{2} \times 2\frac{1}{2}$ inches

below:
EDGAR TYTGAT
*Invitation au Paradis*
colour woodcut
$9\frac{3}{4} \times 11\frac{1}{4}$ inches

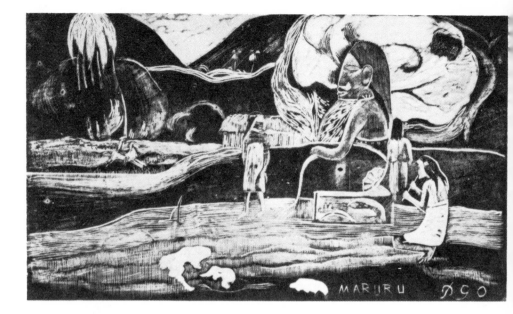

PAUL GAUGUIN *Maruru* woodcut 8 × 13¾ inches

below: ANDRÉ DERAIN *Pantagruel* colour woodcut

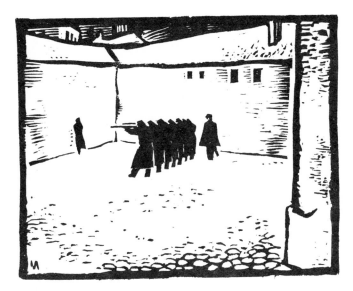

JOHANNES MULDERS
*Execution of Mata Hari*
woodcut, actual size

below:
JOHANN DYKSTRA
*e du 28 Août à Groningen*
woodcut 7 × 10 inches

FRANK MARTIN *Girl and Plants* colour linocut 16 × 11 inches

ALEX SALTO *Dancer* colour linocut

LAURENS *Dialogues de Lucien* colour woodcut $12 \times 8\frac{1}{2}$ inches

of the young and in this capacity is invaluable. But in consequence it is apt to be despised by many who should know better. It is, when properly used, an admirable material, and, if not as good as a fine piece of wood, it has the advantage of cheapness and easier working. The main difference between wood and lino is that the grain of each material imposes and, to a certain extent, controls the expression. On wood the gouging is easier along the grain and the cutting is apt to be bold and angular, making for directness and simplicity. Whereas on lino, where gouging and cutting are easy in any direction, the expression is apt to be more sophisticated, more subtle and serpentine.

Some admirable work has been done on lino in recent years. Matisse has used it for book illustration and one of his cuts is reproduced here. Matisse prefers it to the wood because he cuts directly into it without any previous drawing. In this way he obtains a freshness and a directness which might not be possible otherwise. If the result is not satisfactory he can throw the lino away without a second thought and start again until he has cut the design to his liking.

It is used more for colour work than black and white, but as yet the technique is in its infancy and the enormous possibilities of the medium for colour prints and illustrations have not been sufficiently exploited. Mounted type-high on a wood block it will stand up to good press work for several hundred examples. If a larger edition is required, or advised by the printer, line blocks can be made from the linocuts by electrotype, or by the usual line-block process from a black print from the cut for each colour.

The earliest woodcuts known are those used for repeat patterns on cloth. Both wood and lino are admirably suited for this type of applied design and far too little is done in this line. The engravers are too occupied with the making of prints and the designers do not seem to have realized the immense possibilities of the original cut. Cloth and other suitable material can be printed with oil or specially prepared washable textile inks in a press, or the cut can be pressed on by hand, hammered or trodden with the foot. In the latter cases, if lino is used it will have to be backed with wood or plywood.

The majority of colour prints from lino and wood made in this country suffer from the fault of attempting to obtain a three-dimensional effect by modelling and chiaroscuro and using colour at the same time. Colour and chiaroscuro never work well together; one or the other predominates to the detriment of the second. The colour printed from lino is flat and it would be better used as such with the sensation or suggestion of the third dimension obtained by the subtle placing and combination of colours as in a great deal of contemporary painting. As it is, either black or grey is used for the drawing and the colours are low in value, pale and ineffective. The result is hardly a colour print in the contemporary sense but a recrudescence of the old chiaroscuro print of the Renaissance, when modelling was obtained by the use of two or three low value or dull

colours. The contemporary use of colour, especially as employed by such artists as Matisse, should be sufficient to point the direction in which these prints should develop. Brilliant colours, carefully chosen and composed, can be made to evoke form, space and recession and are infinitely preferable to the tinted black cut.

Even as few as three colours used as flat masses or textured and with judicious overprinting can be made to give a considerable range of colour, tone and variety, quite sufficient to give all the sensation of a third-dimensional design. Black, if it is used at all, should be used as a colour and not, as is so often the case, to delineate and circumscribe the design. A good way of obtaining a pure colour print is to use a method attributed to Vuillard for making his lithographs. A key block is made in black and is used for drawing and registering the subsequent colour blocks. But in the final printing the black key block is omitted and the colours, instead of acting in a subsidiary capacity, become constructional with infinitely more telling effect. Too much overprinting is apt to produce an over-realistic result which is foreign to the proper use of the material, besides tending towards an unpleasant shiny and overloaded effect. Prints from lino should rely mainly on flat masses, textures and line, both incised and in relief.

Most artists will sooner or later discover the method of working which suits them best, but to express an idea in the true sense of the material it is better to avoid working from a fixed preconceived design, which is apt to lead to mere reproduction. Starting off with an initial conception, lightly engraved, each proof should suggest the next step and the finished idea only evolve as the work proceeds. This is the procedure advocated by S.W. Hayter when doing creative intaglio work on metal, when the conception and the technique remain a unity and are not divorced as in so much reproductive work.

On looking at the colour prints of Leon Underwood it is possible to deduce that he works in a somewhat similar manner. Using a scrive or a fine gouge he would appear to draw the main shapes of his design on some four or five sheets of lino. Then inking them up with different colours he experiments by wiping out areas of ink before printing. In this manner the main masses of each colour, their relations and overprintings, can be determined without taking the irrevocable step of gouging. When the final decision is made, the different blocks are cut and subtleties and detail added as suggested by each subsequent proof.

Another method on these lines, known as the 'elimination process', is taught in some schools, notably by John Newick. Children draw or paint, preferably straight on the lino and cut the design as far as they think fit. Prints are then taken in colour and the lino is again cut, inked with a second colour and superimposed on the first set of prints, and this is repeated until the desired effect is obtained. In this way the material is purely creative, as the original drawing is lost at the first inking and each step, as the work proceeds, suggests the further development of the design.

# *Technique*

Wood: plank
Knife: preferably Japanese type
Scrive: not strictly necessary
Machine oil

Gouge: Medium or one broad and one fine
Sharpening stones: carborundum and arkansas

## TECHNIQUE

THE WOOD used for cutting should be plank but it can of course be end grain if preferred though the latter is far more expensive, and in this case unnecessary The best woods are any of soft even grain, such as pear, cherry, lime, maple sycamore or American white wood. When bought ready polished it is usually type high for printing in a press, but if only hand-burnished proofs are to be taken it can be anything between half and three-quarter inch high. It is quite easy to make the blocks oneself. An American student used the ends of orange boxes, sandpapered down and polished. Harder woods make cutting difficult and woods where the spring and autumn rings vary a great deal in density make the cutting uneven unless the tools are extremely sharp. But these latter if sandpapered print the grain of the wood, giving an agreeable background texture.

THE KNIFE. The small blade of an ordinary pocket-knife is quite serviceable if string is bound round it to protect the fingers and prevent it shutting up. A surgeon's scalpel is also an admirable tool. The most usual one and that sold for the purpose is the Japanese knife, a thin blade about a quarter-inch wide and three inches long fixed in a handle. It is bevelled and sharpened at an angle of $45°$. Papillon in his book on woodcutting published in 1766 recommends watch springs, tempered, cut and sharpened to an angle in this way. They are obviously eminently suitable for fine work.

THE SCRIVE. This tool is not strictly necessary but is useful. With it as with a gouge it is possible to cut a white line in one instead of with two strokes as with the knife. It is the wood carver's V tool, a sort of hollow burin with the pointed cutting edge set back slightly from the top edges. Properly sharpened it is possible to cut across the grain as well as with it.

GOUGES are either hollow, the usual type for woodcutting, or solid as for wood engraving. In this case only the rounded type is used and the hollow ones are preferable. When razor sharp they will cut across the grain. But the general practice is to cut only with the grain which makes for unity in the final result as well as being easier. Solid gouges have a tendency to lift the fibres of the wood when cutting in either direction and will almost invariably do so across the grain.

It is best to have at least two, a fine one for producing greys and a broad one for clearing away large areas.

SHARPENING. Two stones are necessary to sharpen the knife, a carborundum, not too coarse, for sharpening, and an arkansas for honing. The bevelled side of the blade is laid flat on the stone and rubbed back and forth with a plentiful supply of oil till perfectly sharp. The burr on the edge and the scratches left by the rough stone are then polished off on the arkansas. Oil should always be cleaned off the arkansas stone after using, as it does not penetrate the stone and is apt to dry and form a coat. Linseed oil should never be used, but only a good mineral or machine oil. The hollow V tool, or scrive, as well as the hollow gouges are far more difficult to sharpen. Their outside edges must be rubbed carefully on the two stones till absolutely sharp and a slip stone used to take off the burr on the inside edge. A slip stone is a wedge-shaped stone, generally aloxite, sharp on one side for the scrive and rounded at the other for the gouges. Practice is the only means of becoming a good sharpener of these hollow tools.

DRAWING ON THE WOOD. To put the drawing on the wood the same method is used as for any other form of engraving. It can either be drawn direct on the plank, which has an agreeable surface for lead pencil, or the drawing can be traced, either the main lines of the composition only so that the knife takes up where the pencil left off, or the whole drawing. As the knife and the gouge have distinct limitations it is not likely that the original drawing will be reproduced as in the case of wood engraving, so that there is no reason why a complicated drawing should not be drawn out in its entirety. But as usual it is better to leave most of the expression to the knife and not follow a preconceived idea made in another medium. So as to get the sense of the technique it is useful to go over what has been drawn in pencil on the wood with indian ink. The plank can then be darkened with printing ink, which is then cleaned off allowing the ink lines to show through. Each cut on this dark ground shows up white and the sense of drawing in white on black need never be prejudiced.

CUTTING. Most schoolboys at one time or another have cut their names on wooden desks or walls. The cutting on the plank is no more difficult than this. The width of the line to be cut will determine to a certain extent the angle at which the knife is held. For broad lines the angle will be about 45°. For finer lines it is held almost perpendicular. Lines should never be undercut or they will break under the pressure of a press. The angle of the knife should cut away from them. Curves in any direction are easily cut after a little practice. It is best to complete all the main work with the knife before starting to use the gouge. The cuts with this tool can then be made into a trough already cut without the danger of going too far. Alternatively the tool can be lifted out of the wood by depressing the handle, making a rounded spit-like end to the cut.

This is one of the simplest forms of engraving, as the material and tools do not easily lend themselves to a complicated technique. Their limitations should be kept in mind and should dictate their use. The engraver should draw with the

knife and gouge as he would draw with any other instrument in another medium and above all he should not attempt to reproduce his original drawing. By looking at early Italian prints he will find most of the variations of technique that he may require and by adapting these to his requirements he can invent his own. For rhythm and variety of pure line he cannot do better than look at the Japanese, always providing he adapts and does not imitate.

PROOFING. If the main lines of the design have been put in with indian ink it is possible to take working proofs from the block as the work proceeds without losing the drawing. This is best done by inking the block with black proofing ink and roller and placing it face down on a smooth soft paper, such as India or Japanese tissue when it is available. The block is then turned up again and the surface burnished with a burnisher or the back of a teaspoon. If the artist is doubtful as to the effect of the next series of cuts or whites to be gouged out, these can be cut out of the proof with the knife and the general effect will then dictate the further cutting.

MISTAKES. As in wood engraving, there is, in effect, no easy remedy for mistakes. A bad mistake will have to be plugged and recut (see Wood Engraving). Sometimes it is possible to build up a small wrong cut or a break with plastic wood, but the result is not reliable unless the prints are carefully burnished by hand. Before plugging or plastic wood is employed it will be advisable to see whether the mistake cannot be incorporated in the design. If the mistake is small and plastic wood unavailable or difficult to use, the prints themselves can be corrected with a pencil point dipped in a little proofing ink. But this is no remedy if the block is to be printed in considerable numbers in a press.

OFFSETTING DESIGNS FOR COLOUR BLOCKS. When making colour prints from wood or lino a 'key' block should be selected on which most of the design or all of it appears. The design can, of course, be traced off on to the other colour blocks for engraving but this is an unnecessarily tedious process. The best method is to engrave or cut the key block and take a print of it with plenty of black ink. The second block is then fitted carefully over the print, face down, and the design offset, or printed back, on to it. The offset should be allowed to dry for at least forty-eight hours, or may be fixed with fixative and a diffuser, to prevent smudging while engraving the block. If the key block has been cut with more of the design on it than is required for printing, the excess work can be cut away after the offsets have been made on the remaining colour blocks. On lino the ink from the print will offset more easily if it is wiped over with a rag and turpentine.

## LINOCUT · MATERIALS

Linoleum
Tools: knife, scrives and gouges

Sharpening stones: carborundum,
arkansas and slip stone

## TECHNIQUE

LINOLEUM for cutting should be of good quality, close grained and at least one-eighth inch thick. It should be strong and stiff and not too pliable. In practice it is possible to cut on almost any lino provided it is not the inlaid type but the softer sorts should be avoided. Compressed rubber is another good substance.

TOOLS. Lino cutting tools are made in solid steel, like wood engraving tools, and fitted to handles, or they can be bought very cheaply in the form of steel nibs with a wooden holder. The former are obviously preferable but the latter are serviceable enough. They comprise a knife, various widths of scrive or V tool and the gouges, which also vary in width and are either round or square. All these tools are difficult to sharpen but a little practice will overcome this difficulty. The nibs are cheap and can be replaced if damaged but the holders wear away quickly in the slot which takes the nib where all the pressure comes.

THE CUTTING is precisely the same as for the woodcut save that cuts can be made easily in any direction, as there is no grain. The composite character of the material also allows the engraver to flick out spits and dots with the scrive and gouge, which is not practicable on wood, and the work in general is infinitely easier and quicker. Blunt tools make ragged edges to the cuts and, as on wood, are apt to slip with sometimes disastrous consequences. Lowered areas should be cut as deep as possible if they are not to print in a series of dots and irregularities, but these are sometimes useful for variety, especially in colour work.

MISTAKES. There is no practical remedy for mistakes. Unless a false cut can be incorporated into the design it is best to follow Matisse and throw the lino away and start again.

RAOUL DUFY  *La Carpe*  woodcut $4\frac{5}{8} \times 4\frac{3}{8}$ inches

# WOOD ENGRAVING · *Theory*

Engraving on wood implies the use of the burin, which is the same as that used for metal, and the end grain or cross-section of the tree. The cross-section allows the burin or gouge, or any variation on these tools, to travel in any direction without lifting the fibre as they would do on the plank. Its principal characteristic is the white line. An engraving on wood should be a drawing in white on black, and though the black line may usefully be employed for variety and colour, it is the white line which gives the technique its unique peculiarity and not to employ it is to lose a sense of the medium.

Thomas Bewick has often been credited with the invention of white-line engraving on the end grain. The method had in fact been used for some time, but Bewick was the first to use it with originality and to show the enormous advantages and possibilities of which it was capable. Above all he was, for the most part, the designer of his blocks instead of being a mere reproductive engraver. He made his engravings consist as far as possible of white lines and got his effects by variation of the line rather than by any imitation of penwork such as cross-hatching. It is probable, however, that he did invent such subtleties as lowering and overlaying. The first consists in shaving down and lowering the surface where silvery greys are wanted and then engraving them. The result is that they take neither the full amount of ink from the roller nor the full pressure of the press, and print naturally a light grey. As if this was not enough he invented the overlay, which consists in cutting out the dark portions of a first proof and pasting them on to the tympan of the press over the relevant blacks, to increase the pressure, and so obtain a fuller black than would otherwise be possible. In this and other ways Bewick was able to obtain a wonderful variety of colour, but he had to train pressmen to follow his advice, even to wiping away some of the ink on a delicate grey portion before each print was taken. Bewick's *Fables*, *History of Quadrupeds* and *History of British Birds* are well known. His popularity today is almost as great as ever in Britain, but it owes a great deal to his meticulous technique and to his subject matter, natural history, both of which are always favourably received. His best and most original work, and where he was perhaps most the artist, is the long series of little head and tail pieces where he depicted scenes from the country life he loved. But if we compare his work to the few wood engravings made by William Blake for Thornton's *Virgil* he falls into his place as a little master.

Blake's designs, cut by himself, are little gems of silvery poetry. As pure technique, from the craftsman's point of view, they are not outstanding and as Dr Thornton, like many who can recognize technique when they cannot recognize art, pointed out apologetically, 'They have less of art than genius'. Art, in this context, means of course, craftsmanship; which seems a little curious seeing how good a craftsman Blake was on metal. But this is a classic example of how far more expressive a little crudity may be, when it comes to technique, than the most meticulous engraving, providing the conception is aesthetically adequate. Had Blake cut these designs with more craft, it is possible that they would have lost in their expression, that their beautiful luminosity and silvery quality would have been lessened. The design for the engraving reproduced on page 205 which has already lost the complete rhythm of the composition by being cut down, was later recut by a commercial engraver with 'improvements'. It immediately becomes ordinary and dull and by comparison with Blake's engraving, inexpressive and dead. Whether these blocks are, as Mr Geoffrey Keynes has said, 'in nearly all respects the most completely satisfying woodcuts ever executed' is a matter of opinion, though one or two of them certainly come very near that category. Their great charm is due to their complete simplicity and the direct, unaffected contact of the burin with the wood block.

One of Blake's followers, Edward Calvert, produced a few amazingly competent and perfect little engravings, which have rarely been surpassed for technique and content. But they must rank lower than Blake in that the purely aesthetic qualities of design and expression are not as complete. They are perhaps more the result of a cool romantic thoughtfulness than something fired with the white heat of inspiration.

Bewick, by his original and inventive craftsmanship had shown what the end block and the burin were capable of producing, and he is responsible for the whole history of reproductive wood engraving of the last century. His pupils came to London and set themselves up as professional engravers, and from then on the craft became a trade for the reproduction of drawings by other hands. It was developed to the furthest extremes. The artists either drew direct on the block itself with ink, or their design was pasted on to the block and the engraving cut through it. It was not until the camera was in general use that the drawings could be preserved. Some of the best illustrators of the period drew for the engravers; Keene, Rossetti, Millais, Holman Hunt, Leighton, Pinwell, Sandys and many others. But none of them, except perhaps Sandys, had the slightest conception of the sense and limitations of wood engraving and drew as the spirit moved them, expecting a faithful reproduction of every pen-stroke or a competent rendering of their wash drawings. Despite Rossetti's protests at the mutilation of his drawings by the engraver—and no craftsman who ever lived would have been able to satisfy him—most artists were delighted with the

EDWARD CALVERT  *The Ploughman*  wood engraving, actual size

THOMAS BEWICK
*Fox*
wood engraving
actual size

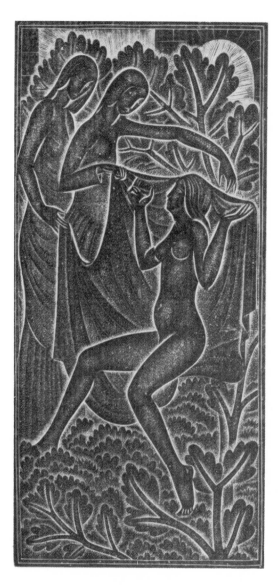

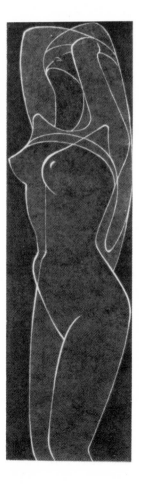

ERIC GILL  *Cranach Press Song of Songs*
wood engraving, actual size

right, above:
LUCIEN PISSARRO  *Eragny Press Mark*
wood engraving, 3 inches diameter

right: JOHN BUCKLAND-WRIGHT  *Girl Disrobing*
wood engraving, actual size

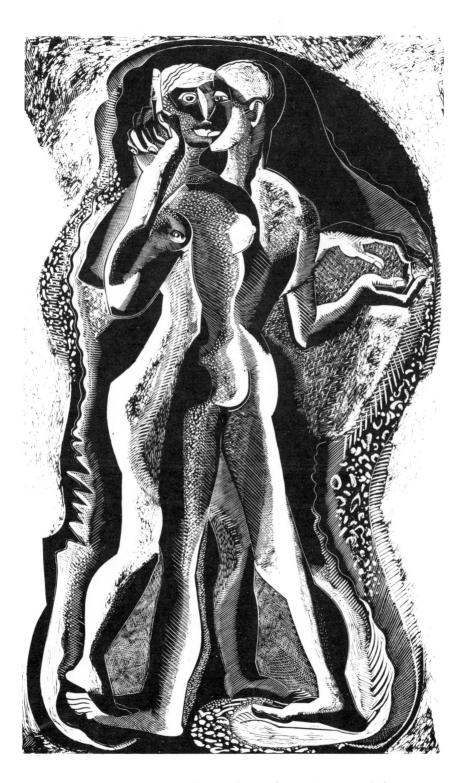

GERTRUDE HERMES  *Two People*  wood engraving 20 × 12 inches     207

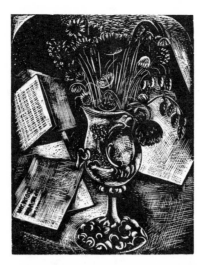

PAUL NASH
*The Bouquet*
wood engraving
$4\frac{3}{4} \times 3\frac{3}{4}$ inches

below:
*Black Poplars*
wood engraving
$6 \times 4\frac{1}{2}$ inches

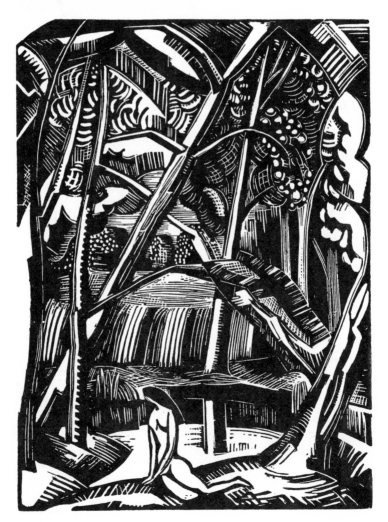

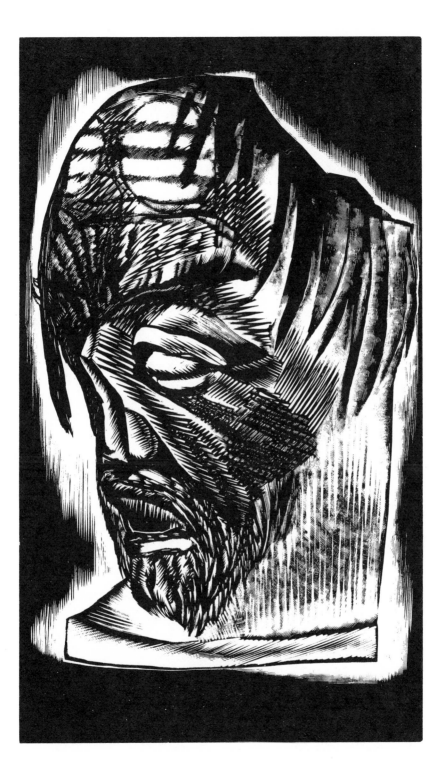

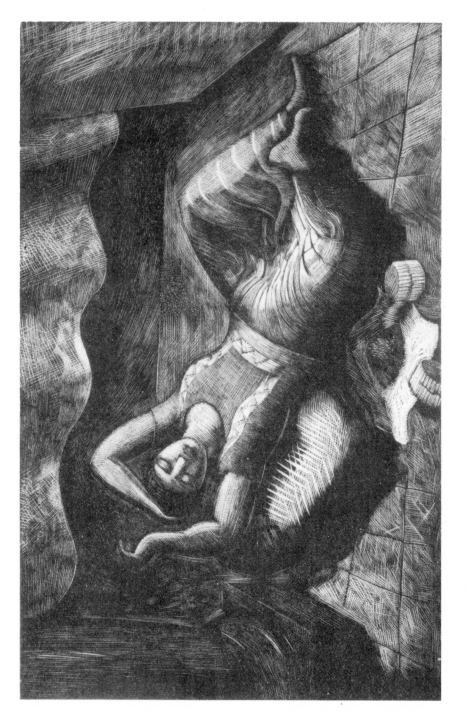

LEON UNDERWOOD  *Tobacco Girl*  wood engraving 5 × 7¾ inches

BLAIR HUGHES-STANTON *Composition* wood engraving $6\frac{3}{4} \times 11$ inches

JOHN O'CONNOR  *Autumn Encounter*  wood engraving $6\frac{5}{8} \times 5\frac{1}{8}$ inches

GEOFFREY WALES *Bright Morning* wood engraving 6¼ × 7½ inches

213

CLIFFORD WEBB *Fossils* colour wood engraving $13 \times 8\frac{3}{4}$ inches

JOHN FARLEIGH *Dead Willow Herb* wood engraving 9 × 6 inches

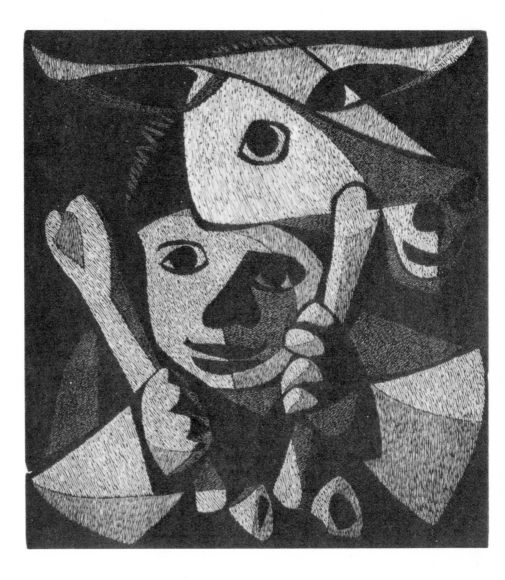

RODERIC BARRETT  *Ass and Man*  wood engraving 7¼ × 6¾ inches

opposite, above:
KANDINSKI  *Kleine Welten*  colour wood engraving 9¼ × 10¼ inches

opposite:
CHARLES QUEST  *Still Life with Grindstone*  wood engraving 9 × 12 inches

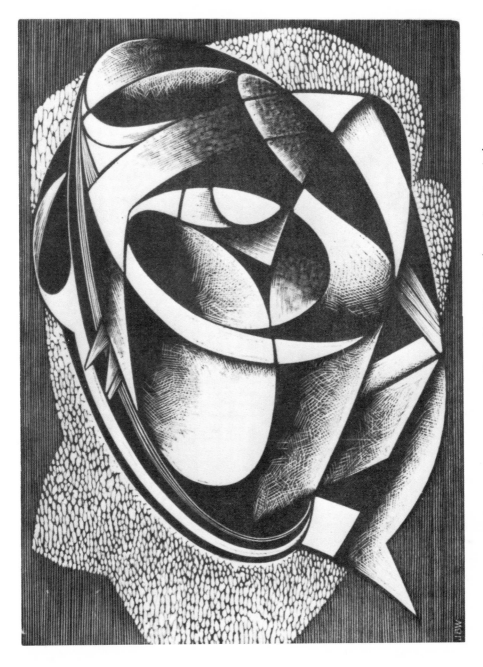

JOHN BUCKLAND-WRIGHT  *Composition No 6*  wood engraving 5¼ × 7 inches

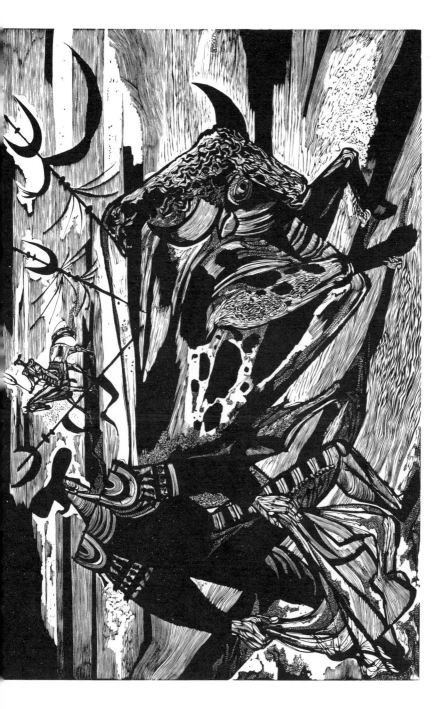

MISCH KOHN  *Bullfight*  wood engraving 15½ × 23¼ inches

below:
REYNOLDS STONE
*Church*
wood engraving
actual size

above:
PAM REUTER  *Ex Libris*
wood engraving, actual size

below:
IAIN MACNAB  *London Mews*
wood engraving, $4 \times 5\frac{3}{4}$ inches

GEORGE MACKLEY  *The House by the Lake*  wood engraving 5 × 6 inches

below: SEIDL-BRUDI  *The Sleigh*  wood engraving, actual size

LYNTON LAMB
*Illustration*
wood engraving
6¾ × 5 inches

right:
KARL ROSSING
*Odyssey*
wood engraving,
actual size

JOHN BUCKLAND-WRIGHT  *Three Bathers*  wood engraving $6\frac{1}{2} \times 4\frac{3}{8}$ inches

JACQUES BOULLAIRE *Pont Neuf* wood engraving, actual size

incredible skill with which their drawings were reproduced by the great work-shops, such as Linton's and Dalziel's, which were set up to cope with the spate of illustration.

In France the prodigious output of Gustave Doré, who produced no less than 119 illustrated books, kept a dozen or more engravers constantly employed. Engravers so servile that when the artist, tired of putting in a long series of windows, wrote 'etc', meaning the engraver to continue them, he found that his 'etc' had been carefully engraved in place of the absent windows! Doré's counterpart in Germany, Menzel, also required the complete self-effacement of the engraver, expecting him to reproduce the varying thickness of the finest and most flexible pen-stroke, so that it is often difficult to realize that it has been necessary for the engraver to approach it from two sides with laborious care. It was due to the exigencies of such artists that facsimile engraving reached the peak it did. It is needless to add that such reproduction, insensitive and mechanical as it was, was infinitely preferable to the careless and inefficient line-block making of today, which often produces a travesty of the artist's work in twenty-four hours.

All the weekly drawings in *Punch* and the *Illustrated London News* were cut on wood. For the latter, as well as for many periodicals, the block was often separated and each engraver cut his own speciality, whether it be skies, figures, foliage or architecture. The pieces were then bolted together and related by the most expert engraver of all, the finisher.

Wood engraving was the one reasonably cheap form of reproduction, but after the invention of the process block the engravers produced even more astounding *tours de force* in a desperate effort to retain their livelihood; repro-ducing half-tone effects with quite incredible dexterity. The apogee was perhaps reached in Timothy Cole's reproductions of paintings, where everything is translated by the most minute and meticulous engraving into soft silvery effects completely foreign to the sense of the medium. There is sometimes an excuse for the interpretation of a work into another medium; there is none for this type of reproduction, the rendering of tone in a line technique with photographic accuracy, however marvellous it may be from a purely technical aspect.

While Bewick's technical prowess had fathered the school of reproductive engraving the work of Blake and Calvert was forgotten and it was not until 1891 that the latter was reintroduced to the British public in an exhibition at the British Museum. This event made a deep impression on several artists and gave birth to original wood engraving in this country. The illustrations by Ricketts and Shannon for their *Daphnis and Chloe* was the first snowdrop of a long season which has now passed into late summer.

Bewick's contribution to contemporary wood engraving was the acceptance of the wood block as a black plane, as the basis out of which the design was to

be cut. This conception means that the engraver proceeds to subtract from the block, cutting it away, slowly revealing, and finally leaving, the design in its entirety. It is what he leaves that counts after the useless wood has been removed. This is the contrary to engraving on metal, black line on white, for then it is what the artist cuts that makes the design. He adds, slowing building it up to completion. In these two methods there is a strong parallel to carving, which is subtracting, and to modelling, which is addition.

Another way is to regard the wood block as a three-dimensional black void, in which each touch of the burin lights up and reveals a little more of the design. This makes a further contrast with line work on metal in that in the latter it is the line itself which is expressive and consequently the result must or should be purely graphic. In wood engraving, on the other hand, although white, purely graphic, line has been used, the normal technique is much more a matter of planes. It is more akin to painting; as though the artist were using light colours on a dark canvas. With his burin as a fine-pointed brush, and his gouges as broad ones, he delineates, stipples in his greys and brushes in boldly his masses of white. The result is a series of planes, a pictorial conception, in which a three-dimensional illusion is given to the two-dimensional plane of the print.

This effect of light slowly revealing the complete composition, this three-dimensional illusion given by the white line and subtracted planes on the black surface of the block is the true characteristic of wood engraving. In the same way the graphic qualities of the black line are the true characteristic of the woodcut.

Necessarily these two conceptions are often combined in the same print. In fact more vivacity and colour are obtained in prints where this is the case. But when Ricketts and Shannon began engraving their original designs on the wood in the 1890's, they, in common with William Morris and others, turned to the early Italian or German woodcuts as a model. Their work, mainly in black line, is occasionally relieved with blacks and white-line passages; as were Lucien Pissarro's illustrations for his Eragny Press publications. It was Sturge Moore, Gordon Craig, Gwendolen Raverat, Noel Rooke and others who first followed in the footsteps of Bewick, Blake and Calvert. Eric Gill used both white line and black line. He was a master of decorative line, but a line which is outline and not contour. Gill's engravings are perfect as book decorations in that his line is calligraphic, beautifully written, and as two-dimensional as the type faces they adorn. There is no jolt from the printed page into the third dimension of a pictorial illustration. He criticized a young engraver for his figures 'lit by candlelight', but his own for the Cranach Press *Song of Songs* and elsewhere were outlined in a phosphorescence of minute white cross-hatching, and remain flat, or at best bas-reliefs, in spite of internal modelling with tiny dotted work. He was an intellectual craftsman who adopted a Byzantine mannerism. But at his

best the white heat of his intensity fused his defects into a nobility of conception that we gladly accept.

One of Gill's pupils, David Jones, started by adopting some of Gill's mannerisms and Byzantine atmosphere, but he was too much of an artist to be long influenced and during his all too short practice of the technique produced some very beautiful and extremely personal engravings typical of one of the finest and most sensitive artists in Britain.

From the teaching of Gordon Craig, Noel Rooke and Eric Gill sprang a host of engravers after the first World War who were to make the history of the technique in Britain. Most prominent were Robert Gibbings, Paul Nash, Leon Underwood, Iain Macnab, Blair Hughes-Stanton, Gertrude Hermes and Eric Ravilious, who was killed in the second World War but whose genius for decorative design still remains outstanding. Most of the best exponents have at some time or another belonged to the Society of Wood Engravers and as such are widely known both for their prints and book illustrations.

In France the technique had been rediscovered by Auguste Lepère and Gusman, who founded the Société de la Gravure sur Bois Originale before the first war, and an enormous impetus was given to wood engraving by its use for book illustration by such editors as Léon Pichon and Pelletan. But the French do not possess the technical precision of the British and in general are more impatient of the niceties required by white-line engraving. Most of their work is direct and simple, depending perhaps more on the black than on white line and suggestive more of the woodcut than engraving. In consequence the new technique produced few outstanding practitioners and the enthusiasm of the public was quickly killed by the mass of mediocre work which decorated a host of cheap literary productions. From 1920 onwards artists in every country took up wood engraving and it would take several volumes to give any adequate survey of their manifold activities.

The technique of white-line engraving has been explored almost to its limits. In the early days, the pleasure of engraving on beautiful end-grain boxwood blocks and the juicy blacks produced in the print led to a great deal of work where black predominated and was misused. Douglas Percy Bliss in his *History of Wood Engraving*, published in 1928, suggested that engravers should learn from the old reproductive engravers and take as much pains to study their craftsmanship as any other. This was good advice and still remains sound. But in those days there seemed to be a spate of good designers who were apt to ignore the fuller possibilities of the medium. Today it is almost the reverse. There are plenty of good technicians who have either little aptitude for original design or nothing new to say. The lessons of Rooke, Gill, Ravilious and others have been well learned but the subject matter has become repetitive, and in the occasional exhibitions of prints or in the books that publish wood engravings,

one looks in vain for something new either in technique or expression among the younger exponents.

A great number of books have been illustrated in this country with wood engravings, the only purely original work which can be printed at the same time as the type, due in large part to the example of the Golden Cockerel Press under Robert Gibbings, and later under Christopher Sandford; of the Gregynog Press and many others. Engravers owe an immense debt to such presses which produce work which is often unsuitable for commercial publications. Such ventures keep the art alive and vital as the French *éditions de luxe* have kept etching and engraving alive in France. But in the opinion of some it is the use of wood engravings as illustrations which has killed them as prints. There may be a certain amount of truth in saying that collectors of prints were averse to paying two or three guineas for one example of an artist's work when he could obtain ten examples in a book for the same price. But if this was the case, the so-called collectors, who are to all intents and purposes non-existent today, did not show much sensitive appreciation: the 'free' print should be the result of some vital aesthetic experience for which the artist must find expression. An illustration, on the other hand, though it may possess at its best the qualities of a free print, is more likely to be on a different aesthetic plane. It must necessarily be controlled to a certain extent by the fact that its natural position is between the leaves of a book and that any possibilities of its existence apart from the text must sometimes be in direct opposition to its purpose. Also the print pulled by an artist must, except in exceptional circumstances, be a more perfect production than one printed with the type at second hand, though there are exceptions where an expert pressman has been able to achieve a better result.

The lack of interest shown in prints today comes more from the fact that, since the war, there is a general need for the more emotional appeal of colour. Also public taste in art is, unfortunately, more a matter of fashion than of genuine appreciation. In the 'twenties original wood engraving was something new and therefore something exciting. Today it is no longer new and if it is to sell, the print must sell on its intrinsic merits. In wood engraving, as in any other art, the technique should not obtrude itself beyond the expression of the subject matter. That is, the means should be subservient to the end. The moment that the meticulousness or crudity of the technique forces itself on the attention it must detract from the expressive qualities of the print. It should be adequate, but never insistent. *Ars est celare artem*, art is the concealment of artifice or skill, is as true today as it ever was, but not sufficient attention is paid to this truth in an age where surface texture has become a fetish. In wood engraving especially, where several different sorts of tools are used, each with its characteristic effect of cutting, it is only too easy, and to the craftsman too tempting, to make expression more important than content. Throughout the history of the

technique what first strikes the consciousness in the best prints is what the artist is saying, not how he has said it. The latter is a purely secondary analytical consideration which may be enjoyed after the imagination has been released and satisfied by the former. The general public should rarely, in fact, ever become conscious of the means. It is only the artist who analyses. So that when the beauty or crudity of the technique is the first thing noticed in a print and in so far as it intrudes itself on our consciousness, the print as an aesthetic unity is a failure.

There are prints whose cutting shows incredible dexterity and love of the medium and there are others where the medium seems to have been used with crudity and almost carelessly but where the content is so insistent, so successful, that the technique is submerged by the content and takes its proper place as a means almost indistinguishable and inseparable from the end. These are the really successful prints, and outstanding among those of today are the engravings of Paul Nash. His cutting was as crude as Blake's but the prints of both possess a magic, an inexpressible quality which lifts them into the category of great are where analysis and criticism fail to follow.

Among contemporaries there would seem to be two main categories; those who follow Blake, whose engraving is direct, expressive to the point of being expressionistic, and sometimes even coarse; and there are those who follow Bewick or Calvert with a meticulous love of the craft. Among the former are such engravers as Gertrude Hermes, Leon Underwood, Macnab, Farleigh, Kohn etc; among the latter, Mackley, Reynolds Stone, the Dutch engravers such as Pam Reuter, and many others. Between these two extremes are a host of engravers who combine these qualities. But of recent years the technique has not shown much sign of adapting itself to more contemporary vision, except by such as Misch Kohn and Robert Quest, both Americans, and Roderick Barrett in Great Britain. The general tendency is on more traditional lines, which may be partly due to the fact that painters in general do not take to wood engraving as they do to etching and to the more direct technique of the woodcut. Nor is there the example of the School of Paris to act as a spur as in these latter techniques. Nearly all the great painters of the Paris School have practised etching or line engraving at some period. A few such as Derain and Dufy have taken to the woodcut but practically none to wood engraving. There is something meticulous in the technique which appeals to the Germanic strain and its best exponents are found in Britain, Holland and the United States; though every country has produced excellent exponents in recent years.

There is another form of wood engraving which has recently reappeared: that is reproductive engraving. When Imre Reiner's prints were first seen in this country they were hailed as a new phase of original wood engraving. They are, of course, nothing of the sort, but the translation, in terms of wood, of his

brilliant pen and wash drawings. Reiner and his followers are merely doing for themselves and others what the reproductive engraver did for artists in the last century, and what Aubert did for Rouault in translating his gouaches into printable form for Vollard's books. How capable such work may be can be seen in the engraving after Seidl by Brudi from Germany on page 221, but such work is the antithesis of the true sense of engraving.

# Technique

## MATERIALS

Wood block: end grain—boxwood, pear, etc.
Burin: lozenge in section
Spitstick: medium
Tint tool: fine
Scaupers: square and rounded

Pen and ink: indian ink
Carbon paper
Sharpening stones: aloxite and arkansas
Oil: machine
Roller: six-inch composition
Proofing ink

## TECHNIQUE

THE WOOD BLOCK. Boxwood is undoubtedly the best wood for engraving and for very fine work only the best Turkey boxwood should be chosen. Coarser work can be done on the softer West Indian box or on any soft, even-grained wood such as pear, holly, cherry or maple. The best boxwood is expensive and should be of even colour without blemishes with close even rings of growth. Only an expert can tell the exact quality of a block. The blocks are usually sold type-high but can be resurfaced two, three or even four times, so that the expense of a good block need not be as high as it appears. Maple is apt to be unpleasant in that there is more difference in hardness between the spring and autumn rings, making the cutting uneven.

End grain blocks are very subject to damp and temperature, even when well seasoned, and are apt to split and warp. Large blocks are, in consequence, generally composed of small ones glued and tongued together. They should be kept on their sides in a dry even temperature. A block left in the sun for a few hours will often split or open at the joints.

In the United States where some artists use larger blocks a veneer of boxwood is glued to a block of some other wood. Substitutes for wood are soft metal such as pewter, process block metal and some types of plastic such as Bakelite. This latter crumbles below the surface when cut and though useful is not to be recommended. Mr Mackley in his admirable book *Wood Engraving* (National Magazine Co, London, 1948) recommends metal supplied by the Dalziel Foundry Ltd, of London, which offers good resistance to prolonged printing.

If the best boxwood is used there is little danger of the fine lines closing under the pressure of the press but this will happen when the softer woods are used. With skilled presswork a good block will stand up to any amount of printing, which is obvious when it is remembered that all the illustrations to newspapers and periodicals were cut on wood up to the end of the last century. Bewick estimated that one of his blocks gave nine hundred thousand prints without serious deterioration.

DRAWING ON THE BLOCK. There are two ways of getting the design on to the block. The first is to draw it on in pencil, remembering that the result will print in reverse, so that all lettering must be reversed and right-handed actions of figures made left hand. The other way is to reverse the drawing and trace it on to the block with carbon paper. In both cases it is advisable to make the drawing in indian ink so that when a working proof is taken the drawing will not be lost. For creative design it is as well not to make this preliminary drawing too definite so that there will be no temptation to follow the drawn lines with a graver. As in metal engraving, the drawing, except in certain instances, should merely 'place' the design on the block, giving the main lines of the composition so that all expression may come from the work of the burin. The exceptions are lettering or architectural details where the subject should be carefully drawn, as it is impossible to correct any error in cutting. When the main lines of the design have been drawn in indian ink, the block should be rolled up with black proofing ink and wiped off. This leaves a dark tone over the block, through which the ink lines are clearly visible, and each cut on the block will then show up a lighter tone and so give the sense of working in white on black.

THE BURIN used for wood engraving is the same instrument as that used for line engraving on metal, save that the point should be bevelled off at an angle of 30°, so that when a fine line is cut it will be deep as well. Lozenge-section burins are preferable for this reason. The burin should be used as much as possible since it produces a line variable in width; the deeper it is pushed into the wood the wider the line. This means that the line itself may be expressive of contour, one of the immense advantages of the engraved line over any other.

THE SPITSTICKER. The main difference between the spitsticker and the burin is that, whereas in the latter the two undersides of the tool are flat, those of the former are rounded and their meeting in the broader forms of spitsticker are not necessarily sharp. These rounded sides allow it to cut curves more easily without bruising the sides of the cut, which the burin is apt to do. The spitsticker may be used as an alternative to the burin, as it also cuts a variable line though not as wide.

THE TINT TOOL. The tint tool, as its name suggests, is for cutting the tints used by the old professional engravers, that is a series of straight, even, uniform lines which turn the black of a block into an even tint of grey. They are made in

many sizes from fine to thick, the latter being indistinguishable from a fine flat scauper. Their main use in the old days was for making skies, corresponding to the ruled engraved lines in metal work. It is the most insensitive tool of all, as the line it cuts, however deep, is more or less the same width. But it has its uses as a variant to the broader and more varied cuts of the burin and spitsticker.

SCAUPERS, or gouges, are mainly used for clearing out white areas. Both the round and flat varieties are useful for this purpose. The flat gouge is also useful for shaving down from the surface of a black area into a white, which, when cross-hatched or otherwise engraved, will produce a delicate shaded effect from black to white through a subtle series of greys.

OTHER TOOLS, which are not absolutely necessary but which are at times useful, are bullstickers, which are broad spitstickers with bulging sides, and multiple tools, which cut two, three, four or even five fine lines at the same time. This latter tool gives a somewhat mechanical effect if over-used. But it has been used successfully by such engravers of the School of Paris as Galanis and Boullaire. The effect is very similar to that of painting on a black surface with a broad brush in white, and cleverly used as in the example by Boullaire it may produce admirable prints. But, generally speaking, the mechanical effect pre-dominates to the detriment of expression.

SHARPENING. All wood engraving tools should be kept clean and extremely sharp. It is possible to engrave with blunt tools, but the cutting is cleaner, deeper and infinitely easier when the tool is kept in good condition. Slipping, disastrous to the block or to the left hand, or both, is almost always the result of bluntness. Tools should be sharpened on an aloxite or fine carborundum stone and then polished on an arkansas stone with plenty of machine oil in both cases. When sharpening, the facet of the tool should be held flat on the stone and rubbed vigorously backwards and forwards, keeping the wrist rigid so that the angle is not changed. When the whole facet is flat and clean it should be polished on the arkansas stone to remove any burr and to hone it. In cases where the belly of the tool, that is the two undersides, is flat and meets in a sharp line, as in the burin and tint tool, the under edge should be true and sharp. When the sharp point of a tool is placed on the finger-nail or on the surface of a polished block it should grip at once if it is really sharp. If it slips at all it requires further attention. All wood engraving tools should be set in the three-quarter round handles normally supplied by the makers, and their total length when held in the hand should be such that about one inch protrudes beyond the finger-tips. When tools wear down from excessive sharpening, longer handles can be procured. The stem of the tool should be bent up at an angle of about 30° where it enters the handle, so that the latter will lie comfortably in the palm of the hand.

ENGRAVING, as on metal, is a technique where both hands are used; the left hand holding the block and the right hand forcing the burin or other tool

through the wood. When a curve is cut the right hand moves only slightly forward while the block is rotated with the left hand in a quick or slow movement which determines the magnitude of the curve. As it is necessary to rotate the block in this manner most engravers prefer to work on a rest such as a book or a sand bag, a round flat, thick leather bag filled with sand. One of the great advantages of such a rest is that the left hand can hold the block by the edges, below the surface, so that in the event of a slip the tool goes into the air instead of making a serious wound.

So long as it is possible to cut any desired line it is not important how the tool is held and each engraver will ultimately discover the position that is best for himself. It will be found, however, that if the fingers are held round the tool the angle of attack will be so steep that it will be impossible to engrave. The best method of discovering the correct hold is to place the tool flat on the table and pick it up with the handle well into the palm. At first this may feel a little awkward but a little practice soon makes the hold feel perfectly natural. The motion of engraving should come from the shoulder. Any attempt to use the wrist or fingers for pushing will mean that the whole sense of the work is niggling and weak.

The tools are not only used for making lines but for making pecks, jabs and dots, varying in length and width, in the surface of the wood. White circular dots are obtained by holding the burin perpendicularly and revolving the block about it. Lines can end abruptly by stopping the cut and lifting the tool out, or gradually, by depressing the handle of the tool during the cut and coming to the surface.

Cross-hatching becomes mechanical and unsightly if the lines are laid at right angles. They should be laid at an angle of about 30° or less and should vary in width and length. That is, a series of lines made with a burin or spitsticker should be crossed at an acute angle by a series of longer lines made with a tint tool. If all shading is done in one direction, preferably the natural right to left movement, the result will be an effect of unity. Shading at different angles is extremely dangerous, as the planes appear to alter direction with the cuts. It is best to shade either in one direction throughout or to make the shading on each flat plane follow the sense of the object. Rounded forms, especially if they are parts of the body, are better shaded across the form than following its curve, which only too often gives the effect of bandaging. Shading across the form, with carefully worked out shadows graduated from black to white, will produce a complete effect of roundness. But here again each artist should form his own technique. Engraving is merely a more difficult form of drawing where no corrections can be made and where there can be no second thoughts. Intense concentration is necessary when one thoughtless cut may ruin a block.

WHITES. When gouging out whites it is best to cut up to an engraved line,

cutting from the centre towards the edges of the area to avoid bruising the surface. Should there be any danger of this a piece of stiff card should be placed so as to protect the wood from the belly of the scauper. Whites should always be cut deep and the sides of the cut cleaned up and shoulders and excrescencies cleared away. Undercutting should be avoided, as the edges may give way under pressure.

ROCKING. Sometimes useful effects are obtainable by rocking the tools from side to side in a forward movement, which makes a series of zigzags, varying according to the tool employed. Every engraver ends by inventing his own particular technique but much time and wood are saved by studying carefully the work of modern engravers, and especially the work of the professional reproductive engravers of the last century. There is still much to be learnt from this apparently dry source.

MISTAKES. Generally speaking, there is no remedy for a mistake in wood engraving. It is possible sometimes to incorporate the error in the design. Otherwise the block will have to be plugged where the mistake occurs, or a portion of the block cut off and replaced. These operations require so much knowledge and skill that it is best to send the block to the makers, who will make an efficient repair.

Lines and small areas bruised by the belly of a tool can sometimes be cured, if not too deep, by putting a drop of water on the bruise and holding a lighted match to it so that the water dries rapidly. This will sometimes bring the bruise back to its proper level. Mistakes have been repaired with plastic wood and gum but in most cases they are apt to collapse again in the press.

ERIC RAVILIOUS  *A Cockerel Device*  wood engraving $3\frac{1}{4} \times 4$ inches

# WOODBLOCK & LINO PRINTING

## MATERIALS

| | |
|---|---|
| Composition roller | Proofing ink |
| Burnisher: or teaspoon or tooth-brush handle | Paper: thin Japanese or India etc |

## TECHNIQUE

The printing of wood engravings and woodcuts is a relatively simple matter. All that is necessary is to roll out the typographic ink on a slab to an even film, transfer it to the block and then to the paper by burnishing the back of the paper laid over the inked block. Provided the paper is of the right kind and does not slip, crumple or tear there is little difficulty in doing this but it becomes tedious when twenty or thirty prints of a medium-sized and delicate engraving are required. It is then that access to a press of some kind becomes an advantage and saves endless time and labour. No artist should allow his blocks to be printed for him unless he is present to check the prints as they are pulled. What is a good print to an efficient pressman may have lost subtleties which only the artist perceives, but once the latter has passed a print as perfect and can rely on really good presswork, he can safely leave matters to the printer. Even Bewick, whose work was always for commercial purposes, had to see that the printer was getting the proper effect before he could allow him to go ahead.

THE ROLLER. Blocks may be inked with a dabber, made of a tight ball of cotton-wool covered with fine silk or kid, but the best implement is the composition roller, obtainable from printing house stores or woodblock makers. The composition, which is cast round a wooden core is delicate and should not be exposed to the sun, heat or excessive damp. The roller should be kept clean and when put away it should lie on its back or be hung up so that the composition does not flatten. Dust should be cleaned off before using.

INKS are bought in tins or tubes, the latter being more convenient as skin is not formed with contact to the air. Black proofing ink can be obtained from any maker of typographical inks, or artist's supply shops. Messrs T. N. Lawrence, the main manufacturers of woodblocks in London, supply a very stiff ink which is extremely useful for delicate and intricate engravings. This ink is sold in tins as it is too stiff to squeeze through a tube, but care should be taken to keep it airtight. Also obtainable from the same sources is a considerable range of admirable coloured inks, both brilliant, matt and water-colour.

ROLLER UP AND INKING. A stone slab, a sheet of zinc, other metal, or glass is necessary for spreading the ink. The ink should be squeezed out of the tube in a line at the top of the slab equal to the width of the roller. The roller should be rolled into it once and the amount picked up rolled out flat on the slab. When more ink is required it can be picked up from the reserve at the top in the same manner. In this way the ink film will not be too thick. It is better to under-ink to begin with rather than to over-ink and risk blocking the finer lines. Only trial, error and experience will teach the engraver exactly how thick the ink should be, as some papers require more ink than others.

The block can be held in the hand or placed on a table for inking. Held in the hand it is easier to avoid too much pressure which might force the ink into the finer lines. The roller should be passed over the block in all directions several times until completely covered with an even film of ink. If when spreading the ink on the slab the roller makes a sticky noise there is too much ink. It should make practically no noise at all and the ink should look like the finest black silk.

BURNISHING. Copperplate burnishers are excellent for burnishing the back of a print but a teaspoon or a toothbrush handle will answer the purpose equally well. The paper, which should be large enough to allow for margins sufficient to go under a mount, should be laid face up, the face being the smoother side of the paper, on a flat surface and the block pressed down in position upon it. If the block is under-inked the paper will not stick but, inked sufficiently, the block can be turned up with the paper adhering to it and burnished. Burnishing should be done evenly, smoothly and with increasing pressure as the work proceeds. The burnisher should not be allowed to press into the whites. If the paper is delicate it should be burnished through a thin piece of smooth card so as not to crumple or tear it. Before pulling the proof off the block, each corner in turn should be lifted to see that the ink has taken evenly and sufficiently. If not the print should be pressed down again and the burnishing continued. When finished the print is carefully peeled off the block and laid aside to dry. If any lines have been filled with ink, the block should be cleaned with petrol before re-inking. The petrol will dry in a few minutes, whereas turpentine may take several hours, during which it will be impossible to print.

PAPERS. For burnishing, all papers must be thin and smooth. Thin and medium Japanese papers, India papers, imitation India papers, and even thin imitation vellum writing papers are all suitable. All thicker papers require a press. Most papers have a smooth and rough side and the smooth side should always be used.

PRESSES. There are three main types of presses for printing woodblocks and lino; the platen press used by printers for proofing letterpress; the cylinder press for woodblock printing made by Kimbers; and the adapted die press, which is used by engravers in France.

THE PLATEN PRESS, which may be either an Albion or a Columbian, may occasionally be acquired second-hand, but it is rare and expensive. The process of printing on the press is comparatively easy but requires experience before perfect prints are pulled. The bed is rolled out from under the platen, the tympan lifted, the inked block with a piece of paper upon it laid centrally, face up, upon the bed, the tympan lowered and the bed rolled back under the platen, which is then pressed down with the impression handle. It is seldom, however, that a block will print well without packing, which should be soft, such as newspaper etc, and should be placed above the printing paper or attached to the tympan. Blocks less than type-high should be laid on stiff boards on the bed to raise them sufficiently. If parts of a block do not print properly owing to warping or irregular impression from the platen, they should be packed up with small pieces of torn newspaper till they do. Printers proofing delicate blocks make overlays by cutting out the badly printed portions of a print on thin paper and gumming it to the backing on the tympan in the correct position. By regulating the pressure in this way perfect prints can be obtained. For information concerning the construction and working of platen presses it is advisable to consult an experienced printer or refer to such books as *Printing Explained* by Herbert Simon and Harry Carter (Dryad Press, 1931) or other authorities.

THE CYLINDER PRESS, or Kimbers Wood Engraving Proofing Press, is built on the same principle as a copperplate press but the bed passing between the upper and lower rollers is fitted with two type-high metal sides, supporting the upper roller, which allows the block to pass underneath. This press is capable of far greater pressure than the platen press, its only disadvantage being that the size is generally too small to take large blocks and lino.

The press is fitted with a tympan, which is laid over the packing or has the packing attached to it. This should be of soft paper and the press very carefully regulated as if the pressure is too great the fine lines of the engraving will be squeezed up and any folds in the packing or grit will be forced into the surface of the block. The press should be adjusted to the correct pressure, using an old block, and then excellent prints can be pulled.

ADAPTED DIE PRESS. In France die presses are adapted for the use of wood engravers. A metal plate with a pin welded to the centre of the underside to fit the cavity for the lower die is used as a bed. The upper die cavity is fitted with a flat blind die about two inches acrosss. A sheet of lino is placed on the bed to ease the pressure, the paper laid upon it and the inked block on the paper face down. The linoleum is then moved about with one hand while the other brings the top die, worked with a spring screw, down on to every square inch of the block, exerting considerable pressure. Perfect prints are easily obtained in this manner on almost any paper, the only disadvantage being that if a block is warped at all it will split under the pressure which is always concentrated at one point.

PAPERS FOR PRESS PRINTING. The smoother the paper, providing it is reasonably soft, the easier it is to pull a good print in a press. Soft sized smooth papers should therefore always be employed. Spongy, laid or fluffy papers are useless. Thick hand-made papers will print if they are carefully damped. They should be, in printers' terms, 'dry to the touch and cool to the cheek'. The Victorians were very careful in their choice of paper for printing wood blocks for illustrated books and many of the poor results obtained today come from the use of unsuitable paper.

TONAL PRINTING. The method of tonal printing used for *Girl Disrobing*, page 206, is not often used. It can be obtained on a press by means of an immense amount of trouble, so much that it is not worth considering. It is best done with a burnisher on Japanese tissue, which is not always obtainable. The block which is only engraved with the white lines is inked for normal printing. Pressed on to the tissue so that the paper sticks to it, it is turned round and rubbed all over evenly, with the finger. The white lines will then show through the back of the tissue and the second tone can be burnished very lightly, following the white lines. The third, or black tone, can then be burnished normally. In this process no card can be used to protect the paper or the design would be invisible and the tissue must be carefully inspected beforehand to see that there are no blemishes or grit which would interrupt the printing and tear the paper. The whole success depends on three delicate even burnishings.

LINO PRINTING, ETC. Lino printing is usually done on a platen press, as it is often on too large a scale for the cylinder press. In this case a plank of wood, about three-quarter inch high, is necessary to raise the lino to type level. Lino can also be printed by hand by means of a hard roller and a burnisher. Bernard Rice's large woodcut *Rammuda*, page 180, was printed in this way on cotton cloth. Misch Kohn's wood engraving *Bullfight*, page 219, was printed in a lithographic press on Chinese paper with excellent results. It gives, however, the type of pressure which embosses the whites which is not always desirable. By using metal strips about the same depth as lino and as long as the bed to support the top roller, lino can be printed on a copperplate press with a thin blanket and paper for packing, on the same principle as the cylinder press.

REGISTRATION FOR COLOUR WORK. For colour work printing, the blocks will have to be correctly registered so that each colour comes in exactly the right place. Provided each block or sheet of lino has the same corner intact it is possible to do this by eye alone. The print must, however, be laid on the bed of the press to do this, so that the second and third blocks, etc, will have to be printed face down, so that the packing will have to be under the block and not on top. Another method is to cut a template for the block. A simple L-shaped piece of wood or lino, whichever is being printed, will suffice and if the printing paper is hinged to this template with cellotape the correct register for

the subsequent blocks will be ensured. If a platen press is used and furniture is available it is better to lock the blocks into formes and register the paper on the tympan by means of printers' clips, which is the professional method of colour printing.

COLOURS. Oil colours are most generally used for lino printing but have certain disadvantages. If three or four colours are printed while the first is still damp there is a tendency for the last colours to 'pick up' the first. If each colour is allowed to dry before printing the next the effect is glossy and unpleasant. There is, however, a moment, which can only be judged from experience, when the print is dry enough not to pick up and damp enough not to shine. Water-colour inks, though not as strong as oil-bound colours, do not possess this disadvantage and generally give better results.

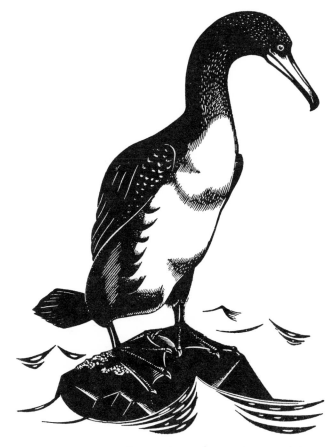

ROBERT GIBBINGS *Cormorant* wood engraving, actual size

# Index to Artists Represented

Numbers in *italics* refer to illustrations

A CATALOG OF SELECTED
**DOVER BOOKS**
IN ALL FIELDS OF INTEREST

# A CATALOG OF SELECTED DOVER
# BOOKS IN ALL FIELDS OF INTEREST

DRAWINGS OF REMBRANDT, edited by Seymour Slive. Updated Lippmann, Hofstede de Groot edition, with definitive scholarly apparatus. All portraits, biblical sketches, landscapes, nudes. Oriental figures, classical studies, together with selection of work by followers. 550 illustrations. Total of 630pp. 9⅛ × 12¼.
21485-0, 21486-9 Pa., Two-vol. set $29.90

GHOST AND HORROR STORIES OF AMBROSE BIERCE, Ambrose Bierce. 24 tales vividly imagined, strangely prophetic, and decades ahead of their time in technical skill: "The Damned Thing," "An Inhabitant of Carcosa," "The Eyes of the Panther," "Moxon's Master," and 20 more. 199pp. 5⅜ × 8½. 20767-6 Pa. $3.95

ETHICAL WRITINGS OF MAIMONIDES, Maimonides. Most significant ethical works of great medieval sage, newly translated for utmost precision, readability. Laws Concerning Character Traits, Eight Chapters, more. 192pp. 5⅜ × 8½.
24522-5 Pa. $4.50

THE EXPLORATION OF THE COLORADO RIVER AND ITS CANYONS, J. W. Powell. Full text of Powell's 1,000-mile expedition down the fabled Colorado in 1869. Superb account of terrain, geology, vegetation, Indians, famine, mutiny, treacherous rapids, mighty canyons, during exploration of last unknown part of continental U.S. 400pp. 5⅜ × 8½. 20094-9 Pa. $7.95

HISTORY OF PHILOSOPHY, Julián Marías. Clearest one-volume history on the market. Every major philosopher and dozens of others, to Existentialism and later. 505pp. 5⅜ × 8½. 21739-6 Pa. $9.95

ALL ABOUT LIGHTNING, Martin A. Uman. Highly readable non-technical survey of nature and causes of lightning, thunderstorms, ball lightning, St. Elmo's Fire, much more. Illustrated. 192pp. 5⅜ × 8½. 25237-X Pa. $5.95

SAILING ALONE AROUND THE WORLD, Captain Joshua Slocum. First man to sail around the world, alone, in small boat. One of great feats of seamanship told in delightful manner. 67 illustrations. 294pp. 5⅜ × 8½. 20326-3 Pa. $4.95

LETTERS AND NOTES ON THE MANNERS, CUSTOMS AND CONDITIONS OF THE NORTH AMERICAN INDIANS, George Catlin. Classic account of life among Plains Indians: ceremonies, hunt, warfare, etc. 312 plates. 572pp. of text. 6⅛ × 9¼. 22118-0, 22119-9, Pa. Two-vol. set $17.90

ALASKA: The Harriman Expedition, 1899, John Burroughs, John Muir, et al. Informative, engrossing accounts of two-month, 9,000-mile expedition. Native peoples, wildlife, forests, geography, salmon industry, glaciers, more. Profusely illustrated. 240 black-and-white line drawings. 124 black-and-white photographs. 3 maps. Index. 576pp. 5⅜ × 8½. 25109-8 Pa. $11.95

ILLUSTRATED GUIDE TO SHAKER FURNITURE, Robert Meader. All furniture and appurtenances, with much on unknown local styles. 235 photos. 146pp. 9 × 12. 22819-3 Pa. $8.95

WHALE SHIPS AND WHALING: A Pictorial Survey, George Francis Dow. Over 200 vintage engravings, drawings, photographs of barks, brigs, cutters, other vessels. Also harpoons, lances, whaling guns, many other artifacts. Comprehensive text by foremost authority. 207 black-and-white illustrations. 288pp. 6 × 9. 24808-9 Pa. $8.95

THE BERTRAMS, Anthony Trollope. Powerful portrayal of blind self-will and thwarted ambition includes one of Trollope's most heartrending love stories. 497pp. 5⅜ × 8½. 25119-5 Pa. $9.95

ADVENTURES WITH A HAND LENS, Richard Headstrom. Clearly written guide to observing and studying flowers and grasses, fish scales, moth and insect wings, egg cases, buds, feathers, seeds, leaf scars, moss, molds, ferns, common crystals, etc.—all with an ordinary, inexpensive magnifying glass. 209 exact line drawings aid in your discoveries. 220pp. 5⅜ × 8½. 23330-8 Pa. $4.95

RODIN ON ART AND ARTISTS, Auguste Rodin. Great sculptor's candid, wide-ranging comments on meaning of art; great artists; relation of sculpture to poetry, painting, music; philosophy of life, more. 76 superb black-and-white illustrations of Rodin's sculpture, drawings and prints. 119pp. 8⅜ × 11¼. 24487-3 Pa. $7.95

FIFTY CLASSIC FRENCH FILMS, 1912-1982: A Pictorial Record, Anthony Slide. Memorable stills from Grand Illusion, Beauty and the Beast, Hiroshima, Mon Amour, many more. Credits, plot synopses, reviews, etc. 160pp. 8¼ × 11. 25256-6 Pa. $11.95

THE PRINCIPLES OF PSYCHOLOGY, William James. Famous long course complete, unabridged. Stream of thought, time perception, memory, experimental methods; great work decades ahead of its time. 94 figures. 1,391pp. 5⅜ × 8½. 20381-6, 20382-4 Pa., Two-vol. set $23.90

BODIES IN A BOOKSHOP, R. T. Campbell. Challenging mystery of blackmail and murder with ingenious plot and superbly drawn characters. In the best tradition of British suspense fiction. 192pp. 5⅜ × 8½. 24720-1 Pa. $3.95

CALLAS: PORTRAIT OF A PRIMA DONNA, George Jellinek. Renowned commentator on the musical scene chronicles incredible career and life of the most controversial, fascinating, influential operatic personality of our time. 64 black-and-white photographs. 416pp. 5⅜ × 8¼. 25047-4 Pa. $8.95

GEOMETRY, RELATIVITY AND THE FOURTH DIMENSION, Rudolph Rucker. Exposition of fourth dimension, concepts of relativity as Flatland characters continue adventures. Popular, easily followed yet accurate, profound. 141 illustrations. 133pp. 5⅜ × 8½. 23400-2 Pa. $4.95

HOUSEHOLD STORIES BY THE BROTHERS GRIMM, with pictures by Walter Crane. 53 classic stories—Rumpelstiltskin, Rapunzel, Hansel and Gretel, the Fisherman and his Wife, Snow White, Tom Thumb, Sleeping Beauty, Cinderella, and so much more—lavishly illustrated with original 19th century drawings. 114 illustrations. x + 269pp. 5⅜ × 8½. 21080-4 Pa. $4.95

A CONCISE HISTORY OF PHOTOGRAPHY: Third Revised Edition, Helmut Gernsheim. Best one-volume history—camera obscura, photochemistry, daguerreotypes, evolution of cameras, film, more. Also artistic aspects—landscape, portraits, fine art, etc. 281 black-and-white photographs. 26 in color. 176pp. 8⅜ × 11¼. 25128-4 Pa. $13.95

THE DORÉ BIBLE ILLUSTRATIONS, Gustave Doré. 241 detailed plates from the Bible: the Creation scenes, Adam and Eve, Flood, Babylon, battle sequences, life of Jesus, etc. Each plate is accompanied by the verses from the King James version of the Bible. 241pp. 9 × 12. 23004-X Pa. $9.95

HUGGER-MUGGER IN THE LOUVRE, Elliot Paul. Second Homer Evans mystery-comedy. Theft at the Louvre involves sleuth in hilarious, madcap caper. "A knockout."—Books. 336pp. 5⅜ × 8½. 25185-3 Pa. $5.95

FLATLAND, E. A. Abbott. Intriguing and enormously popular science-fiction classic explores the complexities of trying to survive as a two-dimensional being in a three-dimensional world. Amusingly illustrated by the author. 16 illustrations. 103pp. 5⅜ × 8½. 20001-9 Pa. $2.50

THE HISTORY OF THE LEWIS AND CLARK EXPEDITION, Meriwether Lewis and William Clark, edited by Elliott Coues. Classic edition of Lewis and Clark's day-by-day journals that later became the basis for U.S. claims to Oregon and the West. Accurate and invaluable geographical, botanical, biological, meteorological and anthropological material. Total of 1,508pp. 5⅜ × 8½.
21268-8, 21269-6, 21270-X Pa. Three-vol. set $26.85

LANGUAGE, TRUTH AND LOGIC, Alfred J. Ayer. Famous, clear introduction to Vienna, Cambridge schools of Logical Positivism. Role of philosophy, elimination of metaphysics, nature of analysis, etc. 160pp. 5⅜ × 8½. (Available in U.S. and Canada only) 20010-8 Pa. $3.95

MATHEMATICS FOR THE NONMATHEMATICIAN, Morris Kline. Detailed, college-level treatment of mathematics in cultural and historical context, with numerous exercises. For liberal arts students. Preface. Recommended Reading Lists. Tables. Index. Numerous black-and-white figures. xvi + 641pp. 5⅜ × 8½.
24823-2 Pa. $11.95

HANDBOOK OF PICTORIAL SYMBOLS, Rudolph Modley. 3,250 signs and symbols, many systems in full; official or heavy commercial use. Arranged by subject. Most in Pictorial Archive series. 143pp. 8⅜ × 11. 23357-X Pa. $6.95

INCIDENTS OF TRAVEL IN YUCATAN, John L. Stephens. Classic (1843) exploration of jungles of Yucatan, looking for evidences of Maya civilization. Travel adventures, Mexican and Indian culture, etc. Total of 669pp. 5⅜ × 8½.
20926-1, 20927-X Pa., Two-vol. set $11.90

DEGAS: An Intimate Portrait, Ambroise Vollard. Charming, anecdotal memoir by famous art dealer of one of the greatest 19th-century French painters. 14 black-and-white illustrations. Introduction by Harold L. Van Doren. 96pp. 5⅜ × 8½.
25131-4 Pa. $4.95

PERSONAL NARRATIVE OF A PILGRIMAGE TO ALMANDINAH AND MECCAH, Richard Burton. Great travel classic by remarkably colorful personality. Burton, disguised as a Moroccan, visited sacred shrines of Islam, narrowly escaping death. 47 illustrations. 959pp. 5⅜ × 8½.    21217-3, 21218-1 Pa., Two-vol. set $19.90

PHRASE AND WORD ORIGINS, A. H. Holt. Entertaining, reliable, modern study of more than 1,200 colorful words, phrases, origins and histories. Much unexpected information. 254pp. 5⅜ × 8½.    20758-7 Pa. $5.95

THE RED THUMB MARK, R. Austin Freeman. In this first Dr. Thorndyke case, the great scientific detective draws fascinating conclusions from the nature of a single fingerprint. Exciting story, authentic science. 320pp. 5⅜ × 8½. (Available in U.S. only)    25210-8 Pa. $6.95

AN EGYPTIAN HIEROGLYPHIC DICTIONARY, E. A. Wallis Budge. Monumental work containing about 25,000 words or terms that occur in texts ranging from 3000 B.C. to 600 A.D. Each entry consists of a transliteration of the word, the word in hieroglyphs, and the meaning in English. 1,314pp. 6⅜ × 10.
23615-3, 23616-1 Pa., Two-vol. set $31.90

THE COMPLEAT STRATEGYST: Being a Primer on the Theory of Games of Strategy, J. D. Williams. Highly entertaining classic describes, with many illustrated examples, how to select best strategies in conflict situations. Prefaces. Appendices. xvi + 268pp. 5⅜ × 8½.    25101-2 Pa. $5.95

THE ROAD TO OZ, L. Frank Baum. Dorothy meets the Shaggy Man, little Button-Bright and the Rainbow's beautiful daughter in this delightful trip to the magical Land of Oz. 272pp. 5⅜ × 8.    25208-6 Pa. $5.95

POINT AND LINE TO PLANE, Wassily Kandinsky. Seminal exposition of role of point, line, other elements in non-objective painting. Essential to understanding 20th-century art. 127 illustrations. 192pp. 6½ × 9¼.    23808-3 Pa. $5.95

LADY ANNA, Anthony Trollope. Moving chronicle of Countess Lovel's bitter struggle to win for herself and daughter Anna their rightful rank and fortune—perhaps at cost of sanity itself. 384pp. 5⅜ × 8½.    24669-8 Pa. $8.95

EGYPTIAN MAGIC, E. A. Wallis Budge. Sums up all that is known about magic in Ancient Egypt: the role of magic in controlling the gods, powerful amulets that warded off evil spirits, scarabs of immortality, use of wax images, formulas and spells, the secret name, much more. 253pp. 5⅜ × 8½.    22681-6 Pa. $4.50

THE DANCE OF SIVA, Ananda Coomaraswamy. Preeminent authority unfolds the vast metaphysic of India: the revelation of her art, conception of the universe, social organization, etc. 27 reproductions of art masterpieces. 192pp. 5⅜ × 8½.
24817-8 Pa. $5.95

CHRISTMAS CUSTOMS AND TRADITIONS, Clement A. Miles. Origin, evolution, significance of religious, secular practices. Caroling, gifts, yule logs, much more. Full, scholarly yet fascinating; non-sectarian. 400pp. 5⅜ × 8½.
23354-5 Pa. $6.95

THE HUMAN FIGURE IN MOTION, Eadweard Muybridge. More than 4,500 stopped-action photos, in action series, showing undraped men, women, children jumping, lying down, throwing, sitting, wrestling, carrying, etc. 390pp. 7⅞ × 10⅝.
20204-6 Cloth. $21.95

THE MAN WHO WAS THURSDAY, Gilbert Keith Chesterton. Witty, fast-paced novel about a club of anarchists in turn-of-the-century London. Brilliant social, religious, philosophical speculations. 128pp. 5⅜ × 8½.
25121-7 Pa. $3.95

A CEZANNE SKETCHBOOK: Figures, Portraits, Landscapes and Still Lifes, Paul Cezanne. Great artist experiments with tonal effects, light, mass, other qualities in over 100 drawings. A revealing view of developing master painter, precursor of Cubism. 102 black-and-white illustrations. 144pp. 8¾ × 6⅜.
24790-2 Pa. $5.95

AN ENCYCLOPEDIA OF BATTLES: Accounts of Over 1,560 Battles from 1479 B.C. to the Present, David Eggenberger. Presents essential details of every major battle in recorded history, from the first battle of Megiddo in 1479 B.C. to Grenada in 1984. List of Battle Maps. New Appendix covering the years 1967–1984. Index. 99 illustrations. 544pp. 6½ × 9¼.
24913-1 Pa. $14.95

AN ETYMOLOGICAL DICTIONARY OF MODERN ENGLISH, Ernest Weekley. Richest, fullest work, by foremost British lexicographer. Detailed word histories. Inexhaustible. Total of 856pp. 6½ × 9¼.
21873-2, 21874-0 Pa., Two-vol. set $17.00

WEBSTER'S AMERICAN MILITARY BIOGRAPHIES, edited by Robert McHenry. Over 1,000 figures who shaped 3 centuries of American military history. Detailed biographies of Nathan Hale, Douglas MacArthur, Mary Hallaren, others. Chronologies of engagements, more. Introduction. Addenda. 1,033 entries in alphabetical order. xi + 548pp. 6½ × 9¼. (Available in U.S. only)
24758-9 Pa. $13.95

LIFE IN ANCIENT EGYPT, Adolf Erman. Detailed older account, with much not in more recent books: domestic life, religion, magic, medicine, commerce, and whatever else needed for complete picture. Many illustrations. 597pp. 5⅜ × 8½.
22632-8 Pa. $8.95

HISTORIC COSTUME IN PICTURES, Braun & Schneider. Over 1,450 costumed figures shown, covering a wide variety of peoples: kings, emperors, nobles, priests, servants, soldiers, scholars, townsfolk, peasants, merchants, courtiers, cavaliers, and more. 256pp. 8⅜ × 11¼.
23150-X Pa. $9.95

THE NOTEBOOKS OF LEONARDO DA VINCI, edited by J. P. Richter. Extracts from manuscripts reveal great genius; on painting, sculpture, anatomy, sciences, geography, etc. Both Italian and English. 186 ms. pages reproduced, plus 500 additional drawings, including studies for *Last Supper*, *Sforza* monument, etc. 860pp. 7⅞ × 10⅝. (Available in U.S. only) 22572-0, 22573-9 Pa., Two-vol. set $31.90

THE ART NOUVEAU STYLE BOOK OF ALPHONSE MUCHA: All 72 Plates from "Documents Decoratifs" in Original Color, Alphonse Mucha. Rare copyright-free design portfolio by high priest of Art Nouveau. Jewelry, wallpaper, stained glass, furniture, figure studies, plant and animal motifs, etc. Only complete one-volume edition. 80pp. 9⅜ × 12¼. 24044-4 Pa. $9.95

ANIMALS: 1,419 COPYRIGHT-FREE ILLUSTRATIONS OF MAMMALS, BIRDS, FISH, INSECTS, ETC., edited by Jim Harter. Clear wood engravings present, in extremely lifelike poses, over 1,000 species of animals. One of the most extensive pictorial sourcebooks of its kind. Captions. Index. 284pp. 9 × 12.
23766-4 Pa. $9.95

OBELISTS FLY HIGH, C. Daly King. Masterpiece of American detective fiction, long out of print, involves murder on a 1935 transcontinental flight—"a very thrilling story"—NY Times. Unabridged and unaltered republication of the edition published by William Collins Sons & Co. Ltd., London, 1935. 288pp. 5⅜ × 8½. (Available in U.S. only) 25036-9 Pa. $5.95

VICTORIAN AND EDWARDIAN FASHION: A Photographic Survey, Alison Gernsheim. First fashion history completely illustrated by contemporary photographs. Full text plus 235 photos, 1840–1914, in which many celebrities appear. 240pp. 6½ × 9¼. 24205-6 Pa. $6.95

THE ART OF THE FRENCH ILLUSTRATED BOOK, 1700–1914, Gordon N. Ray. Over 630 superb book illustrations by Fragonard, Delacroix, Daumier, Doré, Grandville, Manet, Mucha, Steinlen, Toulouse-Lautrec and many others. Preface. Introduction. 633 halftones. Indices of artists, authors & titles, binders and provenances. Appendices. Bibliography. 608pp. 8⅜ × 11¼. 25086-5 Pa. $24.95

THE WONDERFUL WIZARD OF OZ, L. Frank Baum. Facsimile in full color of America's finest children's classic. 143 illustrations by W. W. Denslow. 267pp. 5⅜ × 8½. 20691-2 Pa. $7.95

FRONTIERS OF MODERN PHYSICS: New Perspectives on Cosmology, Relativity, Black Holes and Extraterrestrial Intelligence, Tony Rothman, et al. For the intelligent layman. Subjects include: cosmological models of the universe; black holes; the neutrino; the search for extraterrestrial intelligence. Introduction. 46 black-and-white illustrations. 192pp. 5⅜ × 8½. 24587-X Pa. $7.95

THE FRIENDLY STARS, Martha Evans Martin & Donald Howard Menzel. Classic text marshalls the stars together in an engaging, non-technical survey, presenting them as sources of beauty in night sky. 23 illustrations. Foreword. 2 star charts. Index. 147pp. 5⅜ × 8½. 21099-5 Pa. $3.95

FADS AND FALLACIES IN THE NAME OF SCIENCE, Martin Gardner. Fair, witty appraisal of cranks, quacks, and quackeries of science and pseudoscience: hollow earth, Velikovsky, orgone energy, Dianetics, flying saucers, Bridey Murphy, food and medical fads, etc. Revised, expanded In the Name of Science. "A very able and even-tempered presentation."—The New Yorker. 363pp. 5⅜ × 8.
20394-8 Pa. $6.95

ANCIENT EGYPT: ITS CULTURE AND HISTORY, J. E Manchip White. From pre-dynastics through Ptolemies: society, history, political structure, religion, daily life, literature, cultural heritage. 48 plates. 217pp. 5⅜ × 8½. 22548-8 Pa. $5.95

SIR HARRY HOTSPUR OF HUMBLETHWAITE, Anthony Trollope. Incisive, unconventional psychological study of a conflict between a wealthy baronet, his idealistic daughter, and their scapegrace cousin. The 1870 novel in its first inexpensive edition in years. 250pp. 5⅜ × 8½. 24953-0 Pa. $5.95

LASERS AND HOLOGRAPHY, Winston E. Kock. Sound introduction to burgeoning field, expanded (1981) for second edition. Wave patterns, coherence, lasers, diffraction, zone plates, properties of holograms, recent advances. 84 illustrations. 160pp. 5⅜ × 8¼. (Except in United Kingdom) 24041-X Pa. $3.95

INTRODUCTION TO ARTIFICIAL INTELLIGENCE: SECOND, EN-LARGED EDITION, Philip C. Jackson, Jr. Comprehensive survey of artificial intelligence—the study of how machines (computers) can be made to act intelligently. Includes introductory and advanced material. Extensive notes updating the main text. 132 black-and-white illustrations. 512pp. 5⅜ × 8½. 24864-X Pa. $8.95

HISTORY OF INDIAN AND INDONESIAN ART, Ananda K. Coomaraswamy. Over 400 illustrations illuminate classic study of Indian art from earliest Harappa finds to early 20th century. Provides philosophical, religious and social insights. 304pp. 6⅝ × 9⅜. 25005-9 Pa. $9.95

THE GOLEM, Gustav Meyrink. Most famous supernatural novel in modern European literature, set in Ghetto of Old Prague around 1890. Compelling story of mystical experiences, strange transformations, profound terror. 13 black-and-white illustrations. 224pp. 5⅜ × 8½. (Available in U.S. only) 25025-3 Pa. $6.95

PICTORIAL ENCYCLOPEDIA OF HISTORIC ARCHITECTURAL PLANS, DETAILS AND ELEMENTS: With 1,880 Line Drawings of Arches, Domes, Doorways, Facades, Gables, Windows, etc., John Theodore Haneman. Sourcebook of inspiration for architects, designers, others. Bibliography. Captions. 141pp. 9 × 12. 24605-1 Pa. $7.95

BENCHLEY LOST AND FOUND, Robert Benchley. Finest humor from early 30's, about pet peeves, child psychologists, post office and others. Mostly unavailable elsewhere. 73 illustrations by Peter Arno and others. 183pp. 5⅜ × 8½. 22410-4 Pa. $4.95

ERTÉ GRAPHICS, Erté. Collection of striking color graphics: *Seasons, Alphabet, Numerals, Aces* and *Precious Stones.* 50 plates, including 4 on covers. 48pp. 9⅜ × 12¼. 23580-7 Pa. $7.95

THE JOURNAL OF HENRY D. THOREAU, edited by Bradford Torrey, F. H. Allen. Complete reprinting of 14 volumes, 1837–61, over two million words; the sourcebooks for *Walden,* etc. Definitive. All original sketches, plus 75 photographs. 1,804pp. 8½ × 12¼. 20312-3, 20313-1 Cloth., Two-vol. set $120.00

CASTLES: THEIR CONSTRUCTION AND HISTORY, Sidney Toy. Traces castle development from ancient roots. Nearly 200 photographs and drawings illustrate moats, keeps, baileys, many other features. Caernarvon, Dover Castles, Hadrian's Wall, Tower of London, dozens more. 256pp. 5⅜ × 8¼. 24898-4 Pa. $6.95

## CATALOG OF DOVER BOOKS

AMERICAN CLIPPER SHIPS: 1833–1858, Octavius T. Howe & Frederick C. Matthews. Fully-illustrated, encyclopedic review of 352 clipper ships from the period of America's greatest maritime supremacy. Introduction. 109 halftones. 5 black-and-white line illustrations. Index. Total of 928pp. 5⅜ × 8½.
25115-2, 25116-0 Pa., Two-vol. set $17.90

TOWARDS A NEW ARCHITECTURE, Le Corbusier. Pioneering manifesto by great architect, near legendary founder of "International School." Technical and aesthetic theories, views on industry, economics, relation of form to function, "mass-production spirit," much more. Profusely illustrated. Unabridged translation of 13th French edition. Introduction by Frederick Etchells. 320pp. 6⅛ × 9¼. (Available in U.S. only) 25023-7 Pa. $8.95

THE BOOK OF KELLS, edited by Blanche Cirker. Inexpensive collection of 32 full-color, full-page plates from the greatest illuminated manuscript of the Middle Ages, painstakingly reproduced from rare facsimile edition. Publisher's Note. Captions. 32pp. 9⅜ × 12¼. 24345-1 Pa. $4.95

BEST SCIENCE FICTION STORIES OF H. G. WELLS, H. G. Wells. Full novel *The Invisible Man*, plus 17 short stories: "The Crystal Egg," "Aepyornis Island," "The Strange Orchid," etc. 303pp. 5⅜ × 8½. (Available in U.S. only)
21531-8 Pa. $6.95

AMERICAN SAILING SHIPS: Their Plans and History, Charles G. Davis. Photos, construction details of schooners, frigates, clippers, other sailcraft of 18th to early 20th centuries—plus entertaining discourse on design, rigging, nautical lore, much more. 137 black-and-white illustrations. 240pp. 6⅛ × 9¼.
24658-2 Pa. $6.95

ENTERTAINING MATHEMATICAL PUZZLES, Martin Gardner. Selection of author's favorite conundrums involving arithmetic, money, speed, etc., with lively commentary. Complete solutions. 112pp. 5⅜ × 8½. 25211-6 Pa. $2.95

THE WILL TO BELIEVE, HUMAN IMMORTALITY, William James. Two books bound together. Effect of irrational on logical, and arguments for human immortality. 402pp. 5⅜ × 8½. 20291-7 Pa. $7.95

THE HAUNTED MONASTERY and THE CHINESE MAZE MURDERS, Robert Van Gulik. 2 full novels by Van Gulik continue adventures of Judge Dee and his companions. An evil Taoist monastery, seemingly supernatural events; overgrown topiary maze that hides strange crimes. Set in 7th-century China. 27 illustrations. 328pp. 5⅜ × 8½. 23502-5 Pa. $6.95

CELEBRATED CASES OF JUDGE DEE (DEE GOONG AN), translated by Robert Van Gulik. Authentic 18th-century Chinese detective novel; Dee and associates solve three interlocked cases. Led to Van Gulik's own stories with same characters. Extensive introduction. 9 illustrations. 237pp. 5⅜ × 8½.
23337-5 Pa. $4.95

*Prices subject to change without notice.*
Available at your book dealer or write for free catalog to Dept. GI, Dover Publications, Inc., 31 East 2nd St., Mineola, N.Y. 11501. Dover publishes more than 175 books each year on science, elementary and advanced mathematics, biology, music, art, literary history, social sciences and other areas.